THE
ESSENTIAL
PHOTOGRAPHY
MANUAL

RotoVision

A RotoVision Book

Published and distributed by RotoVision SA,
Route Suisse 9, CH-1295 Mies
Switzerland

RotoVision SA,
Sales, Editorial & Production Office,
Sheridan House,
112/116a Western Road,
Hove,
East Sussex BN3 1DD,
UK

Tel: +44 (0)1273 72 72 68
Fax: +44 (0)1273 72 72 69
Email: sales@rotovision.com
Website: www.rotovision.com

10 9 8 7 6 5 4 3 2 1

ISBN 2-88046-712-8

Designed by Red Alert Design, London

Reprographics in Singapore by Provision Pte Ltd
Printed in China by Midas Printing International Ltd

THE
ESSENTIAL PHOTOGRAPHY MANUAL

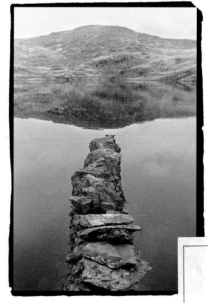

TIM DALY

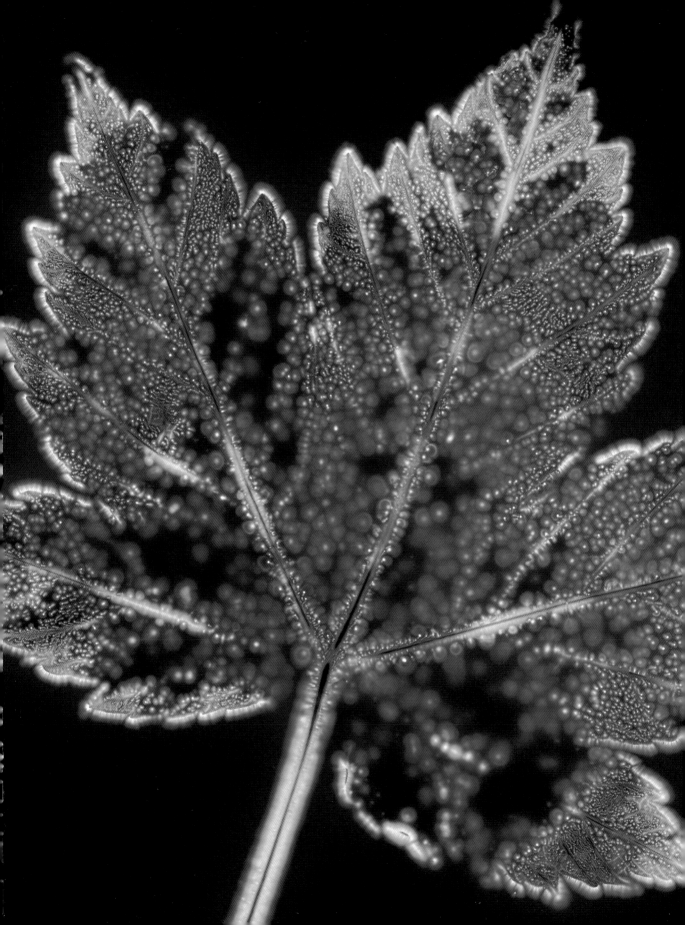

→ CONTENTS

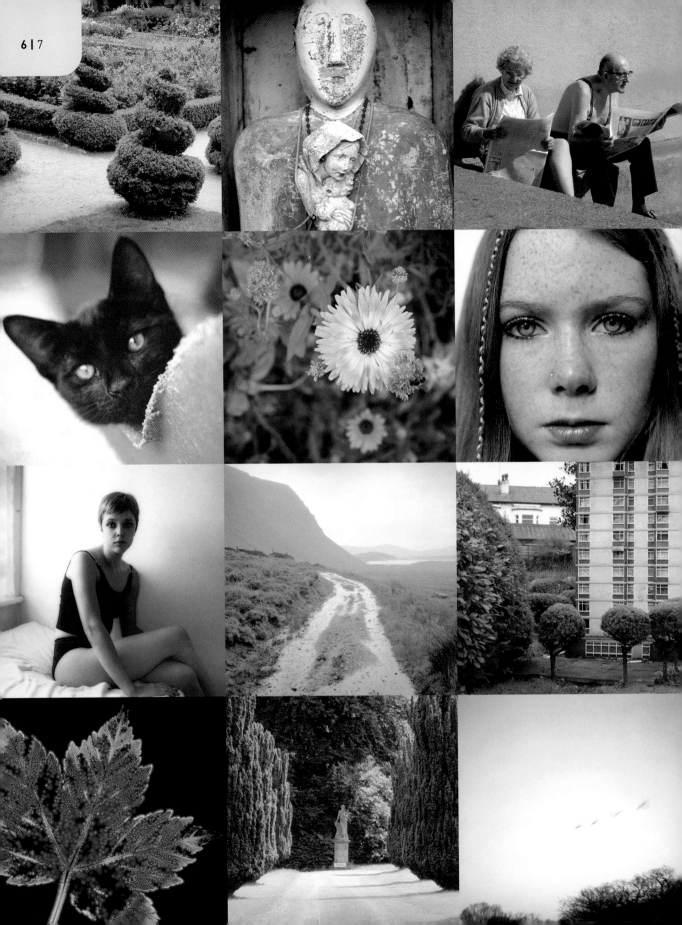

→ INTRODUCTION

The Essential Photography Manual presents all the know-how for those photographers who are just getting started, and advanced tips for the more experienced. With a comprehensive examination of tools, techniques, and processes for both digital and conventional photography, this guide is both a reference book, and source of inspiration. Covering all popular subjects, including landscape, still life and portraiture, special techniques are presented alongside stunning examples from the experts. Each spread is clearly explained with the minimum of jargon, and is designed to build up your skills to make better photographs. With tips on how to deal with tricky situations and advice on selecting equipment, this guide is also an excellent reference book for those studying the subject at undergraduate level. For those keen to develop a broader appreciation of the art of photography, a history section presents the key figures from the last 170 years, and shows how each approach has become established as a standard technique.

Since the birth of the medium in 1839, revolutionary advances in technology have enabled photographers to see the world in a different light. With each development in technology came new possibilities of recording contemporary life. As materials became more light sensitive, so images could be shot on location, and before long, the four corners of the earth were photographed and presented to the wonderment of the world. Over time cameras became more portable and this encouraged the candid style that soon became affordable to all. Moving out of photography's first century saw the birth of color film and the era of the snapshot.

As we stand at the beginning of the 21st century, photography is again undergoing a major revolution with digital cameras and computer-based image-making rapidly becoming the most popular way to make photographs. With such a rapid change in working methods and processes, there's never been a more important time to understand the core techniques of camera use. Whether you're a film-based photographer keen to experiment with new ideas and approaches, or a digital photographer aiming at a greater understanding of shooting skills and exposure, The Essential Photography Manual will help you achieve your goal.

At the heart of all these changes are the three fundamentals of great image-making: preparation, anticipation, and technique. All great photographers prepare for their shoots well in advance by having a thorough understanding of the precise nature of the task ahead, and equip themselves accordingly. Before and during the shoot, it's essential to anticipate and visualize the potential images you could make, as opportunities can present themselves in a fleeting moment. Finally, there's no substitute for good technique, and a photographer that can choose the right settings to match the situation will always end up with dynamic results, and no regrets.

Tim Daly

→ EQUIPMENT

→ **35MM SLR** (SINGLE LENS REFLEX)

STILL THE MOST POPULAR CAMERA SYSTEM IN THE WORLD, THE 35MM SLR IS THE CAMERA OF CHOICE FOR SERIOUS AMATEUR PHOTOGRAPHERS

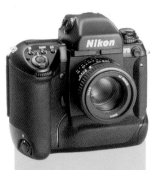

The Nikon F5 is a solidly built SLR aimed at the more demanding professional user.

»TYPICAL SPECIFICATIONS

The 35mm SLR benefits from nearly 70 years of design revisions. Most cameras are built around an electronic circuit which controls functions by relaying information to and from the lens and built-in light meter. To eliminate the possibility of error, devices such as autofocus, automatic film speed detection (DX), and auto film-loading and advance, make recent 35mm SLRs dependent on battery power. Professional 35mm cameras are built around a rugged metal body to cope with wear and tear, and have rechargeable power supplies. At ten times the cost of a basic 35mm SLR, the professional camera does not necessarily produce better image quality—this is dependent on the skill of the operator.

»PRACTICAL USES

The single lens reflex camera is so-called because of a cleverly designed pentaprism. This enables light from the subject to be reflected via a set of internal mirrors until it hits the viewfinder, enabling you to see exactly what will be captured on film. 35mm camera systems are lightweight and extremely portable, and can be used with a wide range of interchangeble accessories such as special lenses, flashguns and motor winds. Facilities for processing and printing 35mm film are available worldwide, making this format the most popular choice.

a Mode dial for changing aperture and shutter speed settings.

b Ergonomically designed grip for holding the camera properly.

c Mid-range 28—90mm zoom lens, permitting wide angle and telephoto shooting without changing lenses.

d Top LCD panel for displaying current settings and controls.

e Screw thread for attaching filters for creative and technical subjects.

f Hotshoe socket for attaching more powerful flash equipment.

g Zoom lens rotator for changing the focal length of the lens.

The Nikon F3 has fully mechnical controls. Compared to electronic cameras with computer-assisted controls, this camera is more reliable in harsh shooting conditions.

Essential additions to your kit

Lens shade
Make sure you buy the correct shade for your lens, rather than a generic rubber type. A dedicated shade is designed to eliminate flare and will give better color saturation and contrast.

Skylight/UV filter
A colorless screw-on skylight or UV filter will both protect your lens from physical abrasions and improve color rendition. Make sure the filter is multi-coated from a reputable manufacturer such as Hoya.

≫CREATIVE CONTROLS

SLRs differ from compacts because they have fully manual controls for selecting aperture, shutter speeds and ISO film speed values. Armed with these controls at your fingertips, even the most complex and demanding subjects can be captured. Modern cameras have all the important controls within reach of your fingertips, enabling you to change your settings whilst the camera is pressed up to your face. Viewfinders commonly display all the current aperture and shutter speed settings and have a focus confirmation light, so you know when to press the shutter

≫LENSES

Many cameras are sold in kit form with a mid-range zoom lens, such as a 35—70mm. While versatile and easier to carry than separate lenses, a better option is to buy a separate camera body plus two prime lenses such as 28mm and 50mm. The inconvenience of changing lenses is easily offset by better image quality. Cameras from manufacturers such as Nikon and Canon are designed to fit a well-established family of lenses, which can be kept if you upgrade to a better camera body later.

≫HANDLING

35mm SLRs are easy to handle, and can be carried around your neck for long periods of time without fatigue. For those who need to make accurately framed photographs which are exposed to bring out the individual nature of each different subject, the 35mm SLR is ideal. Fewer handling errors such as camera shake and poor focus will be made if the camera body is attached to a portable tripod or a monopod.

Most mid-price SLRs have a useful built-in flash unit, powerful enough for most fill-flash situations, but too weak to act as a sole light source.

HISTORY LINK
Robert Frank used the 35mm SLR camera as a convenient way to record his road-movie-style documentary study of America in the 1950s. See his work on page 162.

See his work on page 162.

→ 35MM COMPACT CAMERA

THE ESSENTIAL TOOL FOR THE FAMILY SNAPSHOT, THE COMPACT CAMERA IS DESIGNED TO BE AS EASY TO USE AS POSSIBLE

This Nikon compact camera has a viewfinder positioned directly above the lens to minimize the effects of parallax error.

The dotted perimeter edge of a compact camera viewfinder. This should be used as an approximate, rather than exact, guide to the edge of your frame.

»TYPICAL SPECIFICATIONS

Available for a fraction of the cost of a SLR, the compact camera has fewer user-defined controls and is less able to capture demanding photographic situations such as excessive contrast. Better cameras are fitted with special shooting modes in addition to the fully automatic exposure, such as portrait, macro, landscape, and action sports. Less rugged, these cameras are not designed to withstand the rigors of a physical pastime, and do not respond well to damp or cold conditions.

»PRACTICAL USES

The point-and-shoot camera certainly has its place for great candid photography during family outings, parties, and social occasions. Lightweight, easy-to-handle, and requiring no previous knowledge, these cameras are ideal for those who want to record important family events without learning a technical skill. Well-designed compacts will not fire unless light levels are high enough and sharp focus has been achieved, to avoid later disappointment. Armed with a tiny built-in flash which pops up as necessary, this extra light source will illuminate people and objects up to three metres away.

»CREATIVE CONTROLS

Only the better compacts offer the chance to pick your point of focus and choose an appropriate aperture to achieve a special depth of field effect. More creative results can be achieved if a camera is fitted with a multipurpose zoom lens, so you can make tight crops on the telephoto setting and spacious shots on the wide-angle setting.

⟩⟩LENSES

Two types of compact camera lens are available: fixed focus and autofocus. Fixed focus lenses are found on budget models and single-use cameras, and guarantee sharply focused results on all subjects that sit further than one metre from the camera. Compact camera lenses are fixed and cannot be removed, so many cameras are fitted with a mini-zoom lens such as a 35—105mm. Autofocus is found only on higher price cameras and is operated by half-depressing the shutter release, but unlike 35mm SLRs, the viewfinder image does not display your chosen focal points.

⟩⟩HANDLING

Better compacts are a great addition to any photographers' kit bag as they can be carried in a coat pocket and quickly pressed into action. More expensive models are usually built around a metal body, or have interchangeable lenses and accessories. Most cameras are highly dependent on battery power with autofocus, film advance, and rewind the major contributors. Avoid cameras that use unusual battery types, as they could be expensive to replace on holiday or on a regular basis.

An index print presents a single-sheet reference for all the shots from a roll of film.

Unlike zoom lenses on SLR cameras, the compact zoom is controlled via a switch mounted on the back of the camera body. Operated by the thumb, it changes the focal length of the lens automatically.

→ 35MM RANGEFINDER

AT THE TOP OF MOST PHOTOGRAPHERS' WISH LIST IS THE ULTRA-SLEEK AND STYLISH 35MM RANGEFINDER

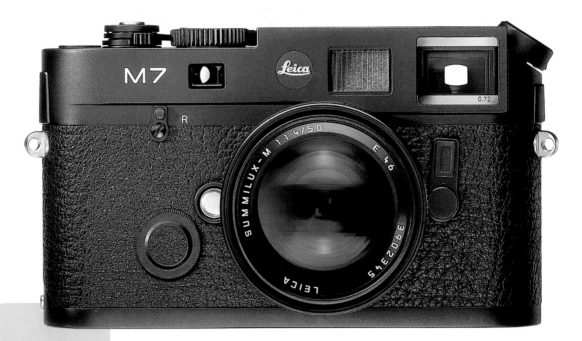

Owning a Leica M7 is like having all your birthdays at once. This 35mm rangefinder offers fast operation in a convenient form. While the new model includes additional electronic functions, this classic model remains largely unchanged.

»TYPICAL SPECIFICATIONS

Built to last a lifetime, the 35mm rangefinder camera is aimed at the connoisseur who wants maximum quality and simple operation. Built with hybrid internal components mixing mechanical parts for durability and reliability and electronics for sophistication, the retro styling of these cameras share little relationship with their 1950s' predecessors.

»PRACTICAL USES

Small, portable and hardwearing, a camera such as the Leica M6 has a conventional film-advance lever, traditionally placed aperture ring on the lens, and a top-mounted shutter speed dial. There are few hidden controls and sub menus, but the simple layout offers quick access to all the key settings. The rangefinder is used by documentary photographers because of its reliablity and size, as it can be easily concealed, and used in a moment. With a coupled rangefinder for composing and focusing, the camera suffers less from the undesirable effects of parallax error, but cannot be used in conjunction with filters.

»CREATIVE CONTROLS

Creative interpretation with this camera is dependant on the photographer, as little is offered in the way of auto controls. Light metering is built in and will be available in center-weighted, and the more precise spot metering, modes—enough to cope with the most demanding exposure conditions.

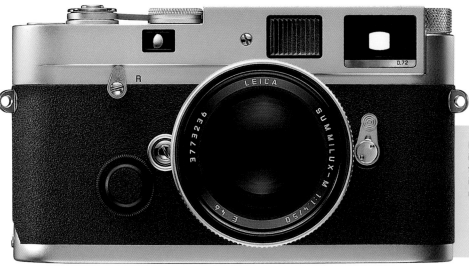

Leicas are available in a range of different finishes, offering an instantly recognizable retro styling.

>>HANDLING

The toughest aspect of using a rangefinder is focusing. Unlike 35mm compact cameras which focus automatically, a coupled rangefinder needs to be focused by hand. Rather than the split screen of a manual-focus studio camera, the coupled rangefinder works by superimposing a tiny section of the subject over itself in the viewfinder, like double vision. When the lens barrel is moved by hand, perfect focus is achieved when the ghost image is merged with the background scene. Totally different to any other kind of camera focusing mechanism, the coupled rangefinder is suprisingly reliable and is best employed on the edge of a shape.

>>LENSES

Better cameras have detachable lenses and offer a suite of alternatives, such as 28, 35, 50mm, and beyond. A firm favorite with documentary photographers is the semi-wide 35mm lens which is wide enough to shoot nearby events and still maintain subjects large in the frame, and is ideal for magazine and newspaper reproduction. At this focal length, a photographer needs to be shooting in the thick of the action rather than detached at the end of a long telephoto lens. Leica rangefinders use the highest-quality Zeiss lenses for the sharpest results you are ever likely to see from a 35mm negative, and allow for a much greater enlargement than normal. Due to the relatively small number of lenses produced each year, an additional lens for this kind of camera can cost as much as the camera kit itself.

HISTORY LINK
Henri Cartier-Bresson used one of the first Leica rangefinders when they appeared in the late 1920s. Excited by its compact size and ease of use, Cartier-Bresson had found the perfect tool for his unique brand of unobtrusive documentary photography.

→ 645

THE PERFECT START TO MEDIUM-FORMAT PHOTOGRAPHY IS OFFERED BY THE VERSATILE 645 CAMERA KIT

The 645 format offers an economical route into medium-format photography.

»TYPICAL SPECIFICATIONS

645 is so called because of the 6x4.5cm image it creates on medium-format roll film. Shaped like a television screen, the format is a slightly taller shape than 35mm film, and can take a little while to get used to. Built with all the same comforts as a 35mm camera, better 645s such as the Mamiya 645 AFD, have autofocus, built-in light metering, automatic film advance, and multiple exposure modes. Most cameras have removable film backs which enable the photographer to change film mid-shoot without wasting unexposed film. Better camera kits include a metered prism, so you can view a fully corrected image through your viewfinder.

»PRACTICAL USES

Lightweight and extremely easy to hand-hold, the 645 is a firm favorite with wedding and portrait photographers, and with the added bonus of 15 exposures on a roll of 120 film, has started to appeal to travel and landscape photographers, too. Bigger and better than 35mm, the 645 film original will easily enlarge to 16x20in without any noticeable loss of quality. Most 645s relay film in a horizontal or landscape position, so the camera is held horizontally during shooting just like a 35mm. The less common 645 rangefinder camera does the opposite and creates portrait images when the camera is held horizontally and landscape-format images when the camera is held on its end. While adequate in a studio setting, the 645 is the most appropriate tool to use for getting high-quality results from demanding subjects on location.

›› CREATIVE CONTROLS

Like a top-quality 35mm SLR, and at about the same price, a good 645 camera offers through-the-lens (TTL) metering for exposure accuracy, full viewfinder readout, and a mix of mechanical and electronic internal parts. The removable film back allows the photographer to pre-load extra film backs with different film and shoot variations without disruptive delays. Like more advanced studio camera systems, additional backs can be purchased for Polaroid proofing films, to check studio lighting and exposure.

›› HANDLING

The 645 is very easy to handle and operate, with the minimum of delay. With little need for external metering and complex exposure calculations, photographers can work at a fast pace and without a tripod. Built around a modular removable film back, it also offers an important route for upgrade to a digital sensor back. With medium-format capture backs just beginning to emerge as a viable option for studio photographers, the versatile 645 is seen as an ideal system for a digital sensor. With the focal length of 645 lenses creating much less of a problem for smaller-sized CCD sensors, the format is an ideal one for those considering future conversion to digital.

›› LENSES

Good camera systems like the Mamiya 645 offer a wide range of supplementary lenses such as a shift lens, and long telephoto and macro lenses to meet the additional demands of an architectural or location fashion photographer. 80mm is used as the standard, and the wide-angle 45mm is equivalent to a 28mm lens on a 35mm system.

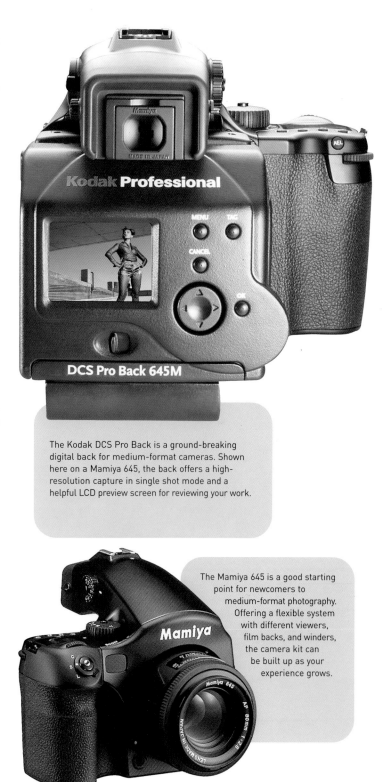

The Kodak DCS Pro Back is a ground-breaking digital back for medium-format cameras. Shown here on a Mamiya 645, the back offers a high-resolution capture in single shot mode and a helpful LCD preview screen for reviewing your work.

The Mamiya 645 is a good starting point for newcomers to medium-format photography. Offering a flexible system with different viewers, film backs, and winders, the camera kit can be built up as your experience grows.

→ 6X6CM AND 6X7CM STUDIO CAMERAS

THE MEDIUM-FORMAT STUDIO CAMERA IS A RUGGED DEVICE BUILT TO WITHSTAND THE KNOCKS OF A BUSY COMMERCIAL ENVIRONMENT

»TYPICAL SPECIFICATIONS

Offered as a standard kit, which normally excludes a prism finder and built-in light meter, studio cameras are designed to work with powerful lighting and precise light meters and flash meters. Too heavy to handhold, these cameras are used on a tripod or heavy studio stand, and fixed in place for most of the shoot. Built around four components: the camera body, removable film back, lens, and finder, the studio camera can also be customized with metered prisms, motorized film advance, and Polaroid film holders.

»PRACTICAL USES

Used for pack shots, portraits, and industrial and corporate assignments, the 6x7cm format is perfect for magazines. The 6x6cm format, as found on classic Hasselblad and twin-lens Mamiya cameras, is a favorite for portraits. Unlike rectangular formats, the square

format camera doesn't need rotating to accommodate a landscape subject, as superfluous detail can be cropped off in the darkroom later. Many editors favor the square format as it gives them an option to lay the photograph out as either a landscape, portrait, or uncropped square. The advantage of 6x7cm is that no cropping is needed, so the resulting image can maintain full quality when reproduced or printed in the darkroom.

»CREATIVE CONTROLS

Better 6x7cm studio cameras, such as the Mamiya RB67, have a rotating film back which is moved into portrait or landscape mode while the camera remains fixed. Focus is achieved by racking the lens out on a small set of rails, and sharp focus is checked on a pop-up glass fresnel screen inside the waist-level finder. Shooting in the studio is easier using a waist-level finder as the potential image can be viewed from a distance to check composition.

»HANDLING

Best operated with a cable release, the studio camera can also suffer from heavy vibration caused when the mirror flicks out of the way during exposure. Most cameras are fitted with a simple mirror lock-up device to enable slow shutter speeds to be used without blurring images. Like rangefinder medium-formats, the shutter is built into the lens and the film is advanced using a separate mechanism to the shutter cock. The much-loved Pentax 67 camera, favored by 1960s' fashion photographer Terence Donovan, is really an oversized 35mm SLR, and is easy to handle for fashion photography.

On the Mamiya RB67, 120 rollfilm can be pre-loaded into removable film backs in advance of the shoot.

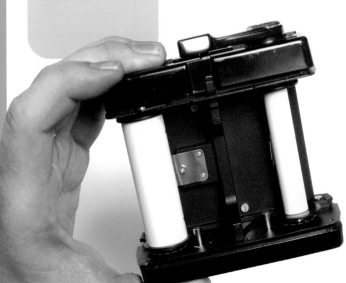

▶▶LENSES

In addition to the standard 80mm for 6x6cm and 105mm for 6x7cm, a wide range of supplementary lenses are available to match demanding assignments. A useful addition to any medium-format kit is a set of three extension tubes. Designed to be inserted between camera body and a standard lens, tubes offer the chance to get in really close and shoot smaller subjects at a high magnification. Lenses for 6x7cm medium-format cameras are not interchangeable with 645 camera systems or the larger 5x4in.

The workhorse of many commercial studios, the RB67 is simple to operate and can be customized with the addition of special lenses and viewers.

The Hasselblad system has remained virtually unchanged for several years and offers a rugged camera with highest-quality lenses. This model is shown with a simple viewer.

→ MEDIUM-FORMAT RANGEFINDER

BUILT WITH THE PORTABILITY OF A LEICA, BUT WITH THE MEDIUM-FORMAT FILM OF A STUDIO CAMERA, THIS KIND OF DEVICE IS FOR SERIOUS PHOTOGRAPHERS ONLY

»TYPICAL SPECIFICATIONS

Three companies dominate the medium-format rangefinder market: Mamiya, Fuji, and less common Plaubel. This camera offers high-resolution results from a lightweight portable body and is great for fast-moving location subjects. Fuji introduced the first mass-produced medium-format rangefinder in a variety of formats including 645, 6x7cm, and the gigantic 6x9cm. The original cameras were built on a similar design, and did not have the advantage of interchangeable lenses. Without the need for heavy, complex mirrors and pentaprism, these cameras are an ideal addition to a landscape photographer's kit bag. Nowadays, autofocus versions make the complex process of focusing a thing of the past.

»PRACTICAL USES

This camera is great for when high-resolution transparencies are required, for commercial reproduction, or for enlargements above 16x20in. Unlike the studio camera, a typical rangefinder cannot be used in conjunction with Polaroid backs, additional film backs, and technical filters, and have a smaller range of lenses and accessories. Aimed at location photographers who do not require the flexibility of a modular camera kit to match changing circumstances and subjects.

»CREATIVE CONTROLS

Essentially, these cameras offer the same kind of controls as a 35mm rangefinder and top-quality compact camera: manual override, aperture priority, autoexposure mode, and an exposure compensation dial. Not all cameras are fitted with a built-in light meter and need to be used with a hand-held light meter or flash meter. The real creativity comes in the photographer's ability to respond quickly to an opportunity.

»HANDLING

Larger formats can be awkward to handle at first and may need faster than normal shutter speeds to compensate. Most cameras use a leaf shutter, that is a shutter based inside the camera lens, rather than fitted over the film inside the camera body. The advantage of a leaf shutter is that it can syncronize with flash at any shutter speed. Great for mixing fill-flash in bright daylight, fast shutter speed flash can create remarkably creative results. Leaf shutter lenses are available for most other camera formats but at a very high cost.

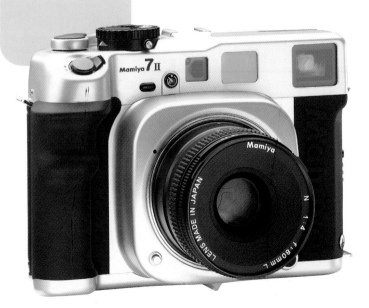

The Mamiya 7 series, unlike other medium-format rangefinders, is designed with inter-changeable lenses, and offers a winning combination of portability and image quality.

The lens quality and the lightweight, positive, feel of the Fuji 6x9cm rangefinder enables the photographer to take shots that can't be achieved in 35mm or with smaller medium formats. The Fuji optics also reproduce the finest details with extreme accuracy.

›› LENSES

Coupled rangefinder lenses usually have an extra grip to help with pulling focus and are much easier to operate than 35mm screw-focus lenses. The disadvantage with rangefinder cameras is parallax error during close focusing, and the difficulty in keeping horizon lines straight. The Plaubel Makina is fitted with a Nikkor lens and a short set of bellows, and is focused, rather unusually, by a dial mounted on the top of the camera body.

HISTORY LINK
Martin Parr is a British-born Magnum photographer renowned for his use of the unusual Plaubel Makina 6x7cm rangefinder camera. Using this in conjunction with a powerful flashgun, Parr's work is rich in both color and humor. He has also often used the accidental cut-offs created by parallax to great effect. See his work on page 173.

Much used by landscape photographers due to their lightweight portability, the medium-format rangefinder is ideal for a remote location shoot.

→ 5X4IN MONORAIL

THE VIEW CAMERA IS THE MOST CREATIVE CAMERA IN EXISTENCE, AND ALLOWS A PHOTOGRAPHER THE CHANCE TO DETERMINE SHAPE, FOCUS, AND PERSPECTIVE DISTORTION

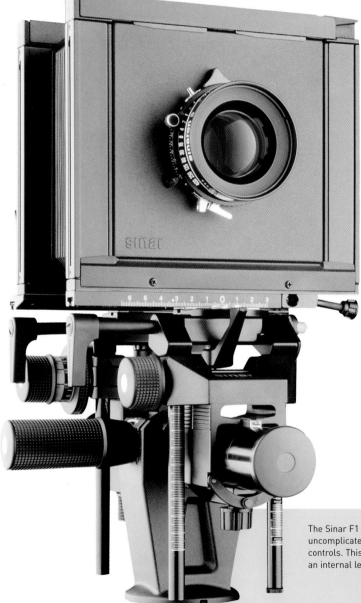

»TYPICAL SPECIFICATIONS

The 5x4in view camera is built around five key components: a monorail, a front and rear standard, a set of bellows, and a lens. Most 5x4in cameras are mechanical, without exposure metering, autofocus, and the other trappings of 35mm photography. Instead, the camera is modular, and can be adapted to suit the task by the addition of different lenses, film holders, and extensions rails. Both shutter and aperture are built in to the lens, which itself fits into a universal panel attached to the front standard. Lenses for the 5x4in are made with a universal fitting, a standard lens starting at 210mm.

»PRACTICAL USES

The advantage of the 5x4in is the control offered by rising, tilting, and swinging the front lens standard in relation to the film plane. Used by architectural photographers to control perspective distortion on large buildings by rising the front standard, the 5x4in is also used in a studio setting. With the ability to place a narrow plane of sharpness on any object in a product shot setting, the 5x4in is still much in use today. Due to the complexities of setting focus and taking an exposure measurement with a hand-held meter, it's impossible to work quickly with a 5x4in.

The Sinar F1 monorail camera is an uncomplicated camera with easy-to-use controls. This model has a lens fitted with an internal leaf shutter.

CREATIVE CONTROLS

Apart from the sophisticated controls offered by camera movements, few other tools are available except aperture and shutter speed scales. Perhaps the most interesting feature of the camera is its ability to focus at very close distances, by extending the distance from the lens to the film plane. With a standard lens, it's possible to reproduce a small object the same size on film, which is an essential reason why jewelry and other small products are shot in this format. Exposure is measured by a hand-held flash meter, but the photographer needs to keep a careful eye on the amount of bellows extension as this will demand a calculation to work out the required increase in exposure.

HANDLING

The camera must be fixed to a tripod before use and is focused by wheeling the rear standard until the subject appears sharp on the ground-glass focusing screen. With excessive ambient light, most photographers throw a black cloth over their heads to help see the dim ground-glass image. Once focused and locked into position, the film holder is inserted into the camera and prevents any further viewing from taking place. 5x4in sheet film needs careful handling and is easily marked by greasy fingertips and must be decanted from the film box into a double-sided 5x4in dark slide, in total darkness. Once the shutter has been cocked and the aperture ring has been closed, the shutter is activated using a cable release.

Single sheets of film are preloaded into a double dark slide under light-tight conditions.

LENSES

Wide-angle lenses for this kind of camera are only useful for interiors and architectural subjects and must be used with a different wide-angle bag bellows set to avoid vignetting. Most photographers opt for the standard 210mm or a slightly more versatile 180mm lens to start with and, in conjunction with an additional monorail extension, longer lenses such as a 360mm offer the chance to shoot close up. An effective lens hood is vital for this kind of camera and this can be combined with a purpose-made filter holder.

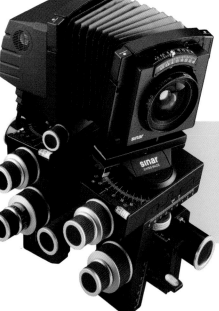

The Sinar P3 is a precision-engineered device with sophisticated camera movements.

HISTORY LINK
Carleton Watkins was the greatest exponent of the view camera on location, producing the prints of the highest possible quality from his negatives. See his work on page 146.

Richard Avedon, a fashion photographer, used the giant Deardorff 10x8in camera to capture his portraits in the American west, so he could produce six-feet high prints.

→ PANORAMIC FORMAT

THERE'S NO NEED TO SHOOT ALL YOUR PHOTOGRAPHS AS A BORING OLD RECTANGLE; THE PANORAMIC FORMAT OFFERS A MUCH MORE DYNAMIC RESULT

»TYPICAL SPECIFICATIONS

There is a variety of panoramic cameras on the market, but all offer almost double the proportions of a 35mm film frame. The Widelux camera has been established as the graduation-picture photographers' favorite. Fitted with a rotating lens that tracks from left to right during exposure, a canny pupil could appear twice in the same photograph by running from one side to the other. A more recent innovation is the Hasselblad Xpan camera, which has interchangeable lenses. Other panoramic cameras based on medium-format film are essentially sawn-off 10x8in view cameras, and offer little in the way of user controls.

»PRACTICAL USES

The panoramic is equally at home with landscape and documentary subjects, and offers the corporate photographer a tool for breaking repetitive conventions. Unlike traditional formats, the panoramic encourages viewers to survey it like a real landscape. Film materials are standard 35mm cassettes, but the developing and printing packages will be limited to film process and contact print at most labs.

»CREATIVE CONTROLS

The Hasselblad Xpan has a function for shooting both 35mm frames and 64mm-wide panoramic frames on the same roll of film, which is ideal for reportage. With standard manual aperture and shutter speed exposure controls, and a coupled rangefinder for precise focusing, the camera is easy to operate on location.

Panoramic format is excellent for shooting landscapes, offering twice the normal width. For 35mm photographers, this extra dimension can take time to get used to.

The Hasselblad Xpan is an innovative camera that shoots both regular 35mm film frames and super-wide panorama frames. The camera is fitted with a coupled rangefinder which works by superimposing a 'ghost' image in the finder to help achieve focus.

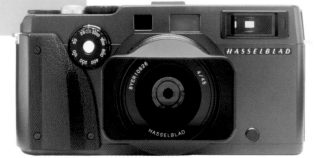

≫HANDLING

Very unusual at first due to the ultra-wide shape in the viewfinder, even experienced photographers will take time to start 'seeing' possibilities. A useful attachment is a miniature photographic spirit level, which is easily clipped into the hotshoe adaptor and can help to set perfect horizontals. Not really used in the upright portrait format, due to the giant sweep from foreground to background, better results are generated when there's a visual link between foreground and background.

≫LENSES

With the option of adding a wider lens comes the additional problem of perspective distortion, but it's important to try the standard lens, as it still includes much more scene than you expect. Proper lens hoods are vital with this kind of camera to stop extraneous light from reducing contrast and color saturation.

≫DIGITAL PANORAMICS

There are panoramic stitching software tools for joining digital photographs for print and web use. Try shooting a 360° wraparound in overlapping segments, then stitch them using Epson Photo Spin or Apple QuickTime Virtual Reality software.

A contact sheet made from three panoramic images produced on color negative film.

HISTORY LINK

Josef Koudelka, the renowned Czech-born Magnum photographer has started to use the panoramic format for his personal landscape work. Excited by the shape and breadth of landscape, Koudelka has opened a new chapter in his work. To see his work, go to page 165.

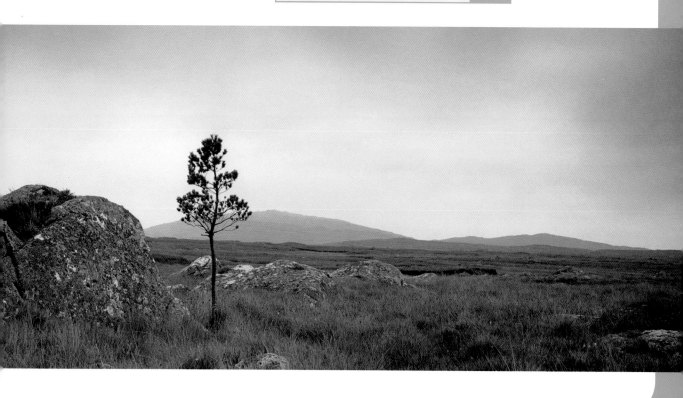

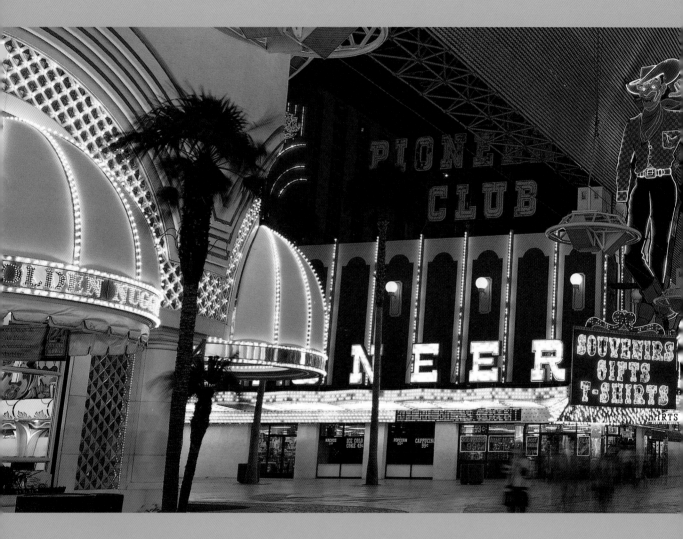

→ DIGITAL COMPACT CAMERA

WITH COSTS FALLING AND SPECIFICATIONS RISING EACH YEAR, A DIGITAL COMPACT CAMERA IS THE IDEAL WAY TO ENTER DIGITAL PHOTOGRAPHY

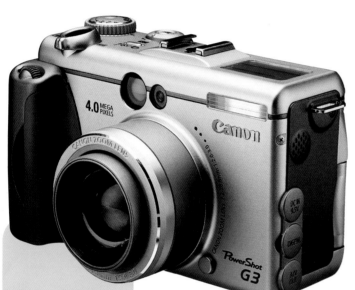

Rugged, and built to withstand repeated use, this digital compact is bigger than most and offers a better solution to keen amateur photographers.

ESSENTIAL ADDITIONS TO YOUR KIT

Extra memory card
Useful if you intend to shoot away on location, a second memory card with a higher capacity is useful to have in reserve.

Universal card reader
An external card reader is a handy way to bypass computer interface incompatiblity problems, especially if you intend to transfer your images to a range of different PCs or Macs.

»TYPICAL SPECIFICATIONS

With a good build quality for both body and lens, this type of camera will enable more creative play than a basic point-and-shoot film camera. With an image sensor capable of making 2—3 million pixels, photographic-quality printing up to A4 size is easily achieved. Unlike film cameras, digital images are stored on a removable memory card which can be erased and used again and again, so there are fewer costs. Different models offer extra value-added functions to tempt the buyer, such as MPEG video-clip creation, sound annotation, or time-lapse controls.

»PRACTICAL USES

A digital compact is great for producing high-quality images for in-house print and web publications, and top-quality pictures of family and friends. Results are the same as a good-quality 35mm film compact camera and, if your digital images are enhanced on a computer, the resulting inkjet prints can be indistinguishable from photographic prints. With a small color LCD preview screen on the reverse of the camera, images can be reviewed as soon as they have been shot, and can be deleted. Different playback modes allow images to be viewed as tiny thumbnails or as a rolling slideshow. Individual images can be deleted from the memory card, opening up space for better photographs. Once captured, images are stored on a memory card and transferred to a computer.

»CREATIVE CONTROLS

Specially devised automatic shooting modes are common, such as portrait, action, landscape, or close-up. These work by applying a pre-set combination of

aperture and shutter speed to match a particular situation. Better compacts have fully manual exposure modes together with a number of aperture and shutter speed settings for photographers who have previous experience with a 35mm SLR camera. Better cameras have a sensor capable of operating within a range of different ISO values, such as ISO 200—800, so you can continue shooting in low light. In addition to the exposure compensation controls borrowed from conventional photography, software-driven settings such as sharpening, white balance, and contrast compensation can be applied.

≫HANDLING

A bonus with a digital camera is the ability to frame and compose a shot by using the LCD screen, rather than the viewfinder. Like looking through the eyepiece of a video camcorder, the LCD preview presents the scene so you can compose your image at arm's length. The LCD playback screen provides access to all camera settings, set by a range of navigation buttons and dials. For those unfamiliar with hand-held games and cellular phones, it takes time to master.

≫LENSES

Digital compacts usually have a non-interchangeable zoom lens, varying from a semi-wide-angle to a moderately long telephoto, so the photographer can shoot indoors and on location. With an autofocus system in place, specific points of focus can be selected by half-depressing the shutter release. Focus points can also be held by holding down the shutter and recomposing, a very useful tool when off-centre compositions are desirable. Better cameras will also have a macro function for close-up photography of small objects or details. Clip-on wide-angle and telephoto lenses can extend a camera's range, at the expense of a slight reduction in image quality.

Many cameras offer the option to shoot short desktop movies which can be played back in QuickTime or Windows Media Player on your home PC or Mac.

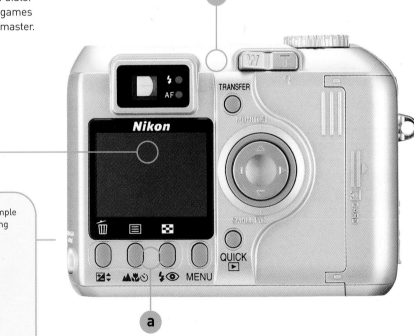

a Better cameras are designed with simple mode selectors for setting up, shooting and viewing.

b The rear LCD preview screen allows you 'live' composing and an instant playback function.

c Many digital compact cameras are much smaller than their film-based counterparts.

→ DIGITAL SLR

AT TEN TIMES THE PRICE OF A BASIC DIGITAL COMPACT, THIS KIND OF CAMERA BRINGS ALL THE CONVENIENCE OF A TRADITIONAL SLR TO THE DIGITAL PHOTOGRAPHER

BROWSER SOFTWARE
Advanced browser software is supplied as standard so that, once transferred, images can be previewed on a computer. Camera settings are saved with image files and can be displayed in the browser.

»TYPICAL SPECIFICATIONS

The digital SLR is designed with all controls within easy access. Capable of creating between 6 to 12 million pixels, enough image data is captured to use on commercial assignments. SLR cameras use higher-capacity Compact Flash or IBM Microdrive cards for storing large files and have additional memory for rapid shooting.

»CREATIVE CONTROLS

Creative controls like aperture, shutter speed, and exposure compensation can be applied manually. There are three metering options to choose from, including centre-weighted, matrix, and spot. The image sensor has ISO settings from 100 to 800, and a white balance function for calibrating to exact color values.

»IMAGE QUALITY

Images can be stored and saved in three formats: raw, TIFF, and JPEG. Once shot, raw images cannot be corrupted or modified. These images depend on the camera's own software to convert into an acceptable format for enhancement. TIFF is available uncompressed in digital cameras, and the files take up more space on a memory card, and take longer to save. The most sensible

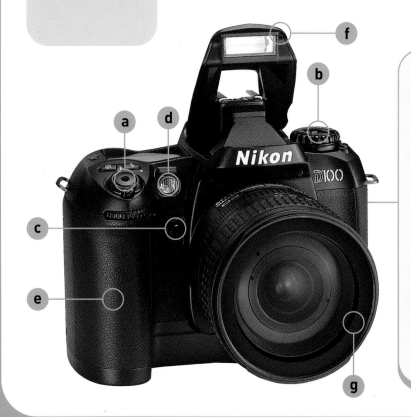

a Shutter release with screw thread for connecting a cable release. Pressed down halfway is the standard way to set an autofocus point.

b Command dial for setting aperture and shutter speed. Unlike medium-format cameras where aperture values are set on the lens itself, the command dial is a quick and easy way to change settings.

c Depth of field preview button, used to preview the extent of sharpness at the current aperture value.

d Autofocus assist for shooting in poor light. This fires a short burst of light to help an autofocus system lock onto an area with sufficient contrast.

e Ergonomic grip for steadier handling.

f Pop-up flash unit for fill-flash photography.

g Interchangeable lens.

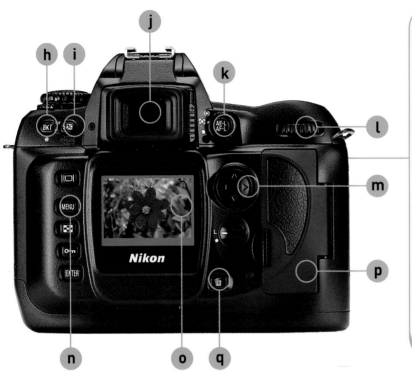

h Auto bracket button for shooting several exposure variations at once.

i Flash intensity control.

j Large viewfinder with dial-in dioptres to match a user's optical prescription.

k Autofocus and autoexposure lock is pressed before recomposing so readings are maintained.

l Main command dial for changing camera settings like ISO, white balance, and autofocus points.

m Selector wheel for navigating LCD menus. This offers a quick way to progress from one menu to another and confirm deleting decisions.

n LCD menu buttons for setting image quality.

o LCD preview monitor with an image preview.

p Memory card compartment.

q Trashcan for deleting images.

format is the compressed JPEG, available in high, normal, and low. With low quality, data compression is greatest but the image quality is poor and, with high quality, the image quality is indistinguishable from a TIFF, but the data savings are not so great.

»PREVIEWS AND CONFIRMATIONS

With a LCD preview screen, a selection of playback options are included, with a zoom function to check focus. An image histogram can be displayed to check exposure in highlight, mid-tone, and shadow areas.

»LENSES

Most digital SLR camera bodies are based on either Nikon or Canon film cameras to take advantage of existing lenses. Image sensors are smaller than 35mm film, so focal lengths are slightly increased. For wide-angle photography, an ultra-wide 17mm corresponds to a 28mm on 35mm. Some cameras have an advanced autofocus which can be used on moving subjects.

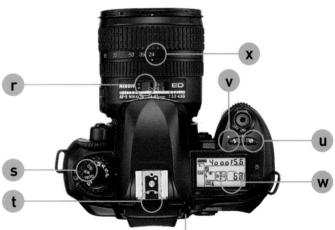

r Focusing distance scale.

s Function dial for setting exposure program modes.

t Hot shoe for attaching external flash units.

u Exposure compensation dial.

v Flash on/off button.

w Control panel showing shooting settings.

x Zoom lens focal lengths.

→ DIGITAL WORKSTATION

IF YOU WANT TO GET SERIOUS ABOUT DIGITAL PHOTOGRAPHY AND IMAGE MANIPULATION, YOU MAY WANT TO SET UP YOUR OWN DIGITAL WORKSTATION

»COMPUTERS

Today's computers are lightning-fast and capable of crunching through complex calculations in a matter of seconds. Digital photography involves lots of data and creates enormous documents compared to humble office word-processing. Big image files need computers with a fast processor to speed through the edits so you are not left clock-watching. With quality and resolution of digital cameras on a steady incline, it's important to equip yourself with a future-proof machine. Good computers are built to allow upgrade and customization as and when you are ready to add extra performance-enhancing components.

Two dominant computer platforms exist: the Apple Macintosh and the Windows PC (personal computer). Both systems are designed to link with all popular software and hardware components and there is no noticeable difference in the end result. The choice of a system should be based on

The Apple G4 computer system is a well-established favorite with imaging professionals due to its ability to run applications like Adobe Photoshop at much faster speeds than competitors.

your own personal preference and employment circumstances. Macs are much favored by design and publishing professionals, whereas the ubiquitous PC-running Microsoft Windows can be found in most offices worldwide.

»HOW MEMORY WORKS

After the processor, the most influential part of your PC is memory. Random Access Memory (RAM) is the part of your computer which stores all unsaved data and open applications during work in progress. During a complex edit or process, data is held within the fast-responding RAM to allow you to operate your PC at top speed. If not enough RAM is installed, overflow data is stored on the hard drive, a component with much slower read-and-write speed, which will slow the process right down. When a computer crashes, all unsaved data held in the RAM is lost, with potentially catastrophic results. For

A top-of-the-range PC such as this Silicon Graphics workstation will provide ample processing speed and clever internal components to rip through the most lengthy filtering command.

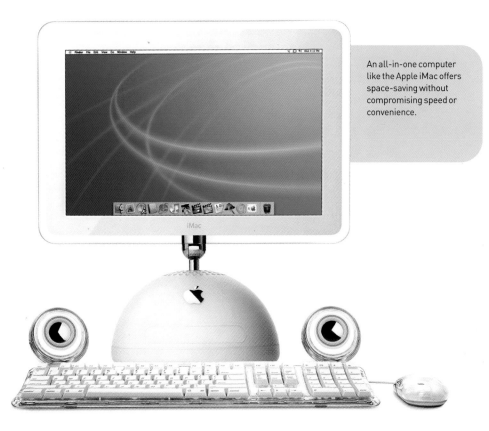

An all-in-one computer like the Apple iMac offers space-saving without compromising speed or convenience.

image editing, it's important to install five times as much memory as the largest document you are ever likely to work on, with 256Mb being a good starting point.

▶▶SOFTWARE

At the heart of the PC is the operating system, sometimes referred to as the system software. Apple's OS X and Windows 2000 are examples of operating system software, designed to allow the physical hardware components and software applications to talk to each other. With each development in digital technology, newer products are designed to only work the most recent operating systems and may not be compatible with older computers running older system software.

▶▶MONITORS

The monitor is the vital part of your PC. If your budget is limited, buy a top-quality monitor at the expense of the fastest processor. Many professionals prefer to use the cathode ray tube (CRT) monitors in favor of the recent thin-film transistor (TFT) models. Opt for a 19in monitor to give you plenty of room on the desktop.

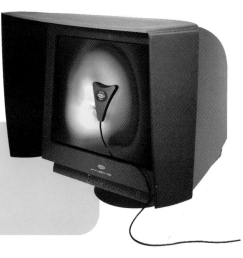

A professional hooded CRT monitor such as the LaCie offers a better environment for accurate colorwork.

→ SCANNING FILM AND PRINTS

**IF YOU'RE PLANNING TO SPEND TIME RETOUCHING AND
RESTORING OLD PHOTOGRAPHS, IT'S ESSENTIAL TO INVEST
IN TOP-QUALITY SCANNING EQUIPMENT**

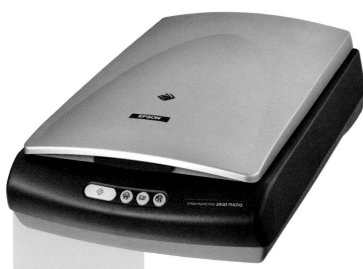

A flatbed scanner is an inexpensive addition to your workstation and offers the chance to manipulate existing photographic prints.

printing. All scanners can be operated within your favorite image-editing packages like Adobe Photoshop, or through stand-alone software applications supplied.

»FLATBED SCANNERS

An essential addition to any workstation is the flatbed scanner. Just like a tiny photocopier, the flatbed is used for scanning photographic prints, drawings and other flat artwork. Good scans are only made when the quality of the original artwork is good too, but improvement can be made by a sensitive operation of the special scanning software. Flatbeds can also be used for capturing shallow three-dimensional objects and can be used for collecting source images for still-life montage projects.

»HOW SCANNERS WORK

Scanners are small, desktop devices which plug into the USB, SCSI, or Firewire socket on the rear of your PC. Inside the scanner is an array of light-sensitive cells designed to convert your original print or film into pixels. Unlike the fixed position, rectangular-shaped sensors found in a digital camera, scanner sensors are typically arranged in a thin strip and track along the original during the scanning process. The quality and price of a scanner is determined by how many pixels it can create per linear inch of original, a term commonly referred to as 'resolution'. High-resolution scanners can extract huge amounts of data from small originals and produce image files suitable for large-scale print out. Lower-resolution devices found at the bottom end of the market do not offer the same level of enlargement, but are perfectly acceptable for most desktop

»FILM SCANNERS

The purpose-made film scanner has a sensor designed to scan at very high resolution due to the tiny size of the originals. Divided into two types—the 35mm scanner and the medium-format scanner—both are able to scan negative and positive film. Successful film scanning is all to do with careful cleaning of the film before the scan and minimizing contrast gain. Many better devices have an additional software toolbox such as Digital ICE, or digital image correction and enhancement. This set offers extra controls for restoring faded color and contrast, plus a useful filter for reducing film grain.

»COMBINATION MODELS

A recent innovation is the multipurpose film and flatbed scanner. Like a flatbed but with an additional light source in the lid,

SCANNING SOFTWARE

All scanners are packaged with basic scanning software, so you can determine how many pixels you want to capture. All have simple controls for capturing in Grayscale or RGB color mode, an enlarge or reduce function and the capture resolution scale. Limited contrast and color controls are offered with budget scanners and this is best tackled post-scan in your image-editing package. Better scanners can be operated through advanced scanning software such as the Silverfast application. With precise tools for on-the-fly correction and color calibration, Silverfast will enable you to use your scanner at top quality at all times.

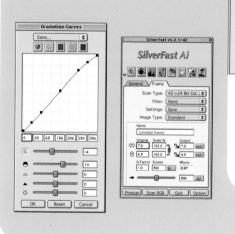

Silverfast scanning software offers an advanced set of software tools for extracting top-quality scans for superior reproduction for the professional or home user.

this kind of peripheral can be used for capturing data from a wide range of film formats and shapes. Best results are achieved when scanning larger-format materials at the highest possible resolution, then down-sampling the document to a smaller dimension. Scans from small-format film such as 35mm will not compare favorably to scans made with a dedicated film scanner. Better models are mid-price devices made by Microtek and Umax.

A top-quality combination scanner can cope with a wide range of transparent and opaque originals and is an ideal device for a small graphics studio or keen photographer.

→ LENSES

IF YOU UNDERSTAND EXACTLY HOW A LENS WORKS, YOU'LL TAKE MUCH BETTER PHOTOGRAPHS

>>FOCAL LENGTHS

A lens is described by its focal length and expressed in millimetres, such as 50mm. This refers to the distance between the surface of the film or image sensor and a point inside the lens when it's focused on infinity. A better way to understand this is to link focal length with how much of the scene can be seen through the lens, referred to as 'angle of view'. The 50mm lens is called a 'standard' lens because it shows the same view as the human eye. The smaller the focal length, the more of a scene you will be able to see through your camera lens. Focal lengths for a standard lens changes with film format, but they can be estimated by measuring a diagonal line from one corner of an exposed film frame to the other. With digital photography, CCD image sensors can be smaller than 35mm film and, thus, the standard lens has a shorter focal length. Each lens usually has its focal length printed on an inner rim.

>>LENS TYPES
Prime lens

Also called a fixed focal length lens, the prime lens cannot zoom closer or pull back from a subject. Fixed focal length lenses are found on cheaper compacts. At the SLR end of the market, interchangeable prime lenses are used for their higher image quality. Many of the world's best photographers use prime rather than zoom lenses, but are forced to move closer to their subjects. Prime lenses usually have wide and fast maximum apertures such as f/2.8 and are available from the specialist wide-angle fish eyes to the ultra-long telephoto for sports photography.

Zoom lens

Zooms are multipurpose lenses designed with a variable focal length such as 28—105mm. A zoom lens allows you to frame subjects at different distances without altering position. At the 28mm end of a lens, a wide angle of view is created for shooting in cramped circumstances. At the 105mm, or telephoto, end the subject is pulled closer, and it is useful for filling the frame with strong shapes. Many mid-price zooms have a poor maximum aperture such as f/4, which is less useful than a

Medium-format lenses often contain a built-in shutter, allowing flash synchronization at any shutter speed. These lenses are not interchangeable between formats and camera systems.

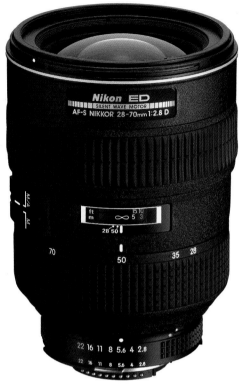

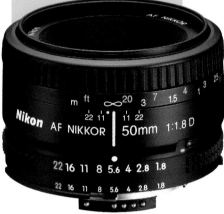

More versatile than the prime lens, a mid-range zoom lens like this 28—70mm Nikon (left) can be used to capture a wide selection of subjects without changing lens. The 50mm lens (below) is often referred to as a standard lens and is designed to mimic the angle of view of the human eye.

prime lens at f/2.8. This can stop photography in low-light conditions from producing dramatic, shallow depth of field effects. This maximum aperture value is rarely constant across the zoom's entire range, often changing from f/4 at the wide-angle end to f/5.6 at the telephoto end.

››VIGNETTING

Strange black corners around your photos are caused by using an incorrect lens shade or too many filters. This effect is called vignetting and results from a light fall-off caused by a physical barrier placed in the path of light at the corners of your image. Although clearly visible on the end result, vignetted corners are difficult to see in the viewfinder, so results can be unpredictable. The best approach is to never attach more than one filter to your lens, nor a lens shade that wasn't designed specifically for your lens. Vignetting commonly occurs in zoom lenses at the wide-angle end but far less at the telephoto.

Although seemingly more versatile and with a greater range, extreme zoom lenses trade off image quality against convenience.

≫SPECIAL LENSES

Wide-angle lens

Wide-angle lenses are best employed when photographing in confined spaces, indoors for example, or in situations where you are forced to be close to your subject. Wide-angles push a subject away from you, and can be a useful tool if you need to photograph an object to show its entire perimeter. With this versatility comes a compromise with distortion. The wide-angle lens will exaggerate any vertical or horizontal lines into converging triangles. This can be an effective way to make dynamic images out of mundane subjects, but less useful for taking a faithful documentary image. With portrait photography, too, this distortion will cause facial features to stretch, producing an unflattering result. Avoid using wide-angles in everyday situations because your subjects will be less impressive on the final print. For photojournalists, the wider 24mm is a well-established favorite, and can be a more versatile tool in tight situations compared with the 28mm. Cheaper wide-angle lenses create barrel distortion and are unable to capture parallel lines faithfully.

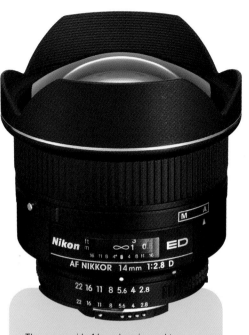

The super-wide 14mm lens is used to create dynamic images in very confined spaces. Only top-quality brands like Nikon prevent excessive distortion.

Only special lens cleaning tissues should be used to clean the coated surface of a lens. Cleaning should be undertaken in a gentle circular motion.

Telephoto lens

A telephoto lens is loosely described as anything with a focal length greater than a standard lens. It is most useful for making distant subjects much bigger in your viewfinder and cropping out undesirable peripheral detail. Many photographers have a telephoto lens as an essential part of their kit. In addition to travel, sports, and architectural photography, the telephoto is extremely useful for portrait photography as it creates little distortion. Fashion magazine cover photographs are taken with a long telephoto lens, as an effect called foreshortening creates a very flattering result. It means that the physical distances between near and far elements compress, producing the opposite effect of the wide-angle. Telephoto lenses are longer than standard or wide-angle lenses. With this increase in size comes extra weight and balance problems. Focused on a tiny, distant object, an extended telephoto lens will incur camera shake, making it essential to use a monopod or tripod. For long lens work, use a faster shutter speed like 1/250th of a second to avoid camera shake. The most demanding of subjects to photograph is a fast-moving spectator sport like football, as there's little time to focus, and the subject keeps moving out of frame. Horseracing action shots are shot by photographers who pre-focus on a fixed point, and then wait for the horses to enter it before pressing the shutter.

▶▶LENS CARE

Like spectacles and contact lenses, all camera lenses are manufactured with an anti-reflective coating to boost image quality. It improves both contrast and color reproduction, but is easily affected by natural oil from your skin. Once smeared, the performance of a lens decreases dramatically, creating flat contrast and washed-out colors. Clean it with special lens-cleaning tissues, or for serious smudges, an alcohol-free spectacle wipe. Dust, sand, and hair will also reduce image sharpness and should be removed with a blower brush, available from photographic retailers, or a soft artists' paintbrush. Any grit that comes into contact with your lens can etch a permanent scratch and ruin it forever.

A purpose-built telephoto lens like this ultra-fast F2.8 model offers quality results, but at a premium price. Much used by sports photographers, the fast telephoto is an essential piece of kit for capturing moving objects at a distance.

→ FILM FORMATS

THERE'S A WIDE RANGE OF FILM FORMATS TO CHOOSE FROM, BUT BIGGEST AND BEST WILL BE AT THE EXPENSE OF PORTABILITY AND CONVENIENCE

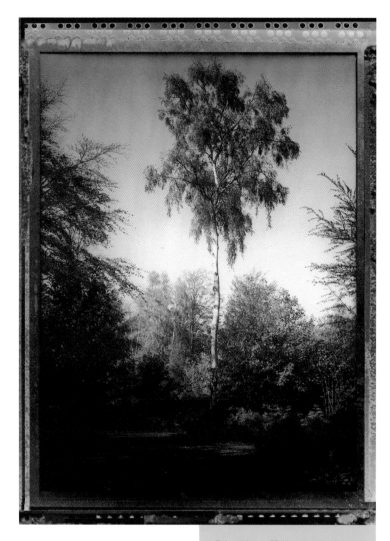

Polaroid type 55 film creates a very unusual edge effect that is much used by advertising photographers.

»APS

The APS film format was developed by camera and film manufacturers in the 1990s to breathe life into the domestic photography market. Aimed at the family user, APS film is smaller than 35mm film and can produce photographic prints in different widths on the same roll of film. APS film can only be used in APS cameras, which are easily identified by a triangular logo. Print quality from APS film is the same as 35mm only at small 6x4in print size and declines noticeably if over-enlarged. After processing, APS film is returned in its original cassette for easy storage.

»35MM

The 35mm format produces original film frames measuring 24x36mm which can enlarge up to 12x16in without loss of quality. 35mm film is universally available and easily identified by the sprocket holes along its edges. This film is made with different sensitivities for color and black-and-white in both transparency and negative forms. All color negative films are designed to be processed in the standard C41 chemical routine, and color transparency material is developed in a chemical process known as E6. Both types of color film are available in different ISO speeds to match low light or studio light conditions. Many press and editorial photographers shoot entirely on 35mm color negative stock for subsequent scanning on a digital workstation. These digital files can easily be converted into black-and-white using Adobe Photoshop. Professional 35mm film has finer characteristics, and gives superior results than cheaper supermarket brands.

35mm film is supplied in a light-tight metal cassette which can be loaded and unloaded in daylight conditions.

››120 ROLL FILM

Roll film is sometimes called 120, 6x6cm, Brownie film, or medium-format film, and is designed for professional use only. Roll film is supplied on a plastic spool and is protected from fogging by backing paper. The film itself is a standard length, but the precise number of exposures available from each roll is determined by the type of medium-format camera used. The Mamiya 645 camera produces 15 exposures from a roll film, a 6x6cm like the Hasselblad makes 12, a Pentax 67 makes only 10 and the extravagant Fuji 6x9cm makes only 6. Roll film is designed using the same photographic emulsions as 35mm film but on a larger scale, and is able to record finer details and be enlarged to a greater size. Most magazine photography uses medium-format film as the larger film size enables high-resolution scanning.

››5X4IN AND 10X8IN SHEET FILM

At the top of the film-format quality league are the 5x4in and 10x8in sheet films. Sold in boxes of 10, 25, and 50 sheets, they are loaded into a special holder for use in monorail cameras and require very careful handling. Mainly used for product and architectural photography, sheet films produce the highest-quality for lithographic reproduction or enlargement. Due to the high cost and expensive processing, many photographers are now

switching to a digital scanning back for similar high-quality results. Despite this, specialized proofing material such as Polaroid type 55 and peel-apart color print film, used before the convenience of a digital workflow, are now in demand for their creative and unusual properties.

Much used by architectural photographers, the 5x4 film format offers exceptionally high image quality.

Medium-format roll film is wound onto an empty film spiral during shooting and needs to be unloaded in subdued light conditions.

→ FILM TYPES

ALL GOOD PHOTOGRAPHERS KNOW THEIR MATERIALS INSIDE AND OUT, AND OFTEN REMAIN FAITHFUL TO A SPECIFIC BRAND

Exposed and processed transparency film needs to be viewed on a professional lightbox to judge exposure and color balance.

»BLACK-AND-WHITE NEGATIVE

Most black-and-white films are designed to be 'panchromatic', or sensitive to all colors in the light spectrum. In theory this means that all colors are reproduced in an equivalent gray tone to its original, but in practice this is far from the case. All black-and-white negative film is marginally over-sensitive to the blue end of the spectrum as daylight is predominantly blue. This causes blue skies to reproduce lighter than anticipated, looking washed out, but is easily rectified by the use of a pale yellow lens filter. When light hits the silver halide emulsion of a black-and-white film, tiny amounts of silver turn black which are then magnified by the later development process. The amount of light reflected off a subject and received by a black-and-white film will therefore create an opposite tone, with white light recording black and an absence of light creating a transparent area on the negative. Once printed in the darkroom on photographic paper, the tones are switched again to result in a positive print.

Black-and-white film is able to record simultaneous detail in both highlights and shadows, known as the dynamic range, across a very contrasty subject compared with other film types. Black-and-white negative film is easy to process in the darkroom, and is also available in a chromogenic form like Ilford XP2, making it suitable for processing in C41 chemicals at photo processors. Unusual emulsions like the Kodak HIE Infrared Black and White are designed to be sensitive to an invisible part of the spectrum and create wonderfully surreal results.

Black and white infrared film is an extremely creative medium for shooting ethereal landscapes. The film's emulsion is sensitive to infrared wavelengths, and needs to be exposed through a special red 25A filter.

›› COLOR NEGATIVE

Color negative film is characterized by a dull orange base color, designed as an aid to later subtractive color printing. Color negative films are primarily designed to be exposed under daylight and conform to an internationally agreed set of measurements called the color temperature scale. Measured in degrees Kelvin, this enables photographers to calibrate their color film material by using color correction filters to counteract unusual shooting conditions, for a cast-free result. Calibrated to work best at 5500K, the color of noon daylight, this kind of film will create colder, bluer results at higher temperatures and warmer, orange results at lower temperatures. Most color negative film is processed and printed at shopping mall photo labs, using automated minilabs designed to automatically correct any color imbalance—even intentionally creative ones. Far superior results are to be gained from a printing service at a professional photographic lab. Color negative film is based on color dyes rather than the black silver of a monochrome emulsion and does not suffer from excessive overexposure.

›› COLOR TRANSPARENCY

For many years the stock film of the professional photographer, the popularity of color transparency is now challenged by high-resolution digital cameras. It is by far the hardest and most unforgiving material to use due to a very narrow exposure latitude or ability to record satisfactory results beyond a half-stop margin of error.

Transparency film is a direct positive, meaning that there is no intermediate negative stage, and is designed to be used for a reproduction, rather than print outcome. Unlike black-and-white negative, this film cannot show simultaneous detail across a wide range of highlights and shadows, and needs careful lighting in the studio and contrast-reducing techniques out on location.

DIGITAL CAPTURE

In the digital workflow, monochrome images are captured in the Grayscale mode and positive color images are captured in the RGB mode. It's very easy to convert RGB color into Grayscale, so there's no advantage in shooting or scanning in the Grayscale mode unless your subject is mono to start with and, even then, it is probably advisable to scan in RGB to ensure better depth to a monochrome image.

→ SPEED, GRAIN, AND NOISE

BOTH FILM AND DIGITAL SENSORS CAN BE MANIPULATED TO WORK UNDER LOW-LIGHT CONDITIONS, BUT AT THE EXPENSE OF IMAGE QUALITY

Coarse grain and excessive contrast is most visible when shooting with the ultra slow speed lith film.

›› ISO SPEED

ISO speed is a term used to indicate the light sensitivity of film and digital sensors. With film, light-sensitive emulsions are made to operate under bright, normal, or low light conditions with speeds such as ISO 50, ISO 100, and ISO 800 respectively. As each of these double, the sensitive material needs half the amount of light to make a good exposure. Moving in the other direction, and halving the ISO from 400 to 200, requires double the amount of light for a good exposure. Best-quality images are produced by using the lowest ISO setting, or film material such as ISO 100 or 50. Many budget digital cameras are designed with just one ISO speed setting, but better digital cameras have a range of ISO speeds that can be set to match conditions, even for a single shot.

›› ISO BY-PRODUCTS: DIGITAL CAMERAS

An increase in ISO incurs an undesirable by-product known as 'noise'. When high ISO settings such as 800 and above are selected, and images are shot under low lighting conditions, insufficient light makes

the sensor create error pixels, and this is the noise. To fill in the missing data, the sensor creates a default bright red or green pixel which stands out from its more subtly colored neighbors. Many noise pixels together produce a drastic loss of both image detail and sharpness. Random noise is most noticeable in the darker areas of an image and, while the effects can be reduced with a software filter, image quality will never be high. Many professional photographers avoid noise by opting to shoot conventional film in low light, which is then scanned afterwards using a dedicated film scanner.

››ISO BY-PRODUCTS: FILM

Like noise, conventional high-speed film is grainy and lacks the subtle colors and sharpness of slower film. With recent huge advances in film technology, excessive grain is only apparent on films beyond ISO 800 and only so if they are over-enlarged beyond 10x8in. With monochrome films, excessive grain is often used as a stylistic device, particularly in fashion and advertising mock-reportage.

››PUSHING AND PULLING

Conventional film can be rated at a different ISO speed than recommended in order to gain sensitivity or precise control over contrast. Pushing film involves increasing the ISO speed of a film, for example from 400 to 800, which is then compensated by an extended development time. Pushing film is a good alternative to using flash, and essential when a subject is too far away to be lit with artificial light. Sports photographers frequently push film when light levels are low, but this effect must be applied to an entire roll of film. Pushing increases the amount of visible grain and will increase contrast. Pulling film is exactly the opposite and is used to modify higher-than-anticipated contrast levels.

Fine grain and low contrast is evident in this still life shot with slow-speed Agfapan 25.

Many studio photographers use the services of a professional lab to push and pull transparency film to even out any exposure or lighting errors. Before the entire film from the shoot is processed a small length of film, called a clip test, is processed first, and analyzed before any decision is made on how best to proceed.

High-speed film produces deep blacks and bright highlights.

→ TECHNIQUES

→ EXPOSURE

CORRECT EXPOSURE IS ACHIEVED BY COMBINING THE RIGHT APERTURE AND SHUTTER SPEED, AND MAKES A CRUCIAL DIFFERENCE TO YOUR FINAL IMAGE QUALITY

»HOW LIGHT METERS WORK

Every SLR camera has a built-in light-sensitive meter, which determines autoexposure functions and, on advanced cameras, the manual exposure read out is in the viewfinder. Light meters only respond to the brightest values in your subject, regardless of their size or color, and can be confused. Bad exposures occur when the photographer relies on the meter to know the most important element of the picture, which it can't. A perfect result occurs when the photographer captures an even balance of highlight and shadow. Too much or too little light will have a big effect on image detail, tone and color reproduction. Large- and medium-format cameras without built-in metering rely on a hand-held light meter.

»APERTURE, SHUTTER SPEEDS AND ISO SPEED

These independent variables are interlinked and when one is changed, another also needs to, to compensate. In addition to the creative consequences of using these scales, their main function is to enable the photographer to shoot in widely varying conditions. The ISO scale sets the sensitivity of the film and works in an identical way in digital cameras by calibrating the image sensor. At low-light levels a higher ISO speed film like 800 is best so that a successful exposure can be made on film with less light than normal. At bright light levels a slower ISO film, such as 100, is most appropriate because it is less sensitive. Better digital compact cameras have a selection of different ISO values such as 100, 200, 400, 800.

Once the lightmeter's sensitivity has been set, then the correct combination of aperture and shutter speed must be set for a good exposure. The aperture is found in your camera lens, and is a hole of varying size designed to let more or less light reach your film. Apertures are always a standard size on all lenses and conform to an international scale described as f-numbers, the most common of which include: f/2.8, f/4, f/5.6, f/8, f/11, f/16, and f/22. At the f/2.8 end of the scale, an aperture is at its largest and lets in the most amount of light available. At the opposite end of the scale, f/22 (and sometimes as much as f/32), an aperture is at its smallest and lets in the least amount of light. To accompany the aperture scale is the shutter speed scale, again designed in a standard range, but in fractions of a second, such as 1/1000th,

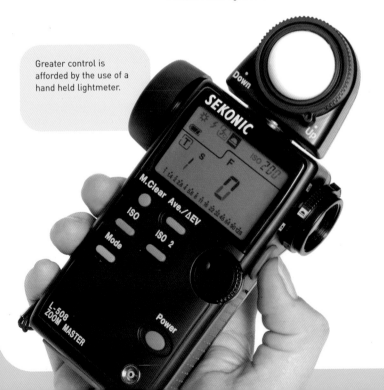

Greater control is afforded by the use of a hand held lightmeter.

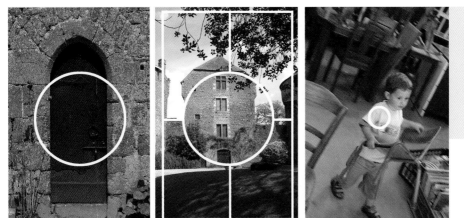

Three metering systems found on most good quality SLRs. From the left: centre-weighted, matrix, or multisegment, spot.

1/500th, 1/250th, 1/125th, 1/60th, 1/30th, 1/15th, 1/8th, 1/4th, 1/2 and 1 second. At the 1/1000th end of the scale, the shutter remains open for short time, but at 1/2 of a second, the shutter remains open for much longer.

≫HALVING AND DOUBLING

With aperture and shutter speed scales, a single sideways step will either double or halve the amount of light hitting the sensor. With the ISO scale, the same sideways step will halve or double the sensitivity of the film or digital sensor. In practice, and when using autoexposure functions, you will not be aware of this taking place, but using a camera in manual mode will mean that you must be more acutely aware of their interrelationship.

≫METERING SYSTEMS

Most cameras use the functional rather than foolproof centre-weighted metering system. Centre-weighted metering works by making an exposure judgement based on subjects that are placed in the centre of the viewfinder. This is perfectly adequate for centrally placed compositions, but can otherwise come unstuck. The more reliable matrix, or segment, metering system is designed to cope with greater demands. It works by taking individual brightness readings from the four quarters of your frame, plus an extra one from the centre. The readings are then averaged out into a single exposure reading, giving a better compromise between light and dark. The more complex spot metering system takes a reading from a smaller area, often the tiny centre circle superimposed in your viewfinder. Useful for getting accurate light readings from skin tones or other small, precise elements of a composition, a good spot reading will emphasize this over less important parts of your image.

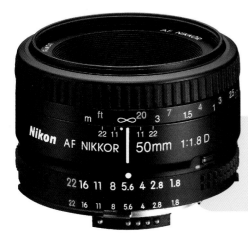

The aperture scale on this 35mm lens is shown on the outer barrel. This can be changed by rotating the barrel or by moving a selector wheel on the camera body.

→ APERTURE AND DEPTH OF FIELD

DEPTH OF FIELD IS ENTIRELY UNIQUE TO PHOTOGRAPHY AND IS DETERMINED BY BOTH LENS APERTURE AND YOUR OWN PROXIMITY TO THE SUBJECT

Deep depth of field helps to evoke a sense of space and distance in the landscape.

Depth of field is a term that describes the plane of sharp focus within the nearest and furthest parts of a photographic scene, and can vary from millimetres to infinity. The human eye focuses so quickly on subjects at different distances that we hardly notice any transition. We are unaware that we can't keep sharp focus on both a close-up object and the distant background simultaneously. With photography however, you can get the best of both worlds and create an image that gives the eye more information than reality. Professionals use depth of field to emphasize their subject matter to make more memorable images.

»APERTURE AND DEPTH OF FIELD

The aperture is a variable-sized circular opening inside your camera lens used to moderate existing light levels for a good exposure, but it also determines depth of field. A typical lens has an aperture range of f/2.8, f/4, f/5.6, f/8, f/11, f/16. In depth of field terms, f/2.8 produces the shallowest result with little sharp detail before and beyond the subject. At f/16, more sharp detail is rendered both before and beyond your main subject. Aperture values in between will correspond.

Access to the aperture scale depends entirely on the type of camera you use. On better compacts this will extend to five or six aperture options, with a full range available on the top-price SLRs. Aperture values are usually accessed via a menu or thumbwheel on the camera, but can only be selected in manual or aperture-priority exposure modes. In auto and other programme modes, the camera meter decides on an appropriate value to generate a correct exposure, without taking your depth of field wishes into account. For many photographers, the aperture priority exposure mode is best as it offers control over depth of field, and leaves the task of selecting an appropriate shutter speed to the camera. With mechanical medium-format and large-format cameras, the aperture scale is found on a circular ring attached to the lens.

Depth of field creates sharp focus over receding planes in a three-dimensional scene. In this close-up example, sharpness falls off abruptly.

Any objects that are not positioned on a plane within the current depth of field will be rendered unsharp.

❯❯YOUR POSITION IN RELATION TO THE SUBJECT

The other crucial factor in creating depth of field effects is your own distance to the main subject. If a potential landscape image is divided up into foreground, mid-ground, and background, then its important to realize that you can't separate objects lying in the same plane with shallow depth of field effects. As subjects get further into the background, it becomes increasingly impossible to assign sharpness to one element and not the other. For mid-range zoom lenses on most SLRs, anything more than five metres away will record with a similar level of sharpness as the furthest parts of the scene. With very close-focused subjects, depth of field may reduce to millimetres, even with a lens set on the narrowest aperture. Many SLRs have an additional depth of field preview button, so you can previsualize the result.

→ SHUTTER SPEEDS

BETTER CAMERAS LET YOU SET SHUTTER SPEEDS MANUALLY, SO YOU CAN CAPTURE A GREATER RANGE OF MOVING SUBJECT MATTER, BUT KNOWING WHEN TO PRESS THE BUTTON IS QUITE DIFFERENT

»SHUTTER RELEASE BUTTON

Like your lens aperture, the shutter is an integral part of the exposure mechanism but can also be used for visual effects. The shutter is activated by the shutter release. Digital cameras do not have the same 'clunk' as film cameras when released, and can cause confusion over whether an exposure has been made. SLR cameras turn the viewfinder dark during an exposure but there is no such black out with compact cameras because they have a separate viewing window to the lens.

»SHUTTER FUNCTION

The shutter controls the amount of time that the film or sensor is exposed to light. Like apertures, shutter speeds are organized into a standard scale, but measured in fractions of a second. Unusually for an international measurement, shutter speeds are expressed in old-fashioned fractions rather than decimal values and typically range as follows: 1/1000th, 1/500th, 1/250th, 1/125th, 1/60th, 1/30th, 1/15th, 1/8th, 1/4, 1/2, and 1s. At the 1/1000th end of the scale, the shutter remains open only

A slow shutter speed used with slow-speed film and a fast-moving subject.

Camera shake is caused by hand holding the camera at speeds slower than 1/125th of a second.

for a short time, but at 1/2th of a second, the shutter stays open for longer. Like the aperture scale, one step along the scale will double or halve the time that the sensitive material is exposed to light.

»CAMERA SHAKE

Blurred images are mostly caused by camera shake rather than poor focusing. It occurs when too slow a shutter speed is selected combined with a movement of the photographer's body as the exposure is taken. The problem occurs most frequently when using telephoto lenses and in low-light conditions. As telephoto lenses capture far-off subjects, any slight movement will cause the viewfinder image to change composition dramatically. Camera shake can be resolved by setting a shutter speed of 1/125th of a second or faster, but if faster shutter speeds can't be used, use a tripod or a wall to steady yourself against. Ultra-long telephoto lenses need a minimum of 1/250th to offset the increase in camera shake due to the extra weight and awkward balancing involved.

»DIGITAL SHUTTER LAG

All digital cameras suffer from an effect called shutter lag caused by a slight delay during the capture, processing, and storing of data on the memory card. In practice,

while the data from the previous image is filed away this prevents you taking another image straightaway. Budget cameras suffer most of all from shutter lag, as they have little or no built-in memory buffer, but on more expensive compacts and SLRs, built-in memory acts as a kind of temporary storage facility so you can keep on shooting. If you are stuck with a camera with lag problems, consider shooting low-quality JPEGs for a faster turnaround. On better cameras uncompressed file formats such as TIFF may offer much better image quality, but will increase the shutter lag due to the lengthy time taken to process and store the files. Like old-fashioned film cameras fitted with motorized wind-ons, the digital camera's ability to record images in quick succession is known as its 'burst rate'. Only top-quality SLRs are able to shoot a rapid sequence of high-quality still images.

»MIRROR LOCK-UP

Professional cameras built with heavy reflex mirrors can vibrate during long exposures, causing loss of sharpness. Mirror-lock function is used to fire the mirror before the main exposure, but prevents further composition.

A very creative effect produced by tracking the movement of flying geese with a slow shutter speed.

→ **FOCUSING**

**AUTOFOCUS IS DESIGNED TO REMOVE THE HUMAN
ERROR OUT OF PICTURE-TAKING, BUT KNOWING
HOW TO USE IT CAN BE LESS PREDICTABLE**

Deliberate defocusing can be a creative method to use for adding mystery to your image.

Most cameras have an autofocus target in the centre of the viewfinder which is placed over the main subject and will work faultlessly, provided the subject is central. Autofocus is activated by half-depressing the shutter button and placing your subject in the centre of the frame, until a light appears in the viewfinder display. Most cameras will not fire if the lens is unable to focus on close subjects or is still tracking a moving subject. Every lens has a minimum focusing distance and will not be able to make sharp results from subjects which are too close. Despite the convenience of autofocus, most medium- and all large-format cameras use manually focused lenses for more creative effects.

»FOCUS POINTS

Especially important when focusing at close range is your exact point of focus. As depth of field extends both in front of and beyond your point of focus, it is essential to pick the right spot to gain the best results. A common mistake when shooting portraits is to focus on the nearest part of your sitter, usually the tip of the nose, which can leave a sitter's eyes slightly unsharp. A much better rule is to select the nearest and furthest away parts that must be sharp, then focus one-third of the way in to maximize depth of field. For stationary subjects—with still life subjects, for example—this can easily be estimated while your camera is placed on a tripod. Most manually focusing lenses on 35mm and medium-format cameras have an additional scale printed on the lens barrel, so you can estimate the likely depth of field at a chosen aperture setting.

SHOOTING DEEP DEPTH OF FIELD
This image demonstrates a zone of sharpness from foreground to background achieved with an aperture of f/16 and a focus point set at a third of the way into the image.

SHOOTING SHALLOW DEPTH OF FIELD
This effect is used to blur a distracting background and lends more emphasis to the main subject. This is effected by selecting a large aperture like f/2.4 or f/4 and framing the subject tightly in the viewfinder.

❯❯AUTOFOCUS PROBLEMS

Autofocus is unable to focus on low-contrast subjects such as areas of flat color, and will track the lens back and forth in error. This problem is solved by recomposing and focusing on the edge of the subject first, then pressing the autofocus lock on your camera. The lock holds the focus setting in place, enabling you to recompose and shoot better results. Most cameras have the lock in an easily accessible position, so that you can carry out focusing without taking the camera away from your eye. Another common autofocus problem occurs when a subject falls outside the center of the frame and the camera sets focus on another distant object by mistake.

SHOOTING SHALLOW DEPTH OF FIELD AT DISTANCE
Used by wildlife and sports photographers, this creative effect can only be made using ultra-long telephoto lenses and won't work on subjects in the background.

→ EXPOSURE ERRORS

THE MOST IMPORTANT FACT TO REMEMBER ABOUT PHOTOGRAPHIC TECHNIQUE IS THAT THE CAMERA METER NEVER KNOWS WHICH IS THE MOST IMPORTANT PART OF THE IMAGE

Underexposed transparencies and digital images are darker than expected and may display curious color casts.

The meter can only respond to variations in brightness, so in many circumstances you have to consciously trick the meter into behaving differently. With so many different levels of light reflecting off objects in your composition, the best exposure is a trade-off between recording simultaneous detail in both highlights and shadow areas. Most good cameras have an exposure lock button located close to your shooting hand, or is accessible when the shutter is half-depressed. Exposure lock is a very useful device which enables you to take meter readings from the important areas of your image, save the reading, and then recompose before shooting.

»HOW TO RECOGNIZE UNDEREXPOSURE

Transparencies and digital images

Underexposed images are dark, lack detail, and the colors are often muddy. With digital images, very underexposed examples display bright red or green error pixels called 'noise'.

Negatives

Underexposed negatives are pale and transparent. Little detail will be recorded and prints may not be fully correctable.

»HOW UNDEREXPOSURE OCCURS

Underexposure occurs when too little light hits the film or digital sensor. It often occurs when shooting in low light on autoexposure mode, as the camera's shutter speed range may not extend beyond a few seconds. A common cause of underexposure when using flash occurs when the subject is further than five metres away, as the small burst of light is too weak to reach

Underexposed negative film is thin and more transparent than a correctly exposed film frame.

On overexposed negative film it can be difficult to see the image itself.

▶▶HOW OVEREXPOSURE OCCURS

Too much light produces pale, low-contrast images with burnt-out detail which cannot be rescued by trickery or darkroom craft. The most common cause of overexposure is using flash to light a subject. Close-up flash can still be too much light for a small aperture value to cope with and will cause image highlights to white out. On manual mode it is caused by selecting a slow shutter speed or large aperture by mistake.

▶▶BRACKETING

If you don't want to spend time worrying about achieving the right exposure with every shot, a sensible way to approach tricky exposure situations is to bracket. Adopted from the world of professional photography, this means taking a number of different exposure variations of the same subject. Bracketing is essentially an insurance against failure and even the most demanding situations can be covered within a five-shot range. It only works on stationary subject matter and is best done with your camera fixed to a tripod to produce five identical results. If your camera doesn't offer an auto-bracketing function, you can easily do it manually using the exposure compensation dial and shoot the following sequence: uncorrected, +0.5, +1.0, -0.5, -1.0.

Overexposed transparency film is often much brighter than expected.

out to distant subjects. Underexposed transparencies are useless, but some monochrome negatives can be rescued in the darkroom by using a high-contrast printing paper to compensate. Images can be rescued by imaging software, but excessive changes will result in the sudden appearance of random-colored pixels and a deterioration in image quality.

▶▶HOW TO RECOGNIZE OVEREXPOSURE
Transparencies and digital images
Overexposed images are bright, have little detail, and washed-out colors. In extreme examples when using a digital camera, so much light reaches the individual sensor cells that it spills over and influences adjacent cells, resulting in a spread out effect called blooming. On transparencies, excessive exposure renders the film entirely clear and without detail.

Negatives
Overexposed monochrome negatives are dark and dense and detail is difficult to observe. Color film and chromogenic black-and-white film suffer less from excessive overexposure, but subsequent prints may lack true sharpness and accurate colors.

Bracketing ensures that at least one film frame out of the sequence will be the correct exposure.

→ NATURAL LIGHT

LIGHT IS THE MOST IMPORTANT RAW MATERIAL FOR SUCCESSFUL PHOTOGRAPHY, BUT IT CAN CHANGE IN AN INSTANT

Natural light changes color throughout the day. Above is a warm-colored landscape shot in the early evening and below is a cooler-colored photograph captured in the early morning.

»NATURAL LIGHT AND COLOR REPRODUCTION

Daylight is infinitely variable both in brightness and color and the human brain largely self-corrects to counteract these changes. Film and digital sensors are much more limited in this task and need to be calibrated first using the white balance function. When shooting in the early morning, natural light has a predominantly bluish color resulting in shots that are cooler in color. Shots taken at twelve noon, with overhead sunlight, produce a more neutral color, but at the end of the day and in early evening, daylight becomes warmer. These changes are recorded on film more vividly than they appear to the eye and can be removed during the printing stage of color negatives. Precise color correction or color-compensating filters can be used on camera when shooting with color transparency material. Digital cameras with an auto-white balance function work to correct these differences, but it pays to experiment with different settings; you don't want your camera to correct deliberately atmospheric color by mistake.

»LIGHT AND NATURAL FILTERS

The color of daylight can also be changed by a subject's immediate surroundings. Light bouncing off colored walls or through tinted glass will cast an unexpected color on your images. For very precise color work on location, such as a fashion shoot, ambient light is filtered out using large white umbrellas held by assistants out of shot. Even the leafy canopy of a tree will act like a giant green filter.

Soft window light can be an effective light source for portraits.

This image was shot with an 81A warm-up filter to prevent green foliage from looking too cold.

››SHOOTING IN FLAT LIGHT

In the absence of strong sunlight during early morning or under cloud cover, the job of shooting delicate colors and subtle tones is actually made easier. Mist and early morning light will soften your image and lower its contrast but will make a more delicate end product. With cloud cover emulating a studio lighting softbox, there will be little difference between exposure readings from sky and land, so you'll have less burning in and dodging to do later. Flat light gives landscape subjects a less impressive sky, but it can be improved by cropping it out using a telephoto lens. Tight crops of far-away subjects is a well-established technique, especially if they are surrounded by a single-color background. Soft-contrast photographs lend themselves to single-color toning, and if you exclude the trappings of modern life from your images, they can be timeless, too.

››EPHEMERAL LIGHTING

Shooting situations which are lit for a fleeting second are very special. The great landscape photographer Ansel Adams purposely waited until natural light 'revealed' his dramatic landscape. With his view camera ready to shoot, Adams captured scenes looking their most atmospheric. When shooting under constantly varying conditions, it's a good idea to bracket exposures, so that you have several variations to choose from.

The tonal range of this monochrome landscape was enhanced using Adobe Photoshop.

→ FLASH

FLASH IS A VERY CREATIVE TOOL AND CAN BE USED FOR MUCH MORE THAN LOW-LIGHT SCENARIOS

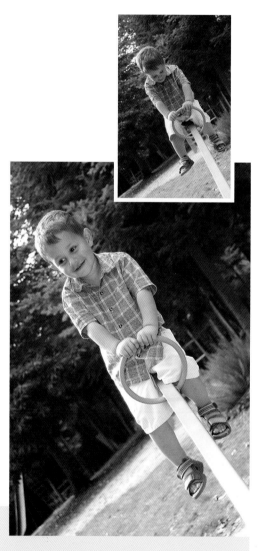

Flash is not just used as the sole source of illumination, but as an extra top-up light source. This technique is called fill-flash, and offers the chance to reduce shadows and increase color saturation on nearby objects.

»HOW A FLASH WORKS

Most 35mm cameras have a built-in flash unit that can be set to fire under a range of challenging lighting conditions. The physical size of the flash unit is not really a good indicator of its power and range, but this is best judged by a factor called the guide number, found deep within the camera manual. The guide number simply states the distance range over which the flash can be relied upon to produce enough light for a successful exposure, but with most compacts, this is rarely over five metres. Used indoors or out in lighting situations that are too low to make a successful exposure, flash works by firing a short burst of light lasting less than a 1/1000th of a second. Unlike natural daylight which is constant, the results of flash light can't be predicted because of the short duration of the burst, so mistakes are easily made. A flash unit is made from a tiny glass tube filled with a special gas, such as xenon, which produces light when charged with an electric impulse. The repeated use of flash will deplete a set of rechargeable batteries in no time at all.

All flash units are self-regulating and switch themselves off when enough light has been produced to light the scene. This works by a clever mechanism which inhibits further output by switching off after light returns to a sensor having bounced off the first object in its path. Awareness of this fact will prevent the kind of rudimentary errors made by most amateur family photographers. For most photographic situations, on-camera flash works perfectly well as long as there are no physical obstructions between the camera and subject. Flash commonly fails

when it reflects back off a close object regardless of its size or position to the intended main subject, switching the light off prematurely. A typical result from this kind of scenario is a dark and underexposed image with a strangely burned-out shape in the foreground.

This soft effect was created by bouncing flash off the ceiling.

≫RED EYE

Red eye occurs when flash is used in low light conditions and reflects off a subject's retina, to create an unnerving red disc over the eyes. This occurs because, in low light, the iris in the eye is open wide to compensate, just like a wide aperture in a camera lens. The red disk effect is caused when flash light is fired into the eye and bounces off the red retina back to the camera in a straight line. On a better camera, this can be resolved using an external unit set slightly to one side, or by using the red-eye flash-reduction mode. Red-eye reduction works by firing a tiny pre-flash to narrow the iris in your subject's eyes before the main burst of light is first off. Strangely, the same effect occurs with animals, but with a differently colored result.

≫FULL FLASH

Full flash mode is used when all other sources of illumination are found wanting, such as a darkened room or at nighttime outdoors. Many compact cameras will simply not fire in low-light situations unless this option is switched on as demonstrated by the thousands of flickering flash lights seen in the crowd at the start of every televized sporting event. Full flash takes no account of any existing ambient light and will fire at maximum power to create a typically stark result, shedding any naturally occurring atmosphere in one fell swoop. Like all other artificial sources of illumination, flash is designed with a specific color temperature and aims to shed a neutral and colorless light on its subjects. As such, most full-flash images are bland and lack the extra warmth of sunny daylight conditions.

Flash needs to be used in conjunction with the right shutter speed. For most fast shutter speeds on a 35mm SLR, the shutter never remains fully open during an exposure. Instead, a narrow open slit moves across the film (below). If too fast a shutter speed is selected, the resulting image will be cropped unexpectedly. Use 1/60th of a second shutter speed or slower to prevent this problem. On lenses with built-in shutters, all speeds will synchronize the flash.

→ COMPOSITION

VERY FEW PHOTOGRAPHERS ARE BORN WITH INNATE COMPOSITIONAL DESIGN SKILLS; MOST ARE BORROWED OR STOLEN ALONG THE WAY

Composition is more to do with what you decide to leave out of the frame than what you include. The image (insert) lacked emphasis due to the empty space in the left of the frame. But, cropped in Photoshop, the version of the image (main), concentrates your full attention on the subject.

Composition is the way a photographer arranges subject matter in the camera viewfinder. For immovable subjects or those out of reach like a spectacular natural landscape, composition is influenced by your shooting position together with your choice of lens. For close-by subjects such as people, composition can be determined by people-organization skills. Without a willingness to experiment, most amateurs place their subjects centrally in the frame and don't experiment with dynamic compositional effects.

»VISUAL ORDER

Compositional skills are only gained through the experience of shooting different photographic situations under challenging circumstances. Like fitting together a jigsaw, photographic composition is based on the position of shapes. When faced with a subject in your viewfinder, each different piece of the visual jigsaw will vie for attention. Busy and cluttered compositions result from too much emphasis in too many areas of the image, and lack a strong emphasis

and a clear message. Saturated colors and detailed patterns can overwhelm the main subject, as can sharply textured backgrounds. Distracting elements can easily be removed from your work by simply changing viewpoint or lens. If you can't move these objects out of your frame, blur them using a wide aperture like f/2.8. Visual weight is the effect of a strong color or tone pulling the viewer's eye in a particular direction and, if used effectively, can act as a counterbalance to the central subject.

≫SYMMETRY
A striking, but easily balanced composition is a symmetrical one. Symmetrical photographs are those which have near identical elements on either side of an imaginary vertical or horizontal line and, as a consequence, have eye-catching appeal. As a starting point, place the main elements of your composition in the centre of the frame until a balance is achieved along the vertical or horizontal axis. Architectural and landscape subjects work well with this kind of approach, but you may need to pull in additional items in the frame to balance things out. These kinds of images don't need to be mathematically equal; the results can look very artificial if they are.

A symmetrical composition showing a near-perfect 'fold'. Square-format photography offers a very creative shape for location landscapes.

≫ASSYMETRY
This kind of image is visually attractive due to the imbalance and total removal from everyday life experience. Most of these kinds of pictures are happy accidents rather than carefully composed shots and the best have a certain element of humor about them.

A digital SLR offers a useful preview function on the rear of the camera, so you can see the outcome of your viewpoint before shooting.

→ PHOTOGRAPHING SHAPE

WHEN ALL OTHER SUBJECTS FAIL TO INSPIRE, THERE'S A HIDDEN WORLD OF ABSTRACT SHAPES TO CAPTURE WITH YOUR CAMERA

The outline or shape of a subject varies depending on your viewpoint and can be manipulated into a stylish and graphic photograph. When faced with a more complex subject, it can initially be difficult to know which angle to shoot from but it's worth the effort to shoot a few variations. Different lenses will enable you to distort shape in varying degrees, with wide angles creating the most radical effects.

»YOUR OWN VANTAGE POINT
All amateur photographers shoot from exactly the same viewpoint, from a standing position. For the point-and-shoot brigade, it's very rare to consider changing this kind of shooting position, unless there's a clear need to cram more people into the

This intriguing tree formed an interesting shape for the photographer to experiment with.

viewfinder. Two alternatives to the standing position are the worm's eye view and the bird's eye view. Squatting with your camera pointing upwards will make a subject look more dominant than it really is. Shooting downwards from a raised position such as a bridge or upper-floor window will make things look tiny and less significant.

»DIRECTING THE EYE
As a photographer you can design your image with links from foreground to background by cleverly organizing lines and intersecting shapes in your viewfinder. As we view a photographic image, our eyes are influenced and guided by strong lines and diagonals. These kinds of skilfully structured photographs capture a viewer's attention and are much better than the accidental snapshots of the amateur. To learn this skill is to look at the landscape paintings of artists such as Constable.

»OUTLINE SHAPES
When faced with the impossible task of shooting into the sun, try making a silhouette image. Outline shapes can be very evocative, particularly if they are intricate and unconventional. The best time of day to shoot a silhouette is towards the end of the day, but you can create a similar effect to an evening sunset with the creative use of exposure. After framing your subject carefully, experiment by shooting several exposures at different rates of underexposure, for example -1 and -2 stops. On a digital camera, unwanted exposures can simply be deleted on location to free up storage space.

❯❯OPPOSITES ATTRACT

Stylish images often result from a meeting of opposites: old and new, dark and light, or straight and curved. Opposites offer the viewer an interesting visual experience by offering different areas of the image for comparison. In our everyday life, we never visually dwell on discreet rectangular 'scenes' but the value of photography lies in its ability to draw our attention to the unnoticed world around us.

In a landscape photograph, lines and diminishing vista views help to pull your eye from foreground to background.

Shadows can become an integral part of your composition, as this curiously shaped example shows.

→ SEEING COLOR

COLOR COMBINATIONS CAN BE BAFFLING AT THE BEST
OF TIMES, BUT SUCCESSFUL RESULTS CAN BE MADE BY
WORKING WITHIN RESTRICTED COLOR PALETTES

Vivid color can be
enhanced by careful
studio lighting.

Kitsch colors can be
humorous, as shown by
this image of a statue in a
unique garden in Ireland.

»COLOR SWATCHES

Like all visual art and design work,
photography can make good use of well-
established color palettes found in books
on painting, textiles, and design. Working
within complementary color selections
will give a coherence to your image that
can't be obtained in a patchwork of
different color values. Like interlocking
shapes and opposing textures, special
color groupings can make excellent
subjects by themselves.

»FULL-VOLUME COLOR PALETTE

For graphic statements and bold, simple
messages, saturated hues are those
colors at their purest, unadulterated by
white, gray, or black, and at their maximum
intensity. Pure colors in abstract patterns,
like those found in stained glass windows,
need careful composition to ensure a good
result. Vivid colors are to be found under
bright overhead sunlight and can also be
created when using fill-flash in a daylight
location. In digital photography, raw and
unprocessed image files such as those
transferred from the camera always lack
the strong color saturation found in the
original subject, but this can be put
back using the Saturation control in the
Hue/Saturation software dialog box.

»MUTED COLOR PALETTE

Much less dominating than a full-color
palette, a muted color palette can work
well. Low-color images can have the
appearance of an aged photograph, and
stand out because of their distance from
reality. The subtle colors of a muted
palette mimic those in an Impressionist
landscape. At the opposite end of the scale,

more tonal colors evoke the fall and spring seasons. Low-volume color is easily photographed in the early morning. For digital photographers, a low-color saturation effect can be applied to any image retrospectively by reducing the Saturation slider to drain away the intensity. Pastel-style effects can also be created by printing digital photographs on uncoated media such as watercolor or specially made inkjet cotton paper.

›› GRAINY COLOR

Like the earliest mechanical color photographic process, Autochrome, a granular color print effect can be created by using a fast-speed color negative film. Originally designed to be used in sports and news photography, fast-speed negative film such as ISO 1600 produces a speckly effect, especially when over-enlarged. This style is useful when you don't require fine detail,and can be used to mimic the look of a Pointilist painting such as those by the

Post-Impressionist Georges Seurat. Digital photographers can vary this theme by applying Noise or Mezzotint filters to any standard color image.

›› DIGITAL COLOR

Just because it wasn't there in the first place doesn't mean you can't paint it in digitally at a later date. Adding a convincing color is much harder than it first seems, but with careful selection and gradual rather than full-on color, it can be used to much more subtle effect.

Digital image-editing software enables you to re-mix original colors for creating a unique interpretation.

→ WORKING IN MONO

FOR PHOTOGRAPHIC SUBJECTS THAT ARE LESS INSPIRING IN COLOR, SHOOTING IN BLACK AND WHITE CAN REALLY MAKE A DIFFERENCE

»CONTRAST

When printing black and white in the darkroom, an alternative range of grays can be introduced to make a print more atmospheric. Unlike straightforward transparencies, contrast change in a black-and-white print can look unique and stylish. Variable contrast photographic paper like Ilford Multigrade is primarily designed to correct dense or thin negatives, but can be used for creative purposes too. High-contrast prints are made when subtle, gray mid-tones are largely removed, leaving strong blacks and bright whites to dominate. Low-contrast prints are the opposite, with blacks and whites replaced by a delicate range of grays.

»CHROMOGENIC FILM

Processed in standard C41 color negative chemistry, a chromogenic black-and-white film, such as Ilford XP2, is a way to get into black and white if you don't have a darkroom. Chromogenic film is tolerant of errors in overexposure, and with an exceptionally fine grain structure, it is ideal for making top-quality enlargements and scanning.

EDGES

To give your photographs a hand-crafted look, rough edges can easily be applied in the darkroom by filing out the negative carrier of an enlarger. In a digital workstation, try the useful Extensis PhotoFrame software.

CHANGING CONTRAST AND TONE DIGITALLY
Just as much tonal control can be effected using good-quality imaging software. Standard contrast and tone manipulation tools are found in both Photoshop and Paint Shop Pro, allowing the creative conversion of digital RGB color files to monochrome. Contrast is best altered using the more sophisticated Levels or Channel Mixer controls.

PRINT TONING
Black-and-white photographs can be made even better by chemical toning. After standard processing, the image is put through an extra stage to introduce a wash of color across the entire print. Copper, sepia, blue, and selenium toner kits are commonly available from photographic retailers and can be used outside the darkroom safelight under normal daylight conditions.

CHANGING CONTRAST AND TONE IN THE DARKROOM
The print (top) is a print from a black-and-white negative of a country scene. The image is relatively high in contrast compared to the one beneath it, and was printed on grade 4 or 5 paper. The print below shows a low-contrast version made by printing on grade 0 or 1 photographic paper.

→ **TONING**

NO LONGER THE PRESERVE OF MYSTERIOUS DARKROOM ALCHEMIST TYPES, CHEMICAL TONERS ARE NOW READILY AVAILABLE ACROSS THE COUNTER IN MOST PROFESSIONAL OUTLETS

»WHAT TONERS DO

Toners fulfil two purposes, firstly to extend the anticipated lifespan of a monochrome print and, secondly, but no less importantly, to enrich it with a color. In a normal black-and-white print, areas of silver gelatin emulsion which have been exposed to light turn black after development, while unexposed areas remain white after fixing washes the unused emulsion away. After the fixing stage, the blackened silver is no longer sensitive to light, but does not remain stable for an indefinite length of time. Chemical toning is an extra stage that occurs after the final washing cycle and can even be applied to older prints that have been washed and dried for some time. Toners work by replacing the black silver with a more stable compound which is suitable for archival use and, with some toners, can enhance the tonal separation of the original print. Most toners, including sepia and selenium-only affect exposed areas of the print and will not change white highlight areas.

»HOW TO USE THEM

Most toning agents like thiocarbimide sepia toner is applied through two separate chemical bath stages. After first wetting the print in a tray of clean water, the first step is to immerse the print into a weak bleaching solution. The bleach works by gradually removing the black areas of the image and determines the richness of the final image color. Left for several minutes, all traces of the image will disappear, leaving a faint gray-brown ghost image. After removing from the bleach, the print is washed again in clean water then put into a tray of toning solution. The colorless sepia toning solution works instantly and will stop working after a relatively short time, leaving the image a rich brown color. The print can now be washed and air-dried.

»HOW TO VARY IMAGE TONE

The creative stage in sepia toning occurs entirely with the bleaching agent and cannot be controlled with the toner itself. Bleached for a short time, image tone will be very subtle and hardly brown at all, but

Chemical toners can be used to expand the existing tonal range of a print and can be applied after the print has been washed and dried.

Different colors can be achieved by varying the processing time or dilution of the chemical toner bath.

more like a warm-toned printing paper. This mild effect is referred to as split toning as the bleach only removes the lighter grays of the print, leaving strong blacks untouched. Richer tones can be achieved by this method compared to a full bleach which can often result in a weak chocolate-colored finish which lacks the contrast of the original print. Many toners—including sepia, and the single-bath selenium—actually reduce the density of the print, so do prepare a slightly darker original than normal.

›› OTHER TONERS

Dye-based toners, such as blue toners, work in a different way to sepia. Dye toners necessitate a very well-washed original which must not be contaminated by processing chemicals at any stage in the process. Dye toners 'sit' on the surface of prints and, unlike conventional toners, will color white highlights if used excessively. These toners intensify the print making it darker than desired, so it's an idea to prepare a lighter image than normal.

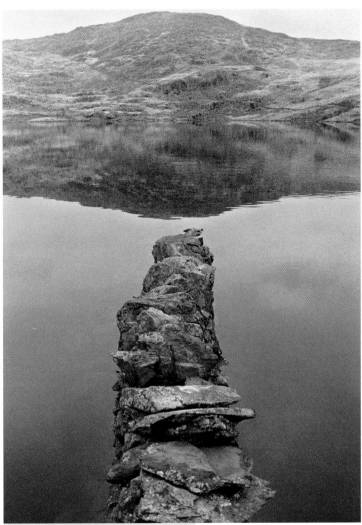

This toned example is markedly different to the same image, opposite.

→ USING STUDIO FLASH

UNLIKE THE UNPREDICTABLE HOT SHOE FLASH GUN, STUDIO FLASH OFFERS A MUCH GREATER LEVEL OF CONTROL

With a subtle-colored background, and clever use of selective focus, studio flash is used to capture the subject at full saturation.

»THE FLASH UNIT

Studio flash units are sold as the self-powered monobloc type or unpowered flash heads that need to be cabled to a separate power pack. Monobloc flash units are the most versatile and can be used without the restriction of a short cable and can synchronize with each other through a built-in light sensitive switch called a slave unit. Flash units actually have two separate light sources, the ring-like flash tube and the bulb-like modelling light. The modelling light is provided so photographers can visualize the likely effects of the flash, but actually switches off momentarily at the point of exposure. On the rear of the unit the intensity of modelling light can be varied, just like a dimmer switch, but it's important to remember that this has no bearing whatsoever on the exposure reading. All but the most basic flash units allow you to vary the output of the flash itself, usually as full-, half- or quarter-power settings. Better units have a stepless control, so you match the intensity to your desired aperture value.

Although illuminated with studio flash, this image hides well the sometimes overpowering nature of artificial lighting.

≫SHOOTING WITH FLASH

Once set up and positioned in the right place, a camera needs to be connected to one flash unit via a sync cable. Plugged into the round 'x sync' socket on the camera or into a hotshoe adaptor, the other end is plugged into the flash unit to guarantee synchronization. More advanced units can be fired using an infra-red trigger system, which is useful in location photography when the unit is at a distance from the camera body. Sync cables offer an unreliable connection and a new one should always be kept in reserve. Better power pack flash outfits can be used with up to four separate heads, each modified to fire at different intensities. Individual monoblocs are sold with different output strengths, with top versions offering maximum power and fastest recharging time, ideal for studio shoots. Cheaper, less powerful units are acceptable for small-scale subjects.

≫STUDIO FLASH ON LOCATION

Interiors photography is shot using studio flash so that it looks like natural light. Positioned into an angle, flash is bounced off the ceiling, like a giant reflector, spreading the light evenly across the room. When mixing flash and ambient daylight together, two light readings need to be taken. After measuring the aperture setting with a hand-held flash meter, an incident reading is taken of the ambient light and incorporated into a slow shutter speed.

≫SAFETY

A flash unit should not be dismantled or exposed to water which could get into the electrical circuit. If a flash tube or modelling light blows, the unit must be disconnected and left to cool down before the tube is changed. Prevent your fingers from touching the glass surface, or it will reduce the lifespan of the bulb dramatically.

An umbrella modifier fitted onto a studio flash head helps to soften the light source.

→ FRAMING IN THE VIEWFINDER

THE MOST DYNAMIC PHOTOGRAPHS ARE DESIGNED AT THE PRECISE MOMENT THE SHUTTER IS FIRED, BUT MOST SKILFUL DECISIONS ARE TAKEN BEFOREHAND THROUGH THE VIEWFINDER

The tiny preview window to the side of all rangefinder cameras, and the ground-glass screen in medium- and large-format cameras, are primarily used to previsualize your final composition. Together with the current image, many cameras display vital information such as focusing confirmation and exposure levels. Bigger viewfinders found on top-quality SLRs are much easier to work with, as are waist-level finders found on medium-format cameras. Tiny LCD screens on the reverse of most digital cameras offer a similar opportunity for photographers to judge a two-dimensional result before committing the photograph to the memory card.

»BIGGER IN THE FRAME IS BETTER

Most family photographs, including those taken with prehistoric compact cameras, never got close enough to fill the frame, and nervous family photographers were constantly aware of accidentally chopping off heads and feet. People and portraits never fit comfortably into the confines of a rectangular photographic frame, so a much better approach is to ignore the need to get everything in and zoom in to the face, or three-quarter length. Basic cameras that don't have zoom lenses are unable to get you closer for tighter crops, but you can easily solve this by moving physically closer to your subject.

This image shows a clever positioning of lines and rectangles within the picture frame.

Joseph Koudelka/Magnum

This sophisticated example was captured by the photographer when all components of the image moved into exactly the right place.

›› PARALLAX ERROR

With older viewfinder film cameras, it's easy to crop off heads by mistake because the viewing window is set slightly to one side of the camera lens and consequently sees a different version of the image. This difference is magnified at close range and can cause unexpected crops when subjects are shot less than a few metres away. This is called parallax error, and is the reason for many catastrophic family snapshots. SLR cameras use an arrangement of mirrors called a pentaprism which allows the photographer to focus and compose directly through the taking lens.

on film. To avoid a disappointing result, frame your images so that there is leeway around the edges. Surplus edge space can be cropped out in the darkroom or digital workstation, but missing image detail can never be put back. If you intend to shoot for publication, leave an even bigger gap around your main subject to allow the designer more flexibility to fit the image to the page grid.

Parallax error causes the image to be unexpectedly chopped off.

›› LARGER FORMATS

Many medium-format cameras are fitted with waist-level viewfinders which provide a laterally uncorrected view. In this instance, objects on the right of the finder screen are, in reality, on the left-hand side. This is less of an issue when shooting studio or immovable subjects, as compositional effects can be previewed even in the wrong aspect. Large-format cameras also suffer from this but with the additional problem that the image on the ground-glass screen is upside down. For both kinds of cameras, non-metered viewers can be attached to provide a fully corrected experience.

›› CROPPING IN TOO TIGHTLY

Many cameras provide an uncertain guide to the exact boundary edges of your image, and rarely display the entire end result. Both film and digital SLRs can show less than appears in the final negative or image file. On viewfinder compacts the problem is the opposite and many show more through the finder than will be captured

Trees and overhanging branches can help to fill the void of an empty sky and divert attention back to the middle of the frame.

→ USING HAND-HELD LIGHT METERS

INDEPENDENT LIGHT METERS FORM THE BASIS FOR ALL STUDIO EXPOSURE METERING AS WELL AS TRICKY SITUATIONS OUT ON LOCATION

»TYPES OF METER

Used in conjunction with medium- and large-format cameras which are not fitted with a built-in lightmeter, the hand-held meter is the precise way of measuring the right amount of exposure. There are three types of light meter available to the professional photographer, the ambient light meter, the flash meter, and the combination meter. The ambient light meter is used to measure continuous light, be it natural daylight, artifical tungsten or fluorescent light, and converts the measured light intensity into a suitable shutter speed and aperture value. The

flash meter doesn't detect ambient light, only the short, sharp burst of light emitting from a flash unit and works by converting this into a suitable aperture value. The more popular combination meter can do both jobs together and is an essential tool for any location photographer faced with constant lighting challenges.

»INCIDENT AND REFLECTIVE READINGS

Unlike built-in camera meters which judge the amount of light reflecting off a subject or scene, both ambient and flash meters can be used to measure the amount of

With the meter held above head height, an incident light reading will enable the medium format photographer to get an accurate exposure estimate.

A reflective reading is taken off the subject itself and helps to preserve it's original tonal range and character.

light that actually falls on to a subject, which is called an incident reading. This reading is made possible by a small, white dome fixed to the meter called an invercone. The translucent invercone provides a temporary cover for the light-sensitive cell and creates a very accurate average reading for subjects which fall within a normal contrast range. For darker and lighter subjects shot on location, ambient light meters can make a different kind of measurement called a reflective reading. With the invercone removed or slipped to one side, the meter is held close to the subject to prevent the influence of other light sources.

›› USING THE FLASH METER

Just like a film camera, the flash meter must first be calibrated with the ISO film speed that will be exposed. Flash meters offer the user two methods of taking a reading, by direct attachment to the flash unit with a sync cord or a non-corded method where the flash is fired by hand as the unattached meter is held *in situ*. After connecting to the unit, the meter is placed in the centre of the subject with the invercone facing directly towards the camera lens. Care must be taken not to stand between the flash unit and the

meter, or an incorrect reading will be produced. Once in position, the flash unit can be fired by activating the meter and the resulting aperture value will be given. For critical large-format work, the flash meter can also be used in multi-flash mode where it can make a cumulative reading after the flash unit is fired several times in succession.

›› USING THE AMBIENT METER

On location, the ambient light meter used in incident reading mode is very easy to work with. After setting the ISO film speed first, the unit is either held above head height when shooting landscapes and far-off subjects or held directly in front of your subject with the invercone again facing your camera lens. Just like the flash meter it is important not to block the passage of light to the meter or your results will be underexposed.

→ FILTERS

FILTERS ARE A CREATIVE WAY TO MANIPULATE COLOR, CONTRAST AND SHARPNESS AND CAN BE USED TO RESCUE MANY A TRICKY PHOTOGRAPHIC SITUATION

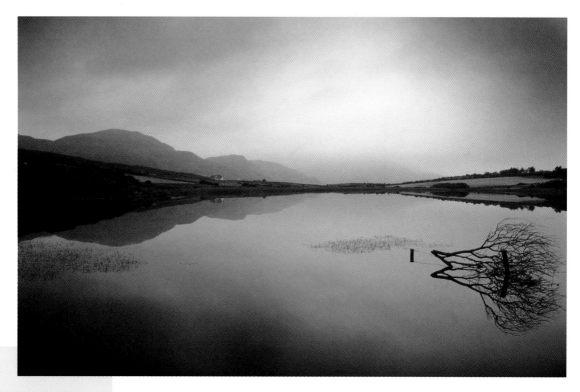

Digital image-editing packages like Adobe Photoshop can be used to introduce filter-like color effects.

»HOW FILTERS WORK

You may think that daylight is colorless, but it is made from a mixture of colors in the visible spectrum. Violet, indigo, blue, green, yellow, orange, and red light are produced at different wavelengths, and all are present in daylight together with non-visible infra-red and ultraviolet light. You can see in rainbows, or when light is split through a prism. Photographic filters work much in the same way as a sieve, allowing some things to pass through, but blocking others. In practice, light is in fact absorbed or transmitted by photographic filters to emphasize your subject matter.

»FILTER TYPES

Photographic filters are available in many different brands and material types such as gelatin, plastic, and glass. Gelatin filters are supplied in a square format and are lightweight plastic which can be cut to the required size or used in special square filter holders that fit over the camera lens. Predominantly used in studio, interiors, or architectural assignments, these filter allow the photographer precise control of color. Plastic filters such as the Cokin professional range are sold in a fixed size, designed to fit into a special mount that is screwed onto the lens or can be inserted into a

Contrast can be modified by the use of deep color filters. From the left, this example shows the same scene unfiltered, using a red filter, and an orange filter.

bellows lens shade on medium-format cameras. Circular glass screw on filters, like those made by Hoya are designed to attach to the front of a lens and are available in different thread sizes, such as 49mm. These filters are designed to be left on the lens for repeated shooting.

›› COLOR-CONTROLLING FILTERS

Color-correction filters known as CC filters, are manufactured in the standard red, green, blue, cyan, magenta, and yellow colors for precise control over subject color. Used in conjunction with a color temperature meter, these filters offer the photographer the ability to respond to unforeseen color imbalance when shooting on transparency material. Each filter is available is varying strengths, for example 5, 10, and 20, and can also be combined. Color conversion filters perform a similar color correcting task by converting artifical tungsten light into daylight and vice versa, for clean reproduction.

›› CONTRAST FILTERS FOR BLACK-AND-WHITE

Surprisingly, black-and-white film can be shot in conjunction with deep color filters to manipulate both contrast and color reproduction. A firm favorite with many black-and-white photographers is a yellow filter left permanently on the lens to correct panchromatic film's sensitivity to the blue end of the spectrum. This helps to make slightly punchier results with reduced sheer, white skies. The same effect to a greater extent is produced by both orange and deep red filters.

›› EXPOSURE FILTERS

Light is never predictable and can sometimes be too intense for your chosen effect. Neutral density filters are gray filters used to reduce the amount of light passing through your lens without creating color imbalance. Known as ND filters, they are available in one-third of a stop increments (0.3) and can be used when you want to deliberately shoot with a very slow shutter speed in bright light. Graduated neutral density filters can be used to even out the imbalance between a bright sky and a darker land.

In situations where there are imbalances in brightness, a neutral density filter can be used to darken down the sky. In this example, compare the unfiltered shot on the left with the filtered version on the right.

→ DIGITAL MANIPULATION

SINCE THE BIRTH OF DIGITAL CAMERAS, THE CREATIVE POSSIBILITIES FOR THE PHOTOGRAPHER HAVE INCREASED A GREAT DEAL

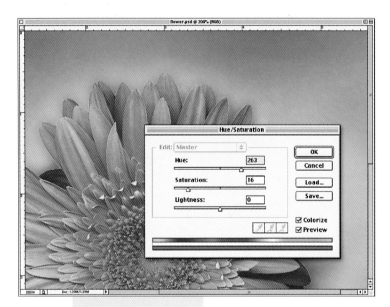

In a digital image, both color and color saturation can be changed to create a new example.

»MIXING AND MERGING

Once images are converted or captured as digital files, they become constructed out of tiny square pixels. With measurable and predictable color, areas of pixels can be moved around within the same image or swapped between two or more different image files. The former hands-on art of photomontage, or mixing the contents of several images together is now much more achievable and in a shorter timeframe, too. All image-editing applications allow you to swap picture information between different files, so you can take a dramatic sky from one image and paste it into another to replace a blander version. Professional montage forms the basis for many advertising images, and expert Photoshop operators command a considerable financial reward for their services.

»CREATIVE COLORING

Pixels are made from a recipe of red, green, and blue which, when combined, form a palette of 16.7 million colors. Despite the enormity of this range, pixel color can easily be changed within a digital

Adobe Photoshop is the software most popular with photographers, offering sophisticated tools for creative image editing. In this example, the photographer is mixing two different versions of the same image.

image using one of many color editing tools. Enhancements can be made to liven up dull colors, remove color casts, or even change colors to a completely different hue. Like any creative technique, knowing how to apply these edits in a sensitive and convincing manner takes time, as well as knowing which images will benefit from the change. All traditional darkroom and film processing effects can be mimicked by digital-manipulation software in a fraction of the time, cost, and with no exposure to chemical agents.

≫SPECIAL PRINTING

Desktop digital printing has developed at lightning speed over the last few years and can now produce photo-realistic results that compare well with traditional prints. The advantages of digital printing are in the speed and convenience of producing at home without a specially converted room and the wide range of special paper types available. In addition to standard glossy and matt papers, many art paper products offer the chance to make textured prints which look like watercolors. Desktop inkjets are versatile machines capable of printing on custom paper and with special ink sets such as warm tone black-and-white. Digital images can also be output via an online photo lab, by uploading digital files via a web browser to a special server connected digital mini-lab, which prints out onto conventional photographic paper.

≫DIGITAL FILTERING

Just like conventional photography digital images can be filtered to remove unwanted colors and errors, but can also be creatively filtered too. Most image-editing applications are packed with a range of textural, geometric, and artists' paintbrush effects that can be applied to make an image look less mechanical

and more hand-crafted. In better image-editors, the Channel Mixer controls work like a special kind of photographic filter and allow you to remix original image colors. The Channel Mixer can also be used for making dramatic color to black-and-white conversions, especially useful if you want to change a color original into a more atmospheric black-and-white print.

→ MAKING PRINTS IN THE DARKROOM

FOR A MORE HAND-CRAFTED RESULT, HAND-PRINTING IN THE DARKROOM GIVES YOU INFINITE CONTROL OVER IMAGE QUALITY

After processing and drying, a contact sheet is made from negative film so you can decide which frames to print.

»THE SIMPLE DARKROOM

A basic darkroom can be set up in any light-tight room for both color and black-and-white printing. The most specialized piece of equipment is the enlarger, used to project film originals onto light-sensitive paper, and to regulate exposure time, an electronic timer is attached to the enlarger. Black-and-white paper processing is a cost-effective route to making high-quality prints, needing only simple open processing dishes, running water, and a room in which safe red lighting can be used. Color printing however, requires a light-tight processing sequence, confined to an autoprocessor which needs careful temperature control.

»FILM PROCESSING

Time, temperature, and agitation are the three most critical factors in film processing, and cannot be modified without disastrous results. All photographic film needs to be removed from its spool and loaded onto a specially designed processing holder in a completely light-tight environment. This process relies entirely on touch and, because it is fiddly, can easily go wrong, particularly for novices to the task. Unprocessed film emulsion is extremely delicate and you must be careful not to touch it at any time to avoid having fingerprint marks resurface at the printing stage.

Precise exposure time is gauged by a test strip. In this example, a single sheet of paper was exposed in strips of 3, 6, 12, 24, 48 seconds.

under a red safe light, continued exposure to light will result in fogging, causing the white base of the paper to turn gray.

≫WASHING AND DRYING

Resin-coated papers are designed to be used in fast processing systems, needing a few minutes' washing before a hot air drying cycle. The superior fiber-based papers, unlike resin-coated papers, are not encased in a plastic coating, so need longer washing and cool air-drying for best results. All archival prints are made using fiber-based papers together with extensive washing cycle to remove all traces of potentially corrosive chemicals.

≫SAFETY

Photographic chemicals need careful handling and can cause skin irritation, particularly after frequent contact. Both film- and paper-processing chemicals should only be handled using rubber gloves and protective eye shields to guard against accidental splashes. Most importantly, too, is a frequent exchange of air in confined spaces or the installation of a purpose-made extraction system.

Variable contrast black-and-white printing paper is the most versatile material on the market.

Like printing paper, there are lots of different brands of film-processing chemicals to choose from, designed to influence contrast, sharpness and changes in ISO speed.

≫PRINTING

Once dried, negatives are inserted into a plastic frame on an enlarger and projected onto light-sensitive photographic paper for a carefully measured time. The enlarger lens is set on a mid-range aperture such as f/8, and a test strip is made using a repeat exposure of 5 seconds. After processing in the developer, stop, and fix, this test print is used to deduce the correct length of exposure required for the final print. Although most black-and-white paper can be used

35mm and roll film is best processed in a light-tight container like this Patterson developing tank.

→ MAKING DIGITAL PRINTS

DESKTOP DIGITAL PRINTING HAS ADVANCED SO MUCH IN THE LAST FEW YEARS, YOU WOULD BE HARD-PRESSED TO TELL AN INKJET FROM A PHOTOGRAPHIC PRINT

→ MORE INFO

Inkjets mimic photographic quality when they are viewed from a distance. Close-up, you can see the individual ink particles.

»HOW INKJETS WORK

Like the grain in photographic film, an inkjet printer uses tiny dots to create the illusion of color by mixing at least four ink colors: cyan, magenta, yellow, and black (CMYK). The resulting color print is constructed out of millions of tiny drops of color, set at different distances from each other and when viewed from a distance, they merge to create the impression of photographic color.

Super high-resolution printers can spray 1440 or 2880 droplets of different sizes on a square inch of printing paper to produce a photorealistic effect.

»TYPES OF PRINTER

The basic four-color inkjet is designed primarily for printing office graphics and text. It makes a bad job printing photographic images with visible dots appearing in white highlight areas. Much better is the printer with two extra ink colors: light cyan and light magenta to mix the subtleties of skin tone. At a slightly higher cost, individual ink cartridges or light-fast inks can give top-quality results. At the top of the range is the professional pigment ink printer suited to archival printing, albeit sacrificing slightly less saturated colors.

A six-color inkjet will produce photoquality print outs that are difficult to tell apart from conventional photographic prints.

PREPARING YOUR IMAGE

Open up your image and make your color and contrast adjustments as normal. Before sending to print, pick the rectangular Marquee tool and make a selection around the area you want to test. Ideally this should contain highlight, mid-tone, and shadow areas. Make sure there's no pre-set feather value on the tool, as this will prevent the test strip from printing.

SELECTING THE TEST AREA

Next, choose File→Print and select the Print Selected Area option. This will now place your image selection exactly in the centre of your chosen paper size. For extra economy, divide your A4 print paper into quarters and set up a Custom paper size to use. Make sure you always use the same paper for testing that you will eventually print on, or the results will be different.

>>PAPER

Just like photographic paper and developer, best results are achieved with inkjet media when used with a recommended ink set. Printer software is made to get the best results out of specific brands, thus do use Epson paper with Epson printers. For a tactile print, try using watercolor paper, or Somerset Velvet Enhanced inkjet paper, acid-free and 100% cotton.

>>COLOR ACCURACY

Accurate color rendition in a digital workstation can be difficult for a new user, but the effectiveness of a system is based on calibrating the monitor first. After test-printing, successful printer settings can be saved and stored for repeated use.

>>HOW TO MAKE A GOOD PRINT

An important stage in all photographic printing is the production of a test strip. These are small slices of an image that have been printed on a piece of paper and can save you a fortune in wasted print resources. In the world of digital printing, there are too many variables to expect a totally cast-free print without testing first.

JUDGING THE RESULTS

Print out three variations by using your Levels mid-tone slider to brighten or darken each one and label with printer settings, paper type, and ink set. In this example, the middle test print looks best. If there are any alterations to make, return to your image file and take off the selection before making final adjustments.

→ SUBJECTS

→ NATURAL LANDSCAPE

**THE MOST CHALLENGING OF ALL PHOTOGRAPHIC GENRES
IS RECORDING THE DRAMA OF THE NATURAL LANDSCAPE**

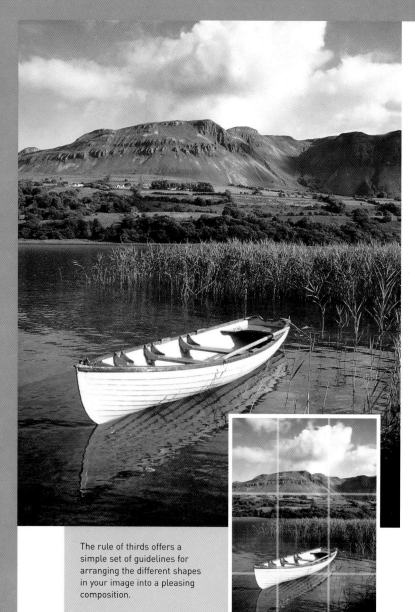

The rule of thirds offers a simple set of guidelines for arranging the different shapes in your image into a pleasing composition.

»THE RULE OF THIRDS

An enduring set of guidelines on which to base your landscape photography is the long-established, but still applicable, rule of thirds. This theory suggests that an image should be divided up into a grid of nine equal but entirely invisible sections and was adopted by many artists and painters in Western art movements. The theory dictates that as long as elements are placed on these grid lines, or at their intersections, a pleasing result can be achieved. There's no need to cram as many elements into your composition to fill the grid, but to position them carefully along the lines. Next time you are out shooting in the open landscape, try some variations on this theme.

»VISTA VIEWS

Composition is far from a task of fitting together objects into a two-dimensional jigsaw. Great use can be made of diminishing distance and depth within the photographic frame by finding a visual link between foreground and background. The limitations of natural light and your own viewpoint rarely allow you to cram more than a few miles of distance into a single shot at the best of times, but open space and the sweeping extent of the countryside can be captured to good effect with a vista view. Vistas are made when a set of parallel lines merge into each other at the vanishing point on the horizon, and in addition to making a great effect, leading your eye from the foreground to the background. Most images are viewed and dismissed within a fraction of a second, so any device that makes the viewer dwell for longer is a good thing.

›› FOCUSING PROBLEMS ON LOCATION

Modern autofocus is unable to focus on low-contrast subjects like large areas of flat-colored landscape, and will track the lens back and forth in error. This problem is solved by recomposing and focusing on the edge of the subject first, then pressing the autofocus lock. The lock holds the focus setting in place, so you can recompose and shoot more creative results. Cameras have the lock in an accessible place, so you can focus without taking the camera away from your eye. Another common autofocus problem occurs when a subject falls outside the centre of the frame and the camera sets focus on another object in the distance by mistake. If in any doubt, try setting your focus point manually.

›› APERTURE AND IMAGE DETAIL

Aperture values influence the amount of detail recorded. A lens records the sharpest detail when set to a value in the middle of its aperture scale. On a lens which ranges from f/2.8 to f/22, the sharpest results will be produced at f/8.

Landscapes can look more interesting when divided into one-third sky with two-thirds land.

The delicate tonal range of this woodland landscape is further enhanced by blue toning.

→ URBAN LANDSCAPE

THE TWENTIETH CENTURY SAW THE GREATEST CHANGES IN THE WAY WE DEVELOPED OUR URBAN LIVING ENVIRONMENT, AND PHOTOGRAPHY HELPED TO RECORD IT

Grim and oppressive environments offer the chance to shoot very atmospheric images.

»SOCIAL DOCUMENTARY

In today's world, circumstances change our environment at a rapid pace. People and their lifestyles can be a good photographic subject, but just as much information can be read from facades, signage, and evidence of the personal touch. Great documentary photographers such as Walker Evans scoured small-town America to find hand-painted signs, house fronts, and signs of life to describe the unique character of those living through the harsh conditions of the American Depression. Signs can be evocative of local culture, beliefs, and personalities which could never be captured in a portrait photograph.

»DIGGING INTO HISTORY

All towns and cities have their fair share of historical symbols. Museums and libraries are a good source of inspiration as they will have excellent records of life under previous generations. Many keen documentary photographers recoup some

Store fronts can provide a detached and ready-made subject for shooting the urban environment.

of their costs by selling their work to local libraries and museums. If you are interested in local history, photography is a perfect medium for recording and preserving the diminishing signs of the past for the future.

››SHOOTING TECHNIQUES

Not all documentary photography is impartial, and without the stylistic leanings of the photographer, but the best is. This facet of photography is concerned with historical accuracy above design and creative interpretation, but this still leaves room for light, composition, and color. Faced with the daunting prospect of decreasing light levels in an inner city location, it's still possible to shoot good-quality images by changing the ISO speed of your film or the sensor on a digital camera. ISO determines the sensitivity of your sensor and film to light, effectively allowing it to work properly under much lower levels than normal. At the top end of the scale, such as ISO 800, you'll be able to capture much the same kind of subject matter as before except for fast-moving objects, and it's a good idea to switch off your flash to preserve the natural light conditions. Try to exclude any point light sources like streetlights from your composition, as these will make your exposure darker than expected. The by-product of an uprating ISO is the random-colored pixel effect called noise in digital

images and grain in conventional film. Noise occurs when there's not enough light for the sensor to make an accurate color pixel, so it creates a bright red or bright green one by mistake. Grain on traditional photographic film also reduces the detail captured in the end result and is caused by an over-development of silver halide crystals into clumps of black silver. Noise and grain is only noticeable if you make large-scale print outs from your files and negatives and will not be as apparent on smaller-scale prints such as 6x4in.

This example was shot inside an historic house, currently in a state of dilapidation. A panoramic format helps to capture the vast interior space with great effect.

Even tiny details can help to convey a message or describe the character of a person, place, or thing.

→ TRAVEL AND ARCHITECTURE

IF YOU'RE MAKING A FLYING VISIT TO A CULTURAL CAPITAL THERE'LL BE PLENTY OF ARCHITECTURAL WONDERS TO RECORD FOR LATER REFLECTION

The detail in the carvings on this archway is softly, and beautifully, lit.

»PORTABLE EQUIPMENT

Cultural sightseeing demands a lightweight and versatile kit that can be put to use in an instant. Limit your lenses to a 35-80mm and 80-200mm zoom, and a 28mm wide-angle will come in very handy for shooting interiors. The large-format but compact 5x4in field camera is designed to be packed away into a small case. With the need to change film in double dark slides in a light-tight environment, a black changing bag is an essential addition to the large-format location kit. Despite the scale of many architectural subjects, a powerful portable flash kit is worth taking too. If you have car transport, consider using a single monobloc flash head with reflector kit for adding light to interior spaces.

»NATURAL LIGHT

On location, natural light is both your best friend and worst enemy, and can make the difference between an atmospheric or lifeless photograph. If you want to shoot the architectural details on a façade, you may be in for a long wait until the light is in the right place, which could mean returning to your location at a specific time of day. If you have a tight schedule, a simple compass will help you to predict the position of the sun in relation to a building at a specific time and save a journey. A low-angle light, commonly found in the morning and evening will draw out textural details much better than overhead midday sun. If you're keen to shoot indoors and aim to retain the atmosphere of an interior, then avoid flash. You'll need to mount your camera on a tripod and experiment with a slow shutter speed or the more flexible 'B' (Bulb) setting.

Light is a crucal factor when shooting architecture outdoors. In dull light, surface details do not appear in relief but in direct light they stand out.

>>LENS AND DISTORTION

If you want to shoot the façade of a building, then shoot from a distance with a telephoto lens, rather than close-up with a wide-angle. Shooting too close gives architectural subjects converging vertical sides, resulting in distortion. Get as far back as you can and use a telephoto lens to frame your building tightly. Try a slightly higher viewpoint than normal, as even a few feet higher will prevent converging vertical sides. Many architectural photographers shoot on top of a lightweight aluminum ladder to raise their angle of view.

>>SHOOTING IN MONO

Many buildings have spectacular surface details but little or no color and therefore look better shot in black and white instead. Modernist buildings, such as the curvy 1920s' style, look great in dramatic black and white which can evoke a period photographic style too. Filters such as the yellow/orange/red series can help to make blue skies black, thereby increasing the contrast of stonework and texture. Digital users can achieve the same results using the Channel Mixer controls in their image-editing program.

This tall structure was captured with a 28mm perspective control (PC) lens. The PC lens helps to keep vertical sides parallel.

→ TRAVEL AND THE PHOTO STORY

A MUCH MORE INTELLIGENT WAY TO RECORD YOUR TRAVELS AND HOLIDAYS IS TO SHOOT A SENSITIVE PHOTO STORY

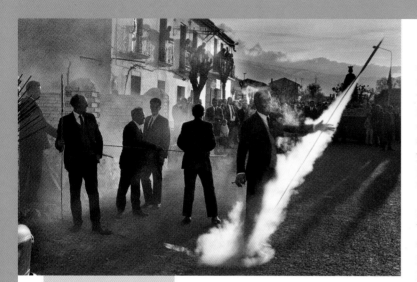

Joseph Koudelka/Magnum

Festivals and religious events can provide rich pickings to those who do their research well in advance.

»GETTING BENEATH THE SURFACE

Great documentary photographs are made when the photographer has developed an in-depth understanding of the cultural environment rather than restrict his or her work to a purely pictorial study. In practice this means researching and reading around your subject, a process which will suggest many more potential locations than a tourist map will ever do. For overseas journeys, a good first step is to invest in a detailed travel guide and spend time searching on the Internet for recent accounts from other travellers. Don't expect to score instant results every time you shoot, but spending more hours planning ahead will always pay dividends in the long run.

»WHAT MAKES A GOOD PICTURE

Photography lets us reflect on events that happen in the flash of an instant. Not just restricted to high-speed action, a sporting moment of glory, or the sight of a rare animal in the wild, but everyday life occurances. The luck factor can never be overestimated, but good photographers make their luck by being ready and in the right place at the right time. If you're keen to try your hand at fly-on-the-wall, documentary-style photography, you'll get a better strike rate if you always have your camera switched on, set to aperture priority, and close to hand around your neck or in your pocket.

»THE DECISIVE MOMENT

The greatest photographic skill, that only comes with practice, is knowing when to press the shutter. The great documentary photographers and photojournalists have all developed this ability as a sixth sense and can predict exactly when to press the shutter and capture the defining moment. The term 'decisive moment 'was first coined by the French photographer, Henri Cartier-Bresson, founder of the acclaimed Magnum Photo agency and, arguably, the world's greatest photographer. Cartier-Bresson declared that all photographers should be able to know exactly when a subject best presents itself to the camera, hence the term 'decisive moment'. Cartier-Bresson's finest work shows a photographer completely in tune with his camera and able to predict when the shapes of his subjects collide to make a great composition and tell a fascinating story at the same time. For lesser mortals, a good way to improve your skills of anticipation is to start by taking a sequence of shots of a subject performing an activity. Try and predict beforehand which stages of the action will provide you with the best photo opportunity, both in terms of composition and defining the essence of the task itself in a single shot.

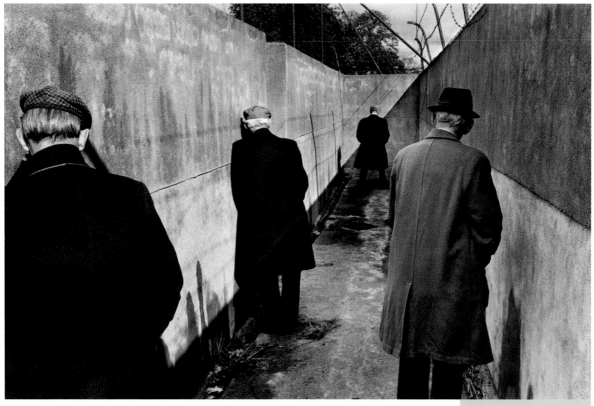

Joseph Koudelka/Magnum

The process is much harder than it at first seems, and you'll need to shoot twenty or so images and then seek out the best one afterwards. Best results usually occur when you've captured the right facial expression together with a key moment.

≫SHOOT AROUND YOUR SUBJECT

Photo stories work best when the sum of the parts is greater than any single image. Aim to capture your subject with a broad brushstroke, shooting details and incidentals as well as the main characters, to add flavor to your story. The very best kind of photo stories work entirely without the need for additional words.

Unexpectedly surreal scenes can help to suggest the character of a different culture or capture a disappearing way of life.

Most opportunities last only for a fleeting moment, so a photographer needs to respond quickly and without hesitation.

→ LANDSCAPE AND THE SEASONS

THE AVAILABILITY AND QUALITY OF NATURAL LIGHT HAS A PROFOUND EFFECT ON THE ABILITY TO TAKE EFFECTIVE PHOTOGRAPHS

Spring offers bright light, new growth and a landscape fresh from the previous winter.

»SHOOTING IN THE SUMMER

The bright, warm daylight of summer will produce saturated, color-rich photographs, but there are a few pitfalls to look out for. With extremes in contrast between deep black shadows and bright white highlights, beware of point light sources such as highlights reflecting off water and glass as both will trick the exposure meter. With such apparent brightness, your camera will create a darker result than you expect. Heat and heat haze can also have an undesirable effect on the way both film and digital image sensors record colors. Most cameras accept screw-on lens filters, so attach an ultra-violet absorbing (UV) filter for better results, or reinstate strong color by using the Saturation command in your image-editing package. Be aware of strong direct sunlight as this will create deep shadows, devoid of detail, and if your subject is small and close enough, use your fill-flash to lighten these shadows. Best results are shot either side of midday, as the direction of the light will be more descriptive, showing texture and fine details. A much more difficult prospect is shooting under strong directional light. Natural subject matter such as flora and fauna can look more animated under bright light as long as there are no pockets of shadow that make details disappear.

Autumn light is weaker and warmer, but provides many opportunities for capturing rich colors.

this could present you with a great opportunity to capture dramatic light, clouds and rainbows. The practicalities of shooting in the cold with a power-hungry digital or film camera should not be overestimated, as the drop in temperature will cause your battery to run out quicker than you expect. If you can afford a second set of batteries keep them in a warm pocket to maintain their charge and reduce the power demands on your camera by using manual wind-on and film-retrieve, and use the LCD preview on a digital camera only when necessary.

Exposure measurement under these conditions will need close attention, and it is good practice to use your camera's exposure lock to take a reading off the largest mid-tone in your viewfinder. For smaller subjects, take a reflected reading off a Kodak Gray card close to your subject.

▶▶SHOOTING IN THE WINTER

With the cold and effort needed to get out into the open, the winter months offer a photographer a challenge. The biggest restriction is the few hours of weak daylight good enough for outdoor photography. Yet despite this, winter is a perfect time to shoot architecture, monuments, and cityscapes, as the low-angled winter light reveals textures and shadows not seen in the summer months. Light is predominantly colorless in winter, losing its rich, warm, red hue and reverting to the seasonal cold blue. Make an effort to get out if the weather looks overcast and changeable for

Winter changes the landscape, and offers a great opportunity to those brave enough to venture out into the cold.

→ PATTERNS OF NATURE

NATURE PROVIDES A RICH TAPESTRY OF SUBJECT MATTER, AND OFFERS THOSE PHOTOGRAPHERS JADED BY URBAN LANDSCAPES A WELCOME ESCAPE

A good technique is to fill your frame with the random patterns created by flowers, whether wild or grown in the garden.

»FLORA AND FAUNA

The repetition of shape and pattern in the natural world can be surprising and worthy of hours of creative investigation. Whether the uniform pattern of a flower or a leaf, or gathering masses of animals or birds on the move, patterns can emerge when you least expect them. Set up your camera for close-up and distance shots; preparing to shoot these subjects can be challenging without a multipurpose zoom lens and a macro function. Faced with a wide scope of subjects, always shoot several crops so that you can select the best version later on. With close-up subjects, experiment with the tilt of the camera to create various compositions, and make your images more graphic by creating diagonal lines that stretch from one corner to the other.

»CLOUDS AND WATER

Infinite variations can be observed in the study of clouds, water, and the shifting sands of the coastline. Every alteration in weather, tide, and time of day sees the patterns of the landscape changing too. Stunning images will always be made in good light and weather, but if you venture out in unsettled conditions, you could be in for a visual treat. Landscape pattern can look predictable and clichéd when shot as stationary scenes, but can look much more

Light and clouds offer an infinitely variable and changing situation. Here, the photographer waited for just the right moment before pressing the shutter.

inventive if an element of movement is introduced to the equation. Using an ultra-slow shutter speed or a timed exposure on the Bulb setting, means that you can record the gradual movement of clouds across the sky or the flow of moving water over the rocks. A great technique to try is to make a multiple exposure of the same scene by dividing the normal single exposure into four or more shorter ones; like time-lapse photography, but within a single frame, variations and changes are recorded as layers, one on top of another, to great effect.

›› DETAILS IN A PHOTO STORY

A vital ingredient in any lifestyle magazine feature is the detail photograph. Intended to offer closer scrutiny of the subject, details help give the reader a better, broader sense of the story. Patterns and textures found *in situ* can provide essential detail images, however small and insignificant, and should be crammed into the frame regardless of cropping out edges.

›› SHOOTING FOR DIGITAL MONTAGE

Patterns and textures can become vital ingredients in digital montage projects and can provide a cohesive element amidst the trickery of the process. Many manipulated images are produced with delicate underlying textures which add another layer of interest to the work. The key to shooting for this kind of image is to make sure that the patterns do not dominate the eye too much, and instead offer a compelling, but subtle component to the piece. Rough textures found on stone, sand, and textiles can provide an unusual addition to digital images which can look too polished and perfect.

A tall avenue of trees captured in early morning light. The angle from which the photographer took this picture is very acute, giving an enhanced sense of perspective.

With each ebb and flow, the tide changes the seaside landscape to create a graphic effect.

→ **NATURE UP CLOSE**

UP CLOSE, THERE'S ANOTHER WORLD WAITING TO BE DISCOVERED BY THE KEEN EYE OF A PHOTOGRAPHER ARMED WITH A FEW SIMPLE TECHNIQUES

Outdoors, the photographer is at the mercy of available light. This example was further enhanced in Adobe Photoshop.

Depth of field doesn't remain consistent for the differing challenges of landscape and macro photography. The closer you get to your subject, the depth of field diminishes until it's reduced to millimetres, even at f/22. If you want to capture detailed images at close range, small apertures force you to use slow shutter speeds, and a tripod.

»LENSES AND MAXIMUM APERTURES

If you are thinking about buying an SLR, spend time researching the lenses to go with it. Cheaper zoom lenses are convenient but often have a variable maximum aperture of f/3.3/f/4.5. This means that the maximum aperture is different at the wide-angle end to the telephoto end of the lens. For shallow depth of field background effects, a maximum aperture of f/4.5 won't blur as much as a f/2.8 lens. Zoom lenses which open up to f/2.8 through their range are more expensive, but will offer more creative freedom. Prime lenses, such as macro or micro are great for shooting close up.

»USING HAND-HELD FLASH

If your camera is fitted with a hot shoe flash socket for attaching a powerful flash unit, you can mount a special device to this called a hot shoe adaptor. This enables you to attach a flexible flash cord so the unit can be taken off your camera and held to one side. Angled flash can mimic the look of natural light and is great for flora and fauna subjects when available light is bland.

»COLOR SATURATION WITH FILL-FLASH

In addition to the contrast-reduction properties of fill-flash, it can also be used to increase the color saturation of nearby subjects. With fill-flash, colors sing out at the maximum values compared to the washed-out effects of dreary natural light. On better cameras, a further fill-flash setting is available: the flash compensation dial. Just like the normal exposure compensation dial, the former enables you to control the flash fire, for example at half-power, quarter-power, or less. These settings can be used to reduce the visual impact of stark flash illumination when mixed with daylight and, if used judiciously, will remove traces of flash use altogether.

In the studio, precise control over lighting and exposure allows the photographer the opportunity to investigate more creative images.

→ SPORT AND THE DECISIVE MOMENT

THE GREATEST MOMENTS IN THE WORLD OF SPORT OCCUR IN A FRACTION OF A SECOND, SO YOU NEED TO BE FULLY PREPARED

A fast shutter speed ensures a pin-sharp image that captures the pained facial expressions of the fighters perfectly.

»FAST SHUTTER SPEEDS

For freezing action subjects, the use of faster shutter speeds is essential. Faster speeds capture a fleeting moment of the action that is too brief for the human eye. Fast shutter technique is the key to the very best wildlife and sports photography, but knowing where to position yourself to see the action is important too. As a guide, for walking pace or other slow actions, 1/250th of a second is fine, whereas for running, 1/500th of a second is necessary. For very fast action, 1/1000th and over is required, for example for motor sports, horse racing, and football. With fast shutter speeds, light hits the sensor for a very short time, so light of a higher intensity must be used to compensate. To increase light intensity, f/2.8 or f/4 should be used. If little natural light at the scene prevents the selection of a fast shutter speed, increasing the ISO value from 200 to 800 will solve the problem.

»FILM

Fast action needs fast film, with speeds of ISO 800 and above a minimum. Most sports photographers shoot using a fully digital system or with ISO 800 color negative film. All medium- and fast-speed film can be uprated—that is, exposed at a faster speed than recommended, and can be doubled. Once exposed in this way, uprated film needs an extended development time to compensate, called push processing. On a digital camera, each image can be exposed with a different ISO speed within the camera's range, but on a film camera, a speed change is fixed for the whole roll.

»SHOOTING AT RANGE

If you want to single-out individual subjects from busy backgrounds, use your widest aperture together with your zoom lens at its maximum setting. Hold your camera steady to prevent camera shake, as any blur will be magnified. Pick your focus point, making sure your autofocus doesn't mistakenly settle on a distant subject. This forms the standard technique for all sports photographers, where great images can be spoiled by detailed, distracting backgrounds.

»FINDING YOUR POSITION

You'll get better results if you think first about your shooting point. Athletes place themselves in unique positions, and unless you've anticipated the best position for the action, you'll struggle to make memorable images. Viewpoint is the key to capturing great images of athletics, racket sports, football, hockey, and rugby, but get an idea where to stand by looking for photographers during televized sports events.

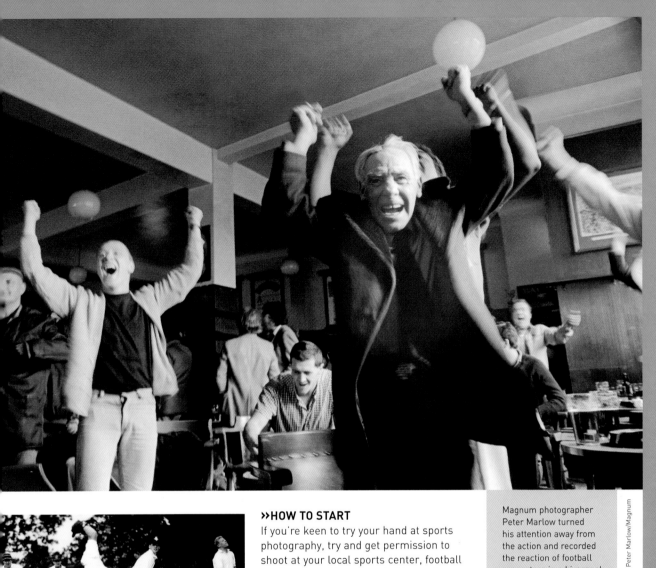

❯❯HOW TO START

If you're keen to try your hand at sports photography, try and get permission to shoot at your local sports center, football stadium, or athletics track. It's much easier to get access to reserve or training events than the big-league events, but these occasions will be just as challenging and without the pressure of jostling for the best positions. You can even offset the cost of your materials by selling prints back to the competitors.

Magnum photographer Peter Marlow turned his attention away from the action and recorded the reaction of football supporters in a Liverpool city pub.

Another great action shot. The fast shutter speed used by the photographer has frozen the cricketer in midair.

→ MOTORSPORT

CATCHING THE THRILL OF THE RACE IN A SINGLE FRAME CAN BE A LIFELONG OBSESSION FOR MOTORSPORTS ENTHUSIASTS

A fast shutter speed and a low vantage point help to express the drama of a jump in midair.

»PRE-FOCUSING

Most motorsport action happens too quickly for even the fastest autofocus lens to respond to it, so most photographers pre-focus instead. This technique involves setting focus on a track fixture, waiting for the action to appear, then firing off a fast sequence just before the car reaches the focus point. With autofocus lenses, it is important to switch over to manual to prevent the servo shunting the lens back and forth during shooting. To further improve your chances of arresting motion, try selecting a point in the race where the action momentarily decelerates, such as the brow of a hill or a bend at the end of a straight stretch of track.

»PANNING

Just like athletics, shooting motorsports will push your ability and equipment to their limit. A firm favorite with motorsports enthusiasts, the panning technique conveys all the drama and excitement of a finely tuned machine at top speed. Panning works when the camera actually tracks the position of a moving object during exposure. Unlike fast-shutter speed photography, the panning technique works on a slower shutter speed, and to gain the skill requires plenty of practice before success is achieved. Arrange your shooting position so the moving object passes from one side of your viewfinder frame to the other, and select a shutter speed of 1/15th of a second. Press your shutter just as the moving object appears and physically move the camera so that it follows its path. As the shutter closes, the resulting image will display a sharpish moving object against a very streaky background. Results are never pin-sharp, but certainly atmospheric. The same kind of effect can be applied to the backgrounds of photographs where the subject's movement is frozen using the Motion Blur filter in Adobe Photoshop.

»SHOOTING RESTRICTIONS

Many events have special restrictions placed on photographers, designed to protect the safety and performance of competitors first and foremost. Flash is very rarely allowable; its potential as a distraction can be disadvantageous at the very least, but possibly also dangerous; a split-second delay could result in an accident. With fast-moving events, you are

very unlikely to get close access to the action, for your own safety, so this will determine the kind of lens that you'll need to use. Practice days can often provide you with closer access and less frenetic action and will give you a chance to test your skills before the main event.

››HIRING EQUIPMENT

If you're planning to shoot a special event in the annual motor sport calendar, it could be the ideal excuse to hire a special piece of equipment. Most professional photo outlets have a lens hire service, where you can rent the kind of super-long telephoto that would otherwise be an expensive investment. Most hire shops base their equipment stock on the professionals' favorites, Nikon and Canon SLR systems, and all have special reduced rates for weekend hire.

A slow shutter speed is used to deliberately blur moving bikers and so give the impression of motion.

→ TRANSPORT

**IF YOU'RE EXCITED BY THE DESIGN AND LOOK OF A
FINELY TUNED SPEED MACHINE, THEN PHOTOGRAPHY
IS THE PERFECT WAY TO PAY HOMAGE**

»STYLE AND DESIGN

Curvaceous, well-proportioned, and ready to be photographed in the raw, cars and bikes have more than enough modelling for creative interpretation. Badges, logos, engineering, and body detailing can all be captured in graphic single frames to glorify the unique style of the shape. For getting in close, a good idea is to use a wide-angle lens to create exciting, distorted shapes and allow you to force together seemingly unconnected parts into a striking image. There's always the danger that at such close range, you'll spot your own reflection in a shiny surface or metallic detail, but this can easily be removed afterwards with most digital image-editing applications.

Digital coloring further enhances this image of a 1950s' classic car interior.

An atmospheric landscape and a blurred motorcycle suggests the spirit of the open road.

>>VINTAGE SETTING

Vintage and classic car clubs meet on a regular basis, so access to stylish machines could not be easier. A great idea for shooting vintage vehicles is to create a setting or a style that complements the period of its manufacture. Most important with this kind of project is to select an appropriate background for your subject, making sure that all modern elements are outside of the picture frame. Telegraph poles, TV aerials, street signage, and even someone's clothes will date an image and ruin your effect. For a good result, consider emulating the look and feel of a vintage photograph by toning the print sepia or blue.

>>MOTOR SHOWS

Despite the abundance of choice on offer, indoor motor shows offers poor-quality lighting for color photography unless you have a portable flash kit. With the green glare of fluorescent lighting, most film-based color work looks insipid and underexposed. On-camera flash is prone to create hotspots on the highly polished surfaces of the vehicles, so it's important to use flash off-camera and held to one side if at all possible. Light travels in straight lines, so flash fired from one side will bounce off and away from the camera lens thereby avoiding a white hot spot.

Digital cameras with a useful white balance function can overcome this kind of poor lighting, and have a specially calibrated setting for fluorescent tubes.

>>SHOOTING THE SCENE

For real railway enthusiasts, the thrill of shooting a rare steam train is enough, but for an even greater memory, try shooting in a dramatic landscape setting. Many of the original steam railways are still in use and carry trains over spectacular mountain scenery. The key to shooting this kind of event is careful planning; if you've got only one chance per day to shoot your target, then you'll need to be set up correctly first. Planning the shoot involves careful map-reading beforehand to track the position of the railway line and potential vantage points along the journey. Shots of a steam train resting in a railway station, surrounded by the distractions of boarding travellers, and so on, cannot compare with a dramatic scene of an engine steaming across the expanse of a landscape.

A close-up of a wrecked vintage car produces a graphic composition.

→ LIGHT AND SHADOW

DEVISING YOUR OWN APPROACH TO IMAGE CONTRAST CAN HELP YOU FORM YOUR OWN PERSONAL SHOOTING STYLE

»SHOOTING WHITE SUBJECTS

Contrary to expectation, white subjects always record darker than you perceive them. Many a classic snowy landscape records as gray and muddy if you leave the camera to judge the exposure. Light meters attempt to turn bright whites into a darker shade of gray and need to be deliberately confused to provide better results. These subjects are often referred to as 'high-key' in both studio and location settings. Using your exposure compensation dial, overexpose your scene by +1 or more stops to compensate.

»SHOOTING BLACK SUBJECTS

Predominantly black subjects are called 'low-key', and formed by dark shades and shapes. When a lightmeter tries to measure a dark scene, it will attempt to convert it to a mid-tone gray instead, stripping away any desired atmospheric effects. To solve this problem try underexposing your subject in increments of half a stop and shoot at least three variations (otherwise known as 'bracketing') to guarantee success.

»THINKING IN TONES

The best photographers are always aware of areas of bright highlight on their subjects and can make exposure

Flat lighting can still be atmospheric, and further enhanced by printing technique in the darkroom or digital workstation.

adjustments when necessary. This sixth sense can be developed by making a quick, visual check of your subject before pressing the shutter button.

›› DARKROOM COMPENSATION

In monochrome photography, contrast values can be adjusted by using one of a number of appropriate paper grades. These days, most black-and-white papers are variable-contrast and can potentially be exposed in one of six different contrast settings on a 0—5 scale. Variable-contrast papers were originally designed to offset any contrast imbalance due to exposure or processing errors, but they can be used to correct flat or contrasting lighting too. In normal circumstances, if a scene of average contrast is recorded and processed correctly, a perfect print can be achieved at grade 2. When underexposure or underdevelopment occurs, producing a thinner and more transparent negative, compensation can be achieved by selecting grades 3—5. Overexposed or overdeveloped negatives have the opposite appearance— denser and blacker than usual—and require lower grades 0—2 to create a print with even contrast.

Shadows themselves can provide an essential ingredient to a great landscape photograph.

›› DIGITAL CONTRAST

Those photographers who want to exercise complete control over image contrast should think about using image-editing software, such as Adobe Photoshop. Tools such as Levels and Curves are designed to create very precise contrast and brightness effects on both color and monochrome subjects. Unlike the one-shot chemical process of the darkroom, the advantage of using a digital system is that all stages of the process are reversible. For those who prefer to shoot with a medium-format camera and film, a dedicated film scanner can offer the flexibility of digital processing combined with familiar film and camera operation.

→ LOCATION STILL LIFE

UNENCUMBERED BY THE COMPLICATIONS OF THE ARTIFICIAL SETTING OF A STUDIO, READY-MADE STILL-LIFE SUBJECTS ON LOCATION CAN BE EFFECTIVE

A single composition using three tiny flowers positioned against a textural rock background.

»THE BEACHCOMBER APPROACH

Many photographers prefer the challenge of the search for a rare and precious subject, rather than settle for an entirely constructed set-up in the studio. The beauty of this approach is that you can never predict your quarry, but you are always in for a pleasant surprise. Combined with a natural inquisitiveness and desire to explore off the beaten track, the beachcomber approach can bring many fruitful rewards. Many photographers were influenced by the tireless pursuits of Edward Weston and Minor White, searching for rare undiscovered objects of natural beauty. Once spotted, these objects were photographed in sensational detail and embellished by luscious post-processing techniques, such as toning and hand-printing.

»THE PORTABLE KITBAG

Roving photographers need a special kind of kit to cope with the rigors of trekking across the countryside. Of primary importance is the camera bag which should be a rucksack type, capable of carrying two camera bodies, an assortment of lenses, and a small tripod. Manufacturers such as Lowe have responded to the needs of location photographers by designing a camera bag around a comfortable rucksack, rather than the other way around. Within the kit should be carried a small but powerful flashgun, such as a Metz 45, together with an extension flash cord, so the unit can be fired away from the camera body. For ultra fine-quality images, a classic field 5x4in camera such as the MPP offers fabulous possibilites with an entirely mechanical operation.

>>CONTROLLING LIGHT

Location lighting is unpredictable, but you can modify this in a number of different ways. To reduce the intensity of harsh and contrasty light on small scale subjects, you can use a portable reflector to liven up shadow areas until they are less dark. The same effect can be produced by using a portable flashgun on half- or quarter-power. Many photographers who prefer to shoot using natural light build small-scale tents out of white nylon or translucent tracing paper to create a diffuse canopy over their subjects.

>>POST-PROCESSING

Enhancing the natural beauty of found still-life images really takes place in the post-processing techniques of special darkroom printing. Flat, featureless lighting can be enhanced by careful burning and dodging under the enlarger to darken and lighten specific areas. Skilled darkroom printers can create wonderful effects to emphasize details of an image that rival the most carefully lit studio subjects. Monochrome still life can be further enhanced with the addition of a further process called toning. In standard black-and-white printing, final prints adopt a neutral gray tone, but this can be replaced by a wide range of colors including brown, copper, red, and blue. Warm-tone images can enhance the tonal range of the print and help to make the image more hand-crafted and less mechanically produced. All coloring and toning effects can be mimicked in most digital image-editing programs with much more flexibility.

A rare limestone pavement found on the west coast of Ireland produces deep clefts in the rocks where mini gardens thrive.

Forgotten possessions found on a set of shelves in a derelict French cottage provide rustic photographic interest.

→ STUDIO STILL LIFE

IF YOU'RE KEEN TO CONSTRUCT YOUR IMAGES IN A DELIBERATE, HANDS-ON FASHION, THEN STUDIO STILL LIFE OFFERS THE ULTIMATE CONTROL

Exact colors and lighting can create striking images from mundane objects. The cropped top and bottom gives emphasis to the texture, too.

»BASIC STUDIO KIT

Unlike studio portraiture and large-scale advertising shoots, studio still life is undertaken on a much smaller scale altogether. An essential part of the set is the still life table, designed and built at such a height to allow the maximum flexibility over both shooting and lighting positions. Most good tables are supplied with a translucent white perspex surface that curves upwards to form a gently sloping shooting curve. This angle-free curve enables the photographer to create the impression of three-dimensional space behind the still life subject. The translucent surface also comes in useful for lighting underneath to remove unsightly shadows or unwanted reflections. Better tables can also accommodate a half-width paper background roll for shooting with specific colors.

The technique of Kirlian photography works by placing sheet film in contact with an object, then exposing it to low levels of x-ray radiation.

LIGHTING

For small sets, a single, narrow spotlight or a flash unit with a medium reflector will provide ample illumination and can be shaped with the addition of card reflectors or barn doors around the head itself.

EXPOSURE TECHNIQUES

Generating enough depth of field at such a close range is the classic problem associated with studio still life and can be a tricky situation for the novice photographer. Studio flash units are made and sold with different strengths, with higher-power devices costing more than low-power units. In certain circumstances, not enough light intensity is created from a single burst of flash to match the desired aperture value to create enough depth of field. In this situation, the flash unit can be fired several times in conjunction with an open shutter and a cumulative light reading is taken until the required aperture value is reached. In these circumstances, no other ambient light can be present during the multi-flash exposure, and the modelling light must be turned off.

WARMING UP STUDIO FLASH

A favorite technique of food photographers is to make an exposure using both color-corrected flash and the warmer tungsten modelling light to make a more appetizing result. Once the flash meter reading is taken, a slower than normal shutter speed is selected to allow the film to record the tungsten light as it flicks back on after the flash has been fired.

LIGHT MODIFIERS

At a small scale, the direction and quality of light can make or break a still life photograph. Unlike the threatrically large white and black reflectors, small subjects can be better served with tiny mirrors, scraps of white card, and opaque strips to block the light. At their most inventive, still life photographers can generate stunning images with throwaway lighting gadgets. Gobos are a well-established light modifier used in the film industry to cast a shadow or light design onto a set to create the illusion of a sunlight effect. Gobos look

Shot in the studio using an old lithographic stone as a background, this simple still life had a creative edge effect added in Photoshop.

like old-fashioned lantern slides that are slotted into a directional spotlight, but you can make your own versions with a sheet of black card and a scalpel.

FLASH SYNCHRONIZATION SPEED

Most cameras can be used with external flash units providing the right shutter speed is set. All professional cameras have a maximum flash synchronization shutter speed, such as 1/60th or 1/125th. If faster shutter speeds are selected, then the resulting photographs display a characteristic strip-like error. This is due to the moving shutter curtain only revealing a portion of the sensor or film at any one time when set to faster speeds.

→ CHILDREN

SECOND ONLY TO ANIMALS IN THE LEAGUE OF DIFFICULT SUBJECTS, TAKING SENSITIVE PORTRAITS OF CHILDREN CAN BE A REWARDING EXPERIENCE

A three-quarter length portrait on location places your child firmly in the context of his or her surroundings.

Shooting great photographs of your children can be a stressful experience, especially if you are conscious of the onset of boredom as you work on your camera settings. Memorable images don't occur by accident but happen as a result of thought, considered planning, and the ability to anticipate a photo opportunity. To make the kind of photograph that marks a moment in your child's life, you'll require great powers of persuasion and stealth.

»FLY ON THE WALL

Candid moments occur all the time, but you have to work fast to respond to these fleeting happenings. Instead of getting in the thick of the action, use a zoom lens and set yourself some distance away to record children going about their playful business unguarded. Natural, unposed photographs convey the unique personality of your child in a way that is far superior to pulled faces or awkward poses. A good idea is to give children something to do which concentrates their attention before you disappear into the background.

»SHOOTING TECHNIQUES

The secret to great candid photography is no more complicated than pressing the shutter at the right time. A good habit to get into is to look through the camera viewfinder and wait patiently for a great photo to occur. Keep your eye on the situation, concentrate or the chance will evaporate. With many informal and candid styles used in advertising, try looking at children's clothing catalogs or magazines for inspiration and picture ideas.

›› FILL-FLASH TECHNIQUE

Often called daylight flash, the fill-flash setting is a very handy tool for enlivening all kinds of photographic subjects, including children's portraits on location. Fill-flash works by firing a much-reduced burst of light that mixes with natural daylight to form a balanced exposure. Great for reducing the dense black shadows under strong, sunny lighting conditions to a far more acceptable gray, the fill-flash helps to reduce contrast and restore balance to objects that fall within its limited range. Much used in press, public relations, and wedding photography, by skilled photographers aiming to reduce heavy shadows cast on a portrait by overhanging eyebrows.

›› SHOOTING A SEQUENCE

It's not essential to concentrate on shooting single iconic images all the time, a sequence can be just as effective. Aim to shoot during a deliberately staged event such as the opening of a parcel, a practical joke, or eating an ice cream, and you'll end up with a large selection of frames. It's important to edit your results down to a few images—maybe four—and present them side by side in a multi-aperture mount or on the same sheet of paper. Running ahead of your child and shooting them as they approach you can provide a humorous sequence.

For very lively children, taking—and displaying—a sequence of images can really express their character better than a single frame.

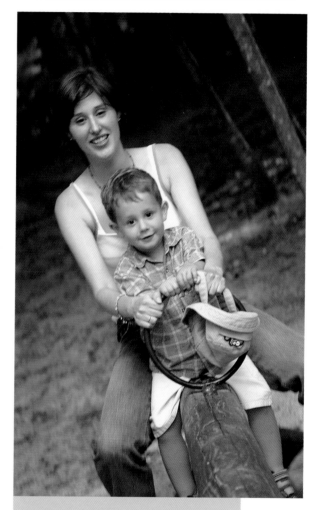

Placed in the midst of a natural landscape and charged with a task that required total concentration, produced a very natural and unposed result.

→ PETS

MOST OF US FIND TAKING PICTURES OF ANIMALS DIFFICULT, BUT ALL YOU NEED TO TAKE CHARACTERFUL PORTRAITS OF YOUR PET IS PATIENCE AND A COUPLE OF ROLLS OF FILM

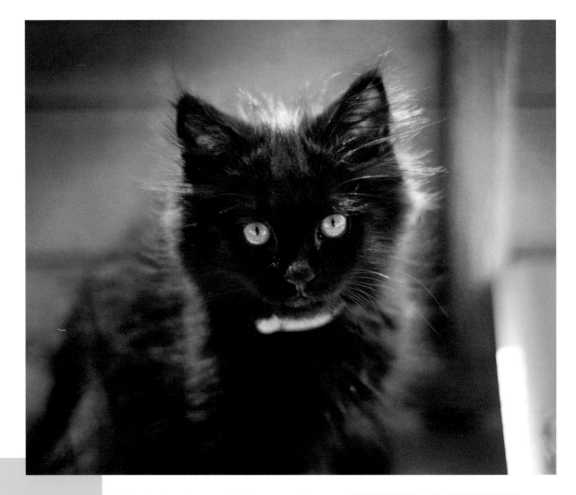

Shot under natural light at close range helped to bring out the vulnerable quality of this kitten.

Animals find the sound of shutters and bursts of flashlight unnerving, so keep your kit portable and simple to operate. Don't expect your pet to co-operate at any stage of the process, but be ready to pounce when a photo opportunity presents itself. You'll rarely get more than a few seconds to make your photographs, unless you're lucky to have a docile pet as your subject.

» EQUIPMENT AND TECHNIQUES

It's a much better idea to take your camera to your pet, rather than expect it to follow your direction. Viewpoint is extremely important, so crouch down to your pet's eye level, rather than shoot downwards from a standing position. Shots taken from above will result in a small, squashed pet portrait. After working out the best

shooting position, frame your pet as tightly as possible in the viewfinder to capture their character. Wait and observe the way your pet's expression changes and, when the moment looks right, press the shutter release. A fraction of a second will make the difference between a dull and an outstanding photo, so it's a good idea to take several frames to be sure you've captured the moment.

››LIGHTING
Use natural daylight whenever possible and look for subtle backlighting to emphasize the texture of your pet's coat or fur. If it's essential to use flash indoors, remember that animals can suffer red eye too, albeit in a different color to humans, but switching to red-eye reduction flash mode will counteract this problem.

››LOCATION
To make better pet portraits, try and convey the attributes you most associate with your pet, for example relaxed and lazy like a cat, or energetic and playful like a dog. Classic backgrounds to show off your pet should be plain and unfussy so as not to vie for attention in your final print. To make the most of a nervous or camera-shy animal, choose a location that has some meaning for your pet, such as their favorite rest spot, or introduce a special toy.

››PETS IN CAGES
If you have a small animal or pet that lives in a cage, push your camera lens against the mesh or glass and it won't appear in your final photo. If you need to use a flash, try using it off-camera and direct the light from above to avoid unwanted 'hotspot' reflections off the glass. Finally, try and coax your pet into the brightest part of the cage with some food as this will make focusing much easier.

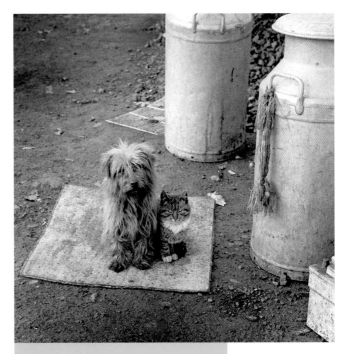

When unusual portraits of two normally adversarial pets offer themselves, be at the ready to take some quickly composed, but effective, shots.

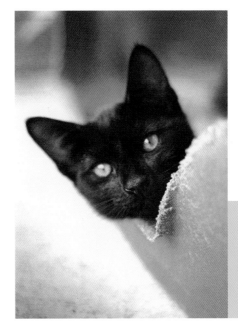

Getting down to ground level will help to bring a new dimension to your pet photographs.

→ WILDLIFE

IF YOU'RE KEEN TO RECORD SIGHTINGS OF A RARE SPECIES, YOU'LL NEED TO BE KITTED UP PROPERLY OR YOU'LL MISS THE OPPORTUNITY

This well-observed image of swans does much to avoid the search for the perfect specimen.

»STARTING OFF

There's no need to book a safari in the Kalahari desert to enjoy your first taste of wildlife photography, there are many animal sanctuaries and wildlife parks closer to home. The best wildlife images are taken by dedicated professionals who spend long hours waiting for perfect photographic moments, but you can cut the wait by shooting in your back yard or local park. The principles behind wildlife photography are simple; be invisible to your subject, shoot many frames quickly and get the subject big in the frame.

»THE LONG WAIT

Many keen wildlife photographers start off by shooting from within a tried-and-tested well-established hide or vantage point in an animal sanctuary as this tends to guarantee clear sight of the subject. More experienced photographers use portable hides to conceal their position, made from lightweight nylon and resembling a very large hat with sides extending to ground level. For nocturnal and very time-comsuming projects, cameras and lighting rigs can be operated by an infra-red trigger. This works when the movement of an animal breaks the continuous beam of light, which in turn fires the shutter and flash simultaneously. Like all other photographic situations, advance preparation, such as laying down food and other attractants to lure the animal into the right position for the light and lens, are the key to success.

►►SPECIAL LENSES

Shy animals need to be shot with an ultra-long lens such as a 200mm or 300mm telephoto. A lens of this type can be bought in many different qualities with a price determined by the size of its maximum aperture. The best, but most expensive lenses are those which open to f/2.8, allowing fast shutter speed shooting together with blurred background depth of field effects. Cheaper lenses such as f/4 or f/4–f/5.6 will not be as versatile, but will work perfectly well under bright light conditions together with slightly faster ISO 400 film. Long telephoto lenses are heavy and need to be supported by a tripod or monopod during long stake outs.

►►EXPOSURE AND SHOOTING TECHNIQUE

Birds pose a challenge to the photographer as they are often shot against a bright white sky or against highly reflective water. In these circumstances it's important to overexpose your film to prevent a poor silhouette. When shooting against a bright sky, you should attempt at least +1 stop overexposure to start with and, if you are using a digital SLR, you can even preview the most successful exposure compensation by looking at the rear LCD panel. Animals can move and change position very quickly, so its important to use a motorized film wind-on when possible. Three or more frames shot in quick succession will offer you three different poses and positions to choose from.

►►SHOOTING AWAY ON LOCATION

If you plan to shoot abroad, it's a good idea to have a roll of film processed after the first day of shooting. This will give you confidence that your kit is functioning properly, and will give you a taste of the good work you're going to make on your trip. For digital users, its essential to offload image files onto stable removable media during a long trip, such as CDR disks. Never leave all your files on one storage source, such as a laptop or camera, just in case you lose them to technological failure, damage, or loss.

Shot with an ultra-long telephoto lens, wildlife photographers need great powers of concentration and patience.

→ LOCATION PORTRAITS

SET WITHIN THE CONTEXT OF AN EVOCATIVE LOCATION, OUTDOOR PORTRAITS CAN BE MUCH MORE ATMOSPHERIC THAN THEIR STUDIO COUNTERPARTS

A wonderfully observed portrait made even stronger by careful framing.

»LOCATION PORTRAITS USING NATURAL LIGHT

Experienced wedding photographers always arrive early to a shoot to hunt out a patch of shade for later portrait photographs. Direct sunlight will make most portrait subjects squint excessively, distorting their facial composure. You'll never be thanked for shooting an unflattering portrait, so you must be prepared to solve lighting problems on the spot and quickly. Overhead light at midday is the main cause of unflattering portraits, creating unnatural shadows. This problem is best solved by shooting under the canopy of any natural shade nearby, such as a tree. Once out of the intense light, your sitters' pupils will open wider and their face will relax from a frown. If you are really keen on shooting portraits, a fold up Lastolite reflector is a good investment and will help you to balance out any shadows still remaining. Fold-up reflectors unravel into sizeable but lightweight disks of white, usually backed by an extra silver or gold flipside. Position the reflector under your sitter's face until it is just out of shot and experiment with the gold variation for a warmer, more flattering result.

»CATCHLIGHT

Location portraits can be further enhanced with the addition of fill-flash to create a catchlight in the eyes. Catchlights make a sitter's eye look more lively and less hidden by shadow or the canopy of a large hat. When using this technique it's important to set your hand-held flash intensity to weakest power output to avoid overcooking your sitter's face.

Photographed in a church, this sensitive portrait evokes a wonderful atmosphere.

››BRACKETING AND EXPOSURE

Most good digital compacts and all SLRs have an additional exposure control called the exposure compensation switch. Identified by the '+/-' symbol, this can be used to counteract lighting situations which would otherwise fool your light meter. It works by allowing more or less light to reach your sensor as follows: to increase exposure, use the + settings, for example +0.3, and to decrease exposure, select the - settings, for example -0.6. Each whole number represents a difference of one aperture value, commonly referred to as a stop. For portrait shots, skin tone is notoriously difficult to reproduce accurately on Asian and Afro-Caribbean subjects. In these circumstances its important to overexpose your image by +1/2 to +1 stops to lighten what would be a far darker result.

››LONG LENS PORTRAITS

Wonderful effects can be created using a very long lens out on location to foreshorten your portraits. For 35mm photographers a 200mm telephoto lens, used in conjunction with a shallow depth of field, will pick out a portrait from its background with stunning effects. With such a long lens it's important to brace yourself steadily to avoid camera shake, which can be further safeguarded against by using a faster 1/250th of a second shutter speed. Pick a point of focus on the nearest eye, rather than the tip of the nose if you want to avoid focusing errors.

Placed in front of a spectacular background, this elderly gentleman makes a truly timeless portrait.

→ STUDIO PORTRAITS

**FOR A CONTROLLED AND CAREFULLY STAGE-MANAGED
SITUATION, STUDIO PORTRAITURE OFFERS THE PHOTOGRAPHER
A GREAT OPPORTUNITY TO GET CREATIVE**

Shot on 5x4in sheet film, this tightly
cropped portrait of a young girl
emphasizes the subtle character
of the subject.

»BASIC STUDIO KIT

Most portrait photographers shoot on
medium-format, but 35mm is acceptable
for enlargements up to 10x8in in size.
In addition to a sturdy tripod and cable
release, two or more studio flash lights
are essential for recreating the different
lighting styles that form a photographer's
stock in trade. Translucent umbrellas
and softboxes are essential for softening
down the quality of studio flash to mimic
natural daylight and a large sheet of white
polystyrene painted black on one side will
help to add or subtract light from one side
of a face. Many background systems are
available for using full- and half-width
background paper rolls and specially
painted fabrics. For roving photographers,
for school portraits, etc., consider using a
collapsible fabric background from Lastolite
mounted on a lightweight lighting stand.

»EXPOSURE PRINCIPLES

Studio portrait technique is based on
exposure readings taken with a hand-held
studio flashmeter. With little or no ambient
light present in the room, no account of
shutter speed, apart from setting the right
synchronization speed, need be taken.
Once the flashmeter has been calibrated
with the current film speed in use, a
recommended aperture value is produced
by holding the meter in close proximity to
the subject while the flash unit is fired.

»LIGHTING QUALITY

Flash light can be modified to create two
very distinct qualities: hard and soft. Hard
lighting is great for enhancing rugged
texture and for creating a moody
atmospheric effect. This kind of light is

>>SHOOTING PROOFS

With these variables in mind, professional photographer always shoot a few proof images, first using instant Polaroid film, so they can check lighting and depth of field. If you are shooting it is well worth shooting a few test images using different aperture settings before launching into a photographic portrait session, just so you can relax about the visual consequences of your set-up.

>>SETTING THE SCENE

The most important skill required by a studio portrait photographer is the ability to create a relaxed atmosphere conducive to good results. All but the most experienced photographic models are nervous, and therefore a little stiff, when faced with glaring studio lights and an array of daunting technology. Music, a well-heated room and an unhurried approach will pay dividends.

Shot with an umbrella flash attachment, this atmospheric studio portrait draws out the character of the sitter.

generated by using a dome-shaped silver reflector with the flash head. Soft light is used to convey delicate, sensitive subjects without harsh shadows. Two light modifiers can be used for this effect, the softbox and the umbrella, and both work by diffusing hard light sources. If neither of these is available, a similar effect can be achieved by bouncing flash off a large sheet of white card, a nearby wall, or a ceiling.

>>CONTRAST

Areas of light and shadow in the studio are created by using two lights or a single light and a reflector. Better flash units have a variable power output, so you can use it to lighten up shadows or a background. If no such controls exist, flash intensity can be controlled by moving the unit nearer or further away from the main subject. Photographers have their favorite lighting set-ups, honed after much experience.

Creating a diffused quality of light, this large soft box is an ideal tool for studio portraiture.

→ GARDEN PHOTOGRAPHY

TAKING PHOTOGRAPHS IS A GREAT WAY TO RECORD SHORT-LIVED BLOOMS, AND EPHEMERAL STILL LIFE CONTINUES TO FASCINATE THE WORLD'S BEST PHOTOGRAPHERS

A busy, colorful composition of contrasting orange and blue flowers found in a border of bedding plants makes an attractive garden shot.

»EQUIPMENT AND TECHNIQUES

To capture the delicate beauty of a flower, close-focusing technique is the key, with a macro lens, extension tubes, or close-up filters. Shooting up close needs a steady grip, so a stable, portable tripod is essential for shooting on location, along with a cable release to avoid camera shake. Lightweight Bembo tripods are ideal for photographers who don't want to be weighed down by a heavy rucksack. In addition to your camera kit, a home-made gadgets will make your job a lot easier: a large piece of white card slotted into a split garden cane can work as a combined reflector and mini wind-break and can be stuck into the soil when needed. Even the slightest sway caused by wind will blur a close-focused subject.

»MAKE YOUR OWN LUCK

There's little point in hunting high and low for the perfect floral still life situation, it's easier to create them yourself. A good idea is to use a block of florists' oasis to hold up cut flowers that are too inaccessible or difficult to shoot in their natural habitat. Working in this way, you can reposition your subject in front of a more sympathetic background and nearer to your camera to make life easier. For an atmospheric effect, use a fine plant sprayer filled with water to mimic the effect of morning dew.

»PICTURE IDEAS

Tried-and-tested picture formulas may sound like a cliché, but will result in unique photographic records of your garden. For shooting single blooms, fill your viewfinder with one centrally placed example and change your aperture to its widest setting, f/2.8 for example, to blur

A formal garden offers the chance to experiment with different types of composition, and to try out the infinity function on your camera.

the background. Look for a complementary or negative color background as this will help to place even more emphasis on your subject. Don't restrict yourself to plant life, but include garden features in your photos; they will add much-needed texture and sense of scale to your work. Try shooting from under the canopy of a tree or a climbing rose and use the overhanging foliage to 'frame' your subject and emphasize a garden's pictorial qualities. This is a great technique to counteract distracting background elements like telegraph poles, TV aerials, or even a dull, gray sky.

≫A GARDEN JOURNAL

Gardens change color and emphasis almost weekly so a good idea is to shoot throughout the seasons to create a photographic journal. Start at the beginning of the season and take pictures to record emerging flowers and color. Note the date and the names of the flowers in bloom in an album. This will make a lovely journal for you to enjoy. Seasonal lighting and color temperature can show the same elements very differently.

Single blooms look sharper, and more impressive, if shot with a wide aperture and shallow depth of field.

→ HUMOR AND OBSERVATION

PHOTOGRAPHY HAS THE ABILITY TO USE VISUAL GAGS TO PRODUCE HUMOROUS IMAGES, AND IT IS AN AREA THAT IS RIPE FOR EXPLOITATION

A mixture of deadpan humor and poignancy is captured in this enduring, quirky image.

»PHOTOGRAPHY AND SURREALISM

Surrealist artists such as René Magritte were very influenced by the ability of photography to capture the incongruous. Although working well before the start of the Surrealist movement, French photographer Eugene Atget made his quiet and personal study of the oddities of the backstreets of Paris. Shop windows, reflections, and unexpectedly posed mannequins suggested a twilight city moving slowly into the uncertainty of the modern twentieth century. Surrealist artists made a career of juxtaposing the unfamiliar alongside one another within the confines of a painting, but photography is as much about what's left out of the frame. In addition to the self-explanatory visual puns, other photographers, such as Henri Cartier-Bresson, developed their own unique observational style based on the chance meeting of unexpected shapes, objects, and people in front of unusual backdrops.

›› OBSERVATIONAL THEMES

Many photographers have based their working life in the pursuit of a visual theme such as light, translucence, or color. Like an abstract painter investigating a limited series of shapes and textures, many photographers find enough interest in a small subject area to develop a body of work rich in variation and experimentation.

›› ODD COUPLES

Within the confines of the viewfinder, things which are not normally associated can be frozen and framed together for posterity. Just like the best sport and action images, humorous connections can be found in everyday life, but only last for an instant. This kind of photography is only possible if you are prepared with a portable camera, easy controls, and multipurpose film. Most professional photographers with aspirations of exhibiting their personal work always carry a top-quality compact for such an occasion. Olympus and Minox make very compact 35mm cameras that can be slipped in a top pocket and placed into action within an instant. Many top-quality compacts have zone focus lenses and do not require the additional delay to pull sharp focus on a transient event.

Shot with a long lens, this kind of observational photograph can be captured at any seaside location.

›› LANGUAGE AND SYMBOLS

Words and street signs can easily be framed out of context and used for humorous effect. Street grafitti, decay, and the opportunist vandal provide rich pickings for those with a keen eye. It can be hard to see familiar surroundings in a different light, but many situations can look quite different within the confines of the picture frame.

›› DIGITAL FABRICATION

With all the possibilities afforded by digital manipulation, there are endless opportunities to make seemingly truthful scenarios by combining one or more original images. Skilled montage work can hide all traces of cutting and pasting and, combined with good color correction, can result in spectacular lies. The best digital fabrications are made from high-resolution originals, where plenty of detail and subtle color can survive the digital knife.

At first glance, this image is nothing out of the ordinary, but closer examination reveals a model village rather than a real apartment block.

Statues and memorials offer rich pickings for the sharp-eyed photographer.

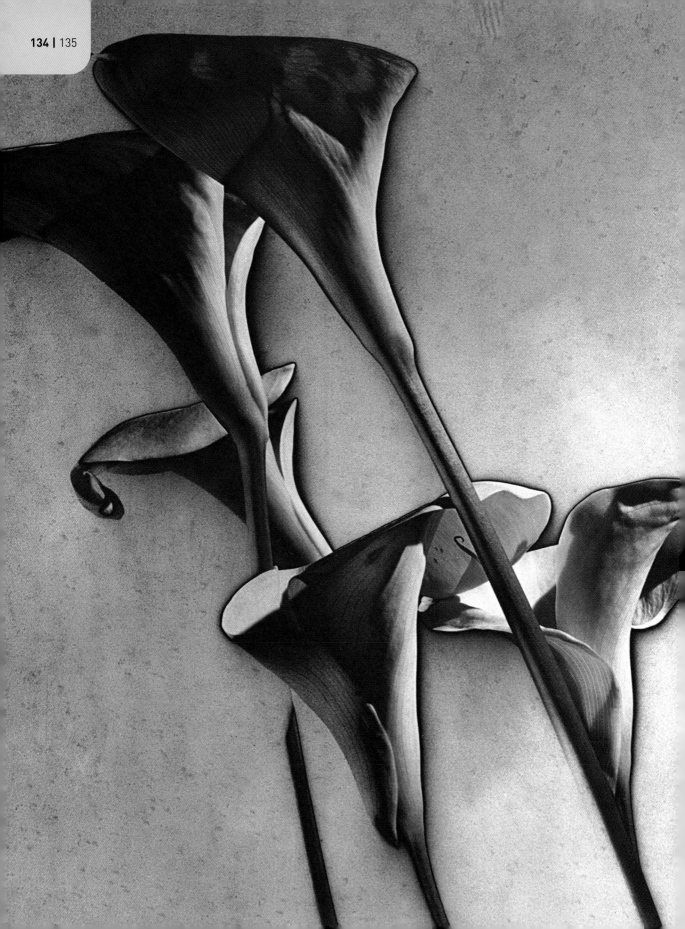

→ HISTORY

→ **EARLY OPTICAL DEVICES**

CAMERA-LIKE DEVICES FOR VIEWING THE WORLD HAVE BEEN USED BY ARTISTS AND SCHOLARS SINCE THE TENTH CENTURY

Science and Society Picture Library

A simple optical aid for drawing, the camera lucida was one of many optical devices to precede photography.

The camera obscura was used by many artists as an artificial aid to drawing and perspective control and worked by a very simple principle. A darkened room or box had a tiny hole cut into one side which projected an image of the outside world onto the opposite wall. The image was faint and upside down, as light travels in straight lines, but the camera obscura became much used by leading artists of the day. Leonardo da Vinci was much impressed by the device and included clear descriptions of it in his writings. Like a latter day pinhole camera, these early optical devices made better quality images when the hole, or aperture was tiny.

When lenses were developed for making the image sharper and clearer, the camera obscura took hold as a popular instrument for drawing. They varied in size starting at the enormous portable studio, frequently on wheels so the artist could be pushed out on location by his servants. Smaller and more portable devices developed with better optics were much favored by the Dutch artist Vermeer. Yet, despite the obvious advantages, many artists were reluctant to be identified as camera obscura users because it was thought to be a mechanical rather than an artistic skill.

When Fox Talbot bought his first camera obscura as an aid to sketching on location, he was fascinated by the appearance of the projected and temporary image. Driven to make permanent this fleeting apparition, Fox Talbot embarked on a series of chemical experiments to 'fix' a camera obscura image onto sensitized paper. These cameras had come a long way since the large-scale

devices used by artists, and Fox Talbot developed a miniaturized and portable version.

The camera lucida was an altogether later invention, patented by William Wollaston in 1807. The lucida was constructed out of a tiny prism attached to a rod, which in turn was fixed to a drawing board. When a sheet of paper was attached to the board and the artist squinted through the prism, a faint outline of the scene became visible at the same time. The artist then would simply trace

the image on to the paper. Useful for estimating perspective, the camera lucida became much used in the nineteenth century by artists out on location.

For Fox Talbot, both of these devices sparked off an interest in mechanical image-making and, as such, are forerunners to all modern camera designs.

Plate taken from the book *Ars Magna Lucis et Umbrae* by Athanasius Kircher, published in 1646. Kircher demonstrated that by placing a lens between a screen and a mirror which had been written on, a sharp but inverted image of the text would appear on the screen.

→ LOUIS JACQUES MONDE DAGUERRE (1787—1851)

INVENTOR OF THE FIRST PHOTOGRAPHIC PROCESS MADE AVAILABLE TO THE GENERAL PUBLIC, DAGUERRE'S LEGACY REMAINED WELL IN USE UNTIL THE 1850s

Limited in range and impossible to use for capturing transitory subjects, the daguerreotype offered an image quality far superior to Fox Talbot's prints made from paper negatives. Exposed directly on a silver-coated copper plate, it produced a laterally reversed image which was very vulnerable to physical damage unless carefully handled. Daguerre's patent reached across the world and became the basis of the leading portrait studios in the most fashionable towns. Physically the same size as miniature paintings, the daguerrotype portrait was encased into a protective glass and fabric mount and often kept inside a velvet lined case. Daguerreotypes needed to be viewed over a dark background, or the silver surface appeared negative. Daguerreotypes from America were the finest ever produced, with a highly polished surface and exceptionally clear image quality. Many later examples were further embellished by the addition of delicate hand coloring.

»TOOLS AND TECHNIQUES

The daguerreotype was a unique process in the history of photography and produced a direct positive image. Compared to Fox Talbot's process in the emerging year of 1839, the daguerreotype exposure could range from fifteen to thirty minutes, although this decreased to under a minute with some improvements. Once exposed onto a sensitized and polished sheet, the plate was developed over the fumes of heated mercury.

An American hand-tinted daguerreotype from the 1840s.

Science and Society Picture Library

→ WILLIAM HENRY FOX TALBOT (1800—1877)

THE INVENTOR OF THE NEGATIVE-POSITIVE PROCESS, WILLIAM HENRY FOX TALBOT WAS A MAN OF MANY TALENTS

Distracted in equal measures by the lure of science and art, Fox Talbot worked for many years until finding a recipe for fixing light. Transitory photographic processes, which never stood the test of time, had been well publicized over the previous 15 years, but it wasn't until Talbot discovered a more stable recipe based on silver salts that permanent photography really became possible. A forerunner to Talbot's camera calotype process was his early photogenic drawings, small and intimate contact prints made inside a printing out frame, without the use of a camera. Talbot's original term did indeed hint at his uncertainty as to whether the prints were mechanical or drawn by hand. By the early 1840s Talbot had patented his process and begun work on an idiosyncratic publishing project called *The Pencil of Nature*. Offered in parts over a two year period, *The Pencil of Nature* was an odd collection of Fox Talbot's diversions including Parisian

street scenes, shelves of pottery, copies of other artists works, and several views of his family estate at Lacock Abbey in England.

»TOOLS AND TECHNIQUES

The calotype process was inexpensive, based on paper negatives coated with light-sensitive emulsion. Positive images were produced by contact-printing negatives with an identically coated sheet of paper. Calotypes were easy to prepare and required little special equipment or technique. A later development found that waxed paper calotypes offered an improved sharpness and clarity.

Lattice window in Lacock Abbey, 1835
The earliest surviving camera negative showing the window of the photographer's home. Nearly 200 individual panes of glass could be counted from this tiny, coarse specimen.

Science and Society Picture Library

→ HILL AND ADAMSON

(1843—1847)

THE PERFECT PARTNERSHIP BETWEEN ARTIST AND TECHNICIAN, THE SHORT-LIVED CAREER OF EDINBURGH'S EMINENT HILL AND ADAMSON PRODUCED GROUND-BREAKING PORTRAITS

Right at the dawn of the photorgaphic medium emerged artist David Octavius Hill and Robert Adamson, a young man with extensive family connections to the leading scientific brains of the day. Forged into a collaborative partnership where one provided the technical expertize and the other the artistic input, Hill and Adamson worked for a mere four years before Adamson's untimely death in 1848. Over that time however, both refined an unusually rich photographic approach,

more remarkable due to the limitations of Fox Talbot's calotype process. With deep contrasts and subtle use of light and dark, Hill and Adamson photographed the leading players of Scottish society of the time and through their technique bestowed authority, leadership, and power on their sitters. Like rough-hewn drawings with light, the calotypes of Hill and Adamson encapsulate a cross-section of Scottish society that represent the unique achievements of that era.

»TOOLS AND TECHNIQUES

The calotype was the cruder of the two early photographic processes, leading to a rough and fibrous texture compared to the pin-sharp Daguerrotype. Yet despite this, Hill and Adamson's prints offered a painterly feel, likened by many to Rembrandt. At this stage of photography, exposure times were painfully slow and the gritty texture of the calotype print drew a veil over pin-sharp detail.

Portrait of an old man thinking (1843-1848) Calotype.

Science and Society Picture Library

→ CARTE DE VISTE

(1850s—1900)

THE FIRST TRULY POPULAR FORM OF PHOTOGRAPHY TO APPEAL TO THE GENERAL PUBLIC WAS THE CARTE DE VISITE

With many commercial photographic portrait studios opening across the UK, Europe, and the US, the carte de visite was an affordable way of having one's likeness captured. Starting in the 1860s, and appealing very much to the bourgeois family, the carte de visite was a credit-card sized portrait that was intended as a calling card. More often collected and exchanged with other families of the time, carte de visites were mass-produced by entrepreneurial studios, where bulk orders for reprints were commonplace. The better photographers of this genre, including Camille Silvy, developed a considerable reputation and commanded fees to match. Each photographer used stock-in-trade backgrounds and sets to offer each family the opportunity to be seen in exactly the right social context. Despite the mass-produced nature of the art form, many carte de visites were exquisitely conceived and thousands survive today. Collected into albums and bound with elaborate decorative mounting, the form survived until the turn of the century and the revolution of the do-it-yourself Box Brownie.

»TOOLS AND TECHNIQUES

Individual portraits were repeatedly exposed on the same light-sensitive plate, to maximize the photographers' profit margin and speed up the laborious process of changing plates. Largely replaced by the larger Cabinet photograph in the late 1860s.

Coated on tin, the Ferrotype was another mass-market portrait format, often mounted in highly decorated cards.

Carte de visite by Camille Silvy, 1866. Silvy was the leading exponent of the format in his day.

→ JOHN THOMPSON

(1837—1921)

LIKE MANY PIONEERING TRAVEL WRITERS, THOMPSON SOUGHT OUT TO CHRONICLE THE EXOTIC IN THE FURTHEST CORNERS OF THE GLOBE

A member of The Royal Geographic Society, Thompson set out to find hidden treasures in the undeveloped world. He travelled to Cambodia and China, returning with sets of images that classified and recorded the unfamiliar customs in an alien cultural landscape. Like the survey photographer Carleton Watkins, Thompson envisaged his work not as a noble gift to advance our social understanding of other cultures, but in a purely promotional light. Designed to encourage those involved in foreign commerce, Thompson's travel photography was annotated with his observations of the intricacies of foreign customs. Like August Sander who later compiled his directory of German social class, Thompson saw photography as the great tool for collecting specimens for learned discussion. Later in his career, Thompson turned his camera closer to home and photographed London streets and the street life of the downtrodden. Skilled in the discovery of rogues and characters, Thompson published his findings in a book, *Street Life in London*, made all the more sensational to his middle-class audience with apt captions and descriptions of his subjects.

»TOOLS AND TECHNIQUES

John Thompson took advantage of recent developments in photographic technology which offered smaller and more portable cameras, ideal for the restless traveller. Roll film was introduced in the 1870s, allowing photographers to discard their tripods and become truly portable.

The Island Pagoda, 1873. Plate 19 from 'Foochow and the River Min', an album of photographs published in 1873

National Museum of Photography, Film & Television

→ HENRY PEACH ROBINSON

(1830—1901)

PREDATING THE ART OF DIGITAL MONTAGE BY 140 YEARS, PEACH ROBINSON'S WORK WAS CONSTRUCTED FROM MANY DIFFERENT SOURCE IMAGES

Much inspired by the English Pre-Raphaelites and sharing many of their themes, Henry Peach Robinson saw himself in the same vein as John Everett Millais and William Holman Hunt. Seeing photography as the only medium fit to exercise his considerable imagination, Peach Robinson found that straight photography, like the emerging Impressionist movement did not show the world as he wanted. Driven by the same obsession for detail as the Pre-Raphaelites, Peach Robinson's early work saw him interpret familiar subjects like the Lady of Shallot, drawing heavily on the Millais painting of the same title. Yet Peach Robinson, who is best remembered for his composite prints, manufactured the most elaborate scenes from many different negatives. Working in an already unfashionable mode after other exponents of the composite like Oscar Reijlander, Peach Robinson's single-mindedness drove him to produce work of increasing complexity. Working on a large scale, his work was designed with a cast of actor-models, carefully chosen costum,e and deliberate backgrounds. Nothing in his work is of an accidental nature, and photography was employed for its mechanical and convincing qualities of reproduction.

›› TOOLS AND TECHNIQUES

Working with large-scale glass negatives, Peach Robinson's complex images were a technical *tour de force*. In the era before the photographic enlargement, glass negatives were printed by direct contact with light-sensitive paper. At a great scale compared to the miniaturized roll films that would revolutionize photography, large glass negatives could be worked on by hand like an artist's printing plate.

Fading Away, albumen print, 1858.

Science and Society Picture Library

→ JULIA MARGARET CAMERON

(1815—1879)

ONE OF MOST SIGNIFICANT PHOTOGRAPHERS IN THE EARLY
HISTORY OF THE MEDIUM, JULIA MARGARET CAMERON
QUICKLY DEVELOPED HER OWN UNIQUE APPROACH

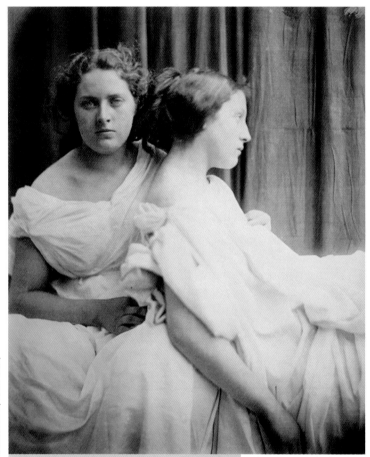

Science & Society Picture Library

Elgin Marbles (second version), 1867.
Portrait of Cyllma Wilson and Mary Ann Hillier.

A remarkable amateur photographer who only picked up the medium at the age of 48, Julia Margaret Cameron established an isolated and self-determined approach in her home in the Isle of Wight, England. Using allegorical tales as a starting point, Cameron photographed her inner circle of prominent friends, family, and house servants. With a simplicity that stripped away the elaborate façade of contemporary studio photography, Cameron was not concerned with capturing likeness or conveying character, but transforming her subjects into another plane. Darwin, Dickens, and Tennyson were visitors and participants in her creations, where the ability of photography to convey time, place, and context was placed firmly on hold. Fixed in a dreamlike state emerging from dark, mysterious backgrounds, her portraits evoke a literary world far removed from reality. Cameron's work was very much undervalued by photography critics until the latter half of the twentieth century, discriminating and disparaging of a female photographer working well outside the dominant genres of her day.

»TOOLS AND TECHNIQUES

Cameron was often derided by male counterparts in their self-interested photography societies, for her total lack of interest in fine-focus technique. Yet with her soft-focused approach, Cameron was investigating an important facet of photography called 'selective emphasis', and contrary to their belief, developed a great deal of expertise in the wet colloidion process.

→ EADWEARD MUYBRIDGE

(1830—1904)

THE FIRST PHOTOGRAPHER TO EXAMINE THE MOVEMENT OF MAN, MUYBRIDGE'S EXPERIMENTS CONTRIBUTED TO THE DEVELOPMENT OF THE MOTION PICTURE.

Obsessed by discovering the exact process of movement by sequential photography, Muybridge is best known for his ground-breaking 'Animal Locomotion' (1887) series. Belonging to an era where both art and science colluded with the new photographic technology, Muybridge's work was published to a hungry public. Just like a print made from a strip of motion picture film, each frame captured an individual slice of movement, separated from the next shot in the sequence by a time delay. Unlike any other form of visual statement, Muybridge's sequential images are the first mechanical artwork to describe the passing of time, albeit in freeze frame. Despite the serious nature of his pursuits, Muybridge chose curiously personal combinations of subject matter, such as this study of a naked man astride a galloping horse. Muybridge's early photographic career saw him working in California alongside Carleton Watkins as a landscapist. In many experiments Muybridge shot individual plates around a 360° panorama, presenting them joined together in sequence to create valuable records of pre-earthquake cityscapes.

»TOOLS AND TECHNIQUES

Shot in specially developed environments where moving subjects triggered a line of camera shutters by a simple trip wire, Muybridge developed his own curious ways of representing movement through a sequence of prints shown side by side. Shot against gridded backgrounds, his process was also the forerunner to photometry.

The Amble, 1887. Plate 590 from Muybridge's 'Animal Locomotion' (1887), showing a nude male rider on a gray horse.

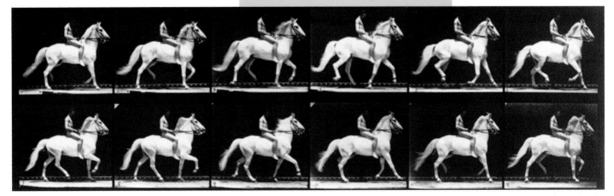

National Museum of Photography, Film & Television/ Science & Society Picture Library

→ CARLETON WATKINS

(1829—1916)

CAPTURING THE DRAMATIC GEOLOGY OF THE CALIFORNIAN LANDSCAPE LONG BEFORE ANSEL ADAMS, WATKINS' IMAGES OFFER A STRIKING PERSPECTIVE ON THE NATURAL WORLD

Just 20 years after the invention of photography, the apochryphal Californian landscape of the Sierra Nevada, and the Yosemite valley in particular, offered photographers the chance to explore a world like no other. Working as a government-sponsored survey photographer, commissioned to make accurate photographic records of the terrain, Watkins travelled and collected scenes across the west. A forerunner to Ansel Adams, sharing both subject matter and working on a similar scale, the best work of Watkins offered a vision of the raw, uncut land before it was harnessed by the white pioneers. Silent, awesome, and still able to take your breath away, these

enormous landscape studies describe Yosemite as one of the wonders of the natural world. With much of his attention drawn to viewpoint, Watkins' work developed photography's ability to encapsulate the scope and enormity of a scene within one single frame. Briefed to produce images that would be of use to future railroad planners and surveyors, Watkins photography had a functional rather than a solely artistic purpose and helped to map out the wilderness for speculating entrepeneurs.

»TOOLS AND TECHNIQUES
Watkins took many of his images with a camera which used gigantic 46x53cm film plates, which offered the chance to print images with very fine detail.

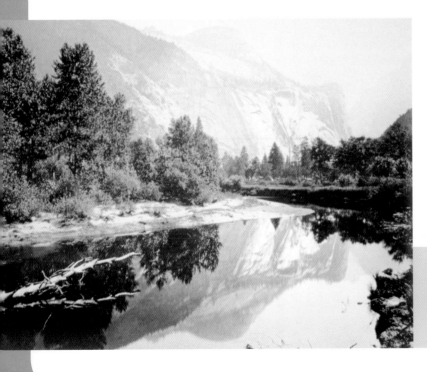

Stream and trees with mountains in background, Yosemite National Park, California, 1865.

→ PETER HENRY EMERSON

(1856—1936)

THE CHRONICLER OF ENGLISH EAST-ANGLIAN LIFE, EMERSON DEVELOPED THE ART OF PHOTOGRAPHY THROUGH A SERIES OF IMPORTANT BOOKS

An intellectual heavyweight, Emerson carved a path to photography through the sciences like many of his contemporaries. Fixated with preserving the disappearing life on the Norfolk Broads on the east coast of England, Emerson used his camera to reinforce and illustrate his own beliefs, rather than as an objective recording tool. Seen as the last great wilderness of the British Isles, Norfolk was a symbol of a simpler—and in some respects—desirable peasant life, where honorable pursuits like reed cutting, hunting, and fishing were still very much alive. Emerson's work owes much to painters such as Millet, who saw the noble peasant as a suitable subject to exercise his considerable talents upon. Not satisfied with recording single, isolated studies, Emerson organized his work into eight books and embellished his visual studies with his own writings. *Pictures of East Anglian Life*, *Life and Landscape of the Norfolk Broads* are the better known titles, but it is the later books like *Marsh Leaves* and *On English Lagoons* which offered a more lyrical and symbolic view of the fragile land.

»TOOLS AND TECHNIQUES

Emerson's finely crafted images were reproduced as platinotypes and sold as portfolios, but his major contribution came in the form of the photographic book. Emerging as an important medium, the photographic book contained high-quality reproductions using the photogravure printing process, capable of generating the same subtle tones found in silver emulsion prints.

Reed Cutters Return Home, 1887.

→ **EDWARD WESTON**

(1886—1958)

INSPIRED BY NATURE, WESTON'S WORK SOUGHT TO CAPTURE THE VERY ESSENCE OF THE WORLD AROUND HIM

From Weston's 'Nude' series.

Remembered as the leading modernist photographer of his generation, Weston set himself apart from the romanticized Photo Secessionists and used the innate characteristics of straight photography to render his subjects. Founder member of the f64 group of photographers with Ansel Adams, a meeting of like minds keen to develop photography's own language, Weston also wrote about the practice of his art in a series of day books. His images are characterized by ultra-sharp focus, frequently using minimum aperture values to render everything in the picture frame at its maximum, Weston omitted nothing. His philosophical position was to use the camera's 'innate honesty' to capture the defining angle, and very substance of his subjects, distancing himself from the pictorial and soft-focus photographers of the previous generation. His favorite subjects were found in Mexico, but he approached a disparate range of themes— capsicums, rocks, and nudes—with the same enquiring eye. Despite his lifelong search for perfect subject matter, Weston's landscape work leaves us with a vision of a remote, unspoilt America, untouched by the pioneers and the twentieth century.

»TOOLS AND TECHNIQUES

Using a plate camera and the finest emulsions of the day, Weston's images are a graceful exploration of tone and sharpness. Like Adams, Weston's prints are hyper real, displaying simultaneous detail far in excess of the human eye's ability.

→ LEWIS WICKES HINE

(1874—1940)

THE FOUNDER OF SOCIAL DOCUMENTARY, HINE'S PHOTOGRAPHS WERE INSTRUMENTAL IN PROVOKING REAL SOCIAL CHANGE

At the beginning of the twentieth century, America was hiding many abuses of human rights from the glare of the camera lens. Trained initially as a sociologist, Hine used his photography to campaign for better rights for child workers. Operating under the auspices of the National Child Labor Committee, as a government sponsored investigator of social conditions, Hine worked tirelessly to capture the truth behind the scenes, despite strong opposition.

Hine's work for the NCLC captured child labour in a variety of circumstances including street traders, mills, glass factories, agriculture, and cannery businesses. Without sentiment, Hine's images capture the brutality of child labor and provided strong evidence for change.

Hine is also remembered for documenting the construction of the Empire State Building, working fearlessly at height to shoot the gangs of fleet-footed workers building one of Manhattan's great symbols.

›› TOOLS AND TECHNIQUES

Despite working undercover, Hine was restricted by a field camera and sheet film, making quick-fire shooting an impossibility. Yet despite this, his work carries a sensitivity and respect for his subjects.

Francis Lance, newspaper vendor, full-length portrait in profile, holding newspapers, May, 1910.

WEBSITE
A substantial collection of Hine's work is held at the US Library of Congress and available for online viewing at www.loc.gov.

http://

→ AUGUST SANDER

(1876—1964)

LIKE EUGENE ATGET, SANDER WAS A COLLECTOR ON A GRAND SCALE, BUT OF PEOPLE AND TYPES OF ALL SOCIAL STRATA

Working in Cologne as a successful commercial portrait and industrial photographer, Sander embarked on a number of personal projects that remain controversial and much-discussed to this day. With a keen mind for classification and organization, Sander set about his Face of our Time project. Capturing an evolving Germany between the wars, Sander sought to document people from all classes and careers. Yet unlike Eugene Atget's largely neutral stance to his subjects, Sander's own thoughts on race and the development of society runs as an undercurrent throughout the work. Yet, when the National Socialist movement's own ideas on ethnicity allowed no room for Sander's opinions, his books were seized and destroyed. Setting each of his sitters within an environment that helped to set their class or career in context, Sander claimed that his approach allowed subjects to reveal more of their innate character. His most innovative work was in the field of the double portrait, where additional layers of tension can be seen between the couple captured within his frame.

»TOOLS AND TECHNIQUES

Using the large-format view camera, Sander's work was deliberate and paced left nothing to chance. Often shooting under challenging lighting conditions, the photographer was able to conjure a skilful response in many different environments.

The Intellectual.

→ JOSEF SUDEK

(1896—1976)

INTERPRETING RECURRING SUBJECT MATTER LIKE A MUSICIAN REVISITS A SCORE, SUDEK'S WORK SAT OUTSIDE THE GENRES SHARED BY HIS CONTEMPORARIES

Intimate and evocative describe the highly personal work of Josef Sudek, the quiet Czech photographer who lost his arm in the First World War. Working in his beloved Prague, much like Atget wandered the streets of Paris, Sudek revelled in capturing the fragile. Sudek was sustained by his love of music, provoking him to work on his 'Labyrinth' series, where images were produced in direct response to music or reading a profound passage of literature. Simple materials, such as flowers, paper, and egg shells, were used by Sudek to reveal great richness. Working in a dreamy existence in his small photographic studio, Sudek's poetic approach to image-making is now much acknowledged by contemporary photographers, keen to move away from realism, and the obvious. Shooting always in a small and understated way, Sudek revisited favorite subjects like a glass of water and the street scene through the window of his studio, each time with a fresh eye. Working with the fragile pigment process, the final prints themselves became as precious as the subjects themselves, and pushed photography away from the mechanical and mass-produced.

❯❯TOOLS AND TECHNIQUES

Very influenced by the lure of vintage print processes, and much out of fashion, Sudek used the carbon tissue process to create his characteristic warm, hand-made prints. Coated onto ivory writing paper, Sudek's images evoke the pictorial style with a modernist feel.

Bread and Egg, 1950.

→ ALFRED STEIGLITZ

(1864—1946)

SUSTAINED BY HIS AWE OF THE NATURAL WORLD, ALFRED STEIGLITZ DEVELOPED PHOTOGRAPHY AS A REFLECTIVE AND CONTEMPLATIVE ART FORM

Set firmly within a pictorial background and one of the leaders in American photographic circles in the early twentieth century, Steiglitz ran his own gallery and forged links with a group of like-minded photographers. Promoting photography as an art form in its own right, Steiglitz and associates, such as Steichen and Frank Eugene, saw themselves very much as official interpretors of natural beauty. Throughout his creative life, Steiglitz was drawn to the observation of nature and natural things, made available to the wider world through the legendary *Camera Work* publications. Driven with a deep respect

for the underlying forces of nature, Steiglitz embarked on a series of cloudscapes, which he called 'Equivalents'. Printed as tiny hand-crafted celebrations of the variations and infinite possibilities of a subject which was freely available to all, Steiglitz saw his type of photography as transcending the mere documentary. Subject matter was deemed secondary to the observation of underlying natural harmonies with Steiglitz orchestrating these forces into a coherent piece. In addition to his 'Equivalents', he also developed a series called 'Songs of the Sky', intended as a more direct allusion to the almost musical flow of nature's rhythms.

»TOOLS AND TECHNIQUES

Steiglitz' work was set very much within the craft of traditional hand-rendered darkroom printing, where images were embellished and burnished with toners, fine papers, and luxurious emulsions.

Georgia O'Keefe: A Portrait, Hands with Thimble.

→ EDWARD STEICHEN

(1879—1973)

VERY MUCH A PAINTER TURNED PHOTOGRAPHER, STEICHEN'S BEST WORK DEMONSTRATES A SOPHISTICATED UNDERSTANDING OF LIGHT

Part of the Photo Secession club organized and promoted by Alfred Steiglitz, Edward Steichen was a master photographer of people. Associating himself firmly with the dominant French painters of his generation, Steichen's sensitive studies celebrated the exquisiteness of the human form, like Rodin's sculpture in two dimensions. Unconcerned with making accurate representations of his subjects in favor of a more interpretive angle, his work is more like embellished life drawing than reality. In his later career, Steichen became a much sought-after portrait photographer, where his sophisticated production values and sense of style were very much in favor. With a skilful understanding of shape, line, and composition, Steichen's later portraits document the changing world of the 1920s, where sleek modernist values replace the misty romantic. In his exquisite portrait of Noel Coward, Steichen uses light and shadow to develop a mysterious shroud around his subject and places an Egyptian cat in the top right corner to counterbalance. Other portraits at this time record the elegant lines of Modernist design and the most influential artists, writers, and designers of the day.

»TOOLS AND TECHNIQUES

Steichen used advanced printing techniques to separate his work from mechanical, mass-produced photography. Employing gum bichromate and the platinum processes, the photographer developed a much more hand-rendered effect, closer to artists' etching than to photography.

Noel Coward Smoking Cigarette, 1932.

→ ROBERT CAPA

(1913—1954)

ROBERT CAPA IS SAID TO HAVE TAKEN HIS CAMERA 'FARTHER INTO THE FIGHTING ZONE THAN HAS EVER BEEN DONE BEFORE', TO RECORD THE GRIM REALITY OF CONFLICT, EXILE, AND DEATH

A risk-taker, carouser, and terrible driver, Robert Capa was also dedicated, passionate, and hailed by the *Picture Post* in 1938, to be the 'Greatest War Photographer in the World'. Indeed, Robert Capa's life was moulded by war, but he despised it.

Born Andre Friedman, a Jew from Budapest, he studied political science in Berlin while working for a picture agency, to whom he sold his first photograph. Driven out of the country by the Nazis in 1933, he settled in Paris, where he met the love of his life, journalist and photographer Gerda Taro. Between them they invented a persona for Friedman— the fabulously rich American Robert Capa, and successfully sold his prints under that name.

Capa's coverage of the Spanish Civil War appeared regularly in *Vu*, *Regards*, and *Life*. His picture of a Loyalist soldier falling in combat brought him an international reputation, and it became a powerful symbol of war.

After Gerda was killed in Spain, a devastated Capa travelled to China, and then to New York in 1939. He photographed some of the major events during World War II, most famously the D-Day landing at Omaha beach.

In 1947 he founded Magnum Photos with Henri Cartier-Bresson, David Seymour, George Rodger, and William Vandivert. The next few years saw Capa travel far and wide with his camera—to Russia with John Steinbeck, and to Israel with Irwin Shaw.

Despite his determination to give up war photography, Capa accepted one final commission for *Life* to document the conflict in Indochina. On May 25, 1954, he died after stepping on a land mine, camera in hand.

In honor of Capa's life and inspiring legacy, the Robert Capa Award was established in 1955 to reward 'superlative photography requiring exceptional courage and enterprise abroad'.

»TOOLS AND TECHNIQUES

Capa said, "If your pictures aren't good enough, you're not close enough." His formula was simple—to take his 35mm camera into the thick of the action and photograph his subjects up close.

Barcelona. General mobilization of all men under the age of 50 as General Franco's troops rapidly approach the city. January, 1939.

→ **PAUL STRAND**

(1890—1976)

WITH A CAREER SPANNING SEVERAL GENRES OF PHOTOGRAPHIC PRACTICE, STRAND DEVELOPED HIS OWN UNIQUE WAY OF COMPOSING THE WORLD AROUND HIM

Connected to the other modernist photographers with his awe of the natural world, Paul Strand's work differs in his ability to juggle his subjects into sophisticated and virtuoso displays of composition. With a precise understanding of how to subdivide the rectangular picture frame, Strand's best work presents the cultural landscape as a series of finely honed and satisfying images. Challenging all previous methods of composition, which was based on 400 years of Western painting, Strand's work was inventive and exciting to look at. In a career which included working as a film cameraman, Strand travelled extensively and developed his unique way of seeing. Like Steiglitz, Strand saw photography's ability to describe the photographer's conceptual intentions alongside a subject's innate beauty, as a way of expressing his own personal ideas about the world. Like many abstract painters of the day, Strand sought to dispense with traditional three dimensional space, favoring flatter subject matter which allowed him to investigate pattern, texture, and the infinite nuances of nature.

>>**TOOLS AND TECHNIQUES**
Not exclusively limited to one particular format or print style, Strand's work is recognizable by his clever division of the picture frame. His later documentary work, best typified by a series taken in small Italian villages, demonstrate his ability to incorporate people into his compositional exercises.

Wall Street, 1915.

→ ANDRE KERTESZ

(1894—1985)

STARTING OFF AS A PHOTOJOURNALIST IN THE 1920s, KERTESZ DEVELOPED AN ABILITY TO SEE BEYOND THE OBVIOUS

A master of observation, the Hungarian-born photographer Andre Kertesz worked in Paris for the ground breaking *Vu* magazine, a photo-illustrated weekly that paved the way for *Picture Post* and *Life*. At that time, photojournalism was stuck in the somewhat staid tradition of the photo story where striking individual images were of secondary importance to an interrelated set. Yet Kertesz contributed an extra dimension to this genre: single, stand-alone photographs that celebrated his observational wit. With a keen eye for structure and design, Kertesz confirmed photography's ability to juxtapose odd bedfellows and make permanent the most transitory of visual coincidences. In short, Kertesz developed a way of seeing that went beyond summary description, but instead invented an observational style that dug deeper. Using the street as his subject, Kertesz saw and froze unexpected collisions with prankish humor which showed his youthful disrespect for the fading establishment. Like Paul Strand, Kertesz used photography's innate powers to re-frame and reinterpret a subject like no other medium could.

»TOOLS AND TECHNIQUES

Using the small format 35mm camera such as the Leica, Kertesz was able to shoot quickly and move without burden. This ability to respond to opportunities which presented themselves in a fleeting moment enabled Kertesz to develop his own unique brand of photographic observation. Armed with the newly invented portable 35mm camera, realism was now the flavor of the moment.

Chez Mondrian, 1926.

→ **MAN RAY**

(1890—1976)

AN INSTRUMENTAL FORCE IN THE SURREALISM MOVEMENT, MAN RAY DEVELOPED A REFRESHINGLY EXPERIMENTAL APPROACH TO PHOTOGRAPHY

Photography was only one facet of Man Ray's creative output, but his interest in pushing the boundaries was evident from the start. His work included sophisticated portraits of glamorous photographer Lee Miller and the leading intellectuals and artists of the day. Man Ray was not afraid to relegate the formal craft of photography to a minor role in an artwork if he felt collage or drawing on the print would add something extra. With a Surrealist eye for unexpected combinations, Man Ray also experimented with simple but mysterious photograms, cameraless images made by placing objects over light-sensitive paper— a body of work called Rayographs. Man Ray was also influenced by the graphic work of Russian Constructivist photographers such as Alexander Rodchenko. Throughout his career, Man Ray remained obtuse about his photographic technique, but his most innovative contribution, the Sabattier technique is almost impossible to reproduce with today's high-speed, light-sensitive materials.

››TOOLS AND TECHNIQUES

Man Ray's technique for creating a combination of negative and positive in the same print has become known as the Sabattier technique. Secretive, and unwilling to discuss his precise methods of making the thick 'mackie' lines around his portraits and still-life subjects, his images became shrouded in mystery.

Gypsy, 1935.

→ WALKER EVANS

(1903—1975)

ONE OF THE MOST INFLUENTIAL PHOTOGRAPHERS OF THE TWENTIETH CENTURY, THE WORK OF WALKER EVANS IS A CELEBRATION OF VERNACULAR AMERICA

Seen by many as the founding father of documentary photography, Evans is best known for his photographic record of the American Depression years of the 1930s. Commissioned by a government department called the Farm Security Administration, he recorded small-town architecture and the life of ordinary people. Detached from his sponsor's political agenda, Evans created a body of work that records devastating conditions without patronizing or victimizing his subjects. His technique was straightforward and direct, and his intention was to show things as they were, not embellished by the stylistic urges of an artist keen to make his mark. Obsessed by signage and the signs and symbols of everyday life, his best work shows a deep respect for the ordinary American.

»TOOLS AND TECHNIQUES

Using mainly a 10x8in view camera, Evans' approach was both methodical and meticulous. Compositions were carefully considered, with little opportunity for fortuitous accidents or impulse. Print detail is sharp and gives elevated status to the humblest of subject matter.

WEBSITE
Many of Evans' images are in the public domain, paid for and preserved by the US state. The Library of Congress in Washington has an extensive collection of his work, available for viewing online at http://www.loc.gov.

http://

Tin building. Moundville, Alabama, 1935, silver gelatin print.

→ HENRI CARTIER-BRESSON

(1908—)

THE GREATEST PHOTOGRAPHER OF THE TWENTIETH CENTURY, CARTIER-BRESSON DEFINED THE DOMINANT WAY OF WORKING FOR GENERATIONS TO FOLLOW

Trained as a painter, Cartier-Bresson's style evolved out of a sharply honed aesthetic which was also influenced by his contemporaries in the Surrealism movement. With independent means, Cartier-Bresson was able to develop a unique way of working and seeing, which steered photography away from the painterly to the graphic. Graphic shapes, lines, and symbols were his recurring themes, regardless of the subjects or countries he was shooting in. Like an abstract painter, he developed his own recognizable language without ever compromising his artistic principles.

A founder member of the Magnum photo agency, Cartier-Bresson continued his personal work in far-flung lands like China, Russia, and India. Each time returning with a stock of virtuoso images, his work was published uncropped in the purest form for a photographer—the monograph. Determined to show that he could previsualize his prints at the moment the shutter was pressed, he printed his images with a black border to denote a full frame, rather than a selective enlargement.

>>TOOLS AND TECHNIQUES
Starting off with one of the first miniature Leica rangefinders, which enabled Cartier-Bresson to travel light and shoot without fuss, suddenly it became possible to record slices of life as it happened. Coining the phrase 'the Decisive Moment' to describe the skilful timing of the shutter release to capture the moment of significance, Cartier-Bresson developed a highly philosophical approach to photography.

Roman Amphitheatre, Valencia, 1933.

BOOK

China

→ DIANE ARBUS

(1923—1971)

WITHOUT COMPARISON, DIANE ARBUS WAS A MOST EXTRAORDINARY PORTRAIT PHOTOGRAPHER, DRIVEN BY AN OBSESSION FOR SOCIAL OUTSIDERS

Unlike any other photographer in the 1960s, Arbus made a habit of crossing the line between acceptable and dubious methods of portraying her subjects. Seeking out those who exist on the edge of society due to their physical, sexual, or political attributes, Arbus collected 'types' like an entomologist collects rare insects. Her uncompromising approach led to some of the most memorable images of that era; lone individuals caught in despair and isolation within an alienating society. Drawn to befriending her subjects in order to gain their confidence, Arbus was able to produce intimate portraits without the startled look associated with documentary work. Children, dwarves, giants, naturists, and transvestites were all subject to her lens, and all emerge transformed with her unsettling but compelling way of recording. Towards the end of her very short career, Arbus pushed the boundaries even further by photographing mentally handicapped subjects in such a way that still provokes argument today, over 30 years after the images were produced.

BOOK

Diane Arbus, Aperture

>>TOOLS AND TECHNIQUES

The signature of an Arbus photograph is its square format and use of crude straight-on flash. Using a twin-lens medium-format camera to frame her subjects, Arbus experimented with drastic flash light which made her sitters look captured and compromised. Often shot with a wide-angle lens to enhance the isolation of her subjects in the landscape, she could make innocent children look terrifying.

A Family on Their Lawn One Sunday in Westchester, New York, 1968-1969.

→ WEEGEE

(1900—1968)

NOW ADORED IN FINE ART CIRCLES, WEEGEE WAS THE FIRST PAPARAZZI PHOTOGRAPHER WHO EARNED A LIVING BY SHOOTING THE GRIM AFTERMATH OF GANGSTER VIOLENCE

Born in Poland, and named after the ouija board due to his apparent sixth sense and uncanny ability to be at the scene of a crime before the police arrived, Arthur Felig carved out a name for himself. Armed with a police radio and portable darkroom in the boot of his car, Weegee could be at the crime scene and have a processed print ready for the tabloid press within a couple of hours. Keen to shoot the image with the most gore and sensationalism, Weegee is seen as the forefather of invasive paparazzi-style photography. Not averse to arranging the scene of crime to fit his compositional tastes or a picture editor's wishes, Weegee's work existed in an era that predates press ethics and codes of practice. Captioned with the bluntest of bylines, which confirmed his curiously detached reaction to violent death, he spent his latter years descending into increasingly seedier markets. Without parallel, Weegee's work exists and is enjoyed for its own sake.

»TOOLS AND TECHNIQUES

Shooting with a cumbersome Speed Graphic plate camera that was hard to focus and not very quick to operate it's not surprising that most of Weegee's subjects lay motionless. Weegee developed a crude flashbulb technique that ensured perfect exposures at a set distance away from his subject, so the look of his prints was very consistent.

Crime Scene of David 'the Beetle' Beadle, 1939.

BOOK
The Naked City

→ ROBERT FRANK

(1924—)

FAMED FOR HIS GROUND-BREAKING PROJECT, THE AMERICANS ROBERT FRANK BROUGHT A FRESH APPROACH TO DOCUMENTARY PHOTOGRAPHY

Swiss-born Robert Frank travelled to the USA and made an historic documentary study of late 1950s' America. Without a plan, Frank climbed into his car and travelled across America shooting a road movie with a stills camera. Dipping into all sections of society—white and black, rich and poor—Frank built up an accurate observation of America that was far from the idyllic society portrayed by government propaganda of the day. Shot as an outsider and freed from all conventional wisdom, Frank stripped away the façade of American society. Without an interested sponsor compromising his artistic and editorial judgement, Frank's independent project differed from magazine- or government-sponsored documentary. Seen as a founder of the independent documentary

movement, Frank continued to work by making his own independent films and books. His later work, produced in the 1990s, records his own lifestyle in remote Nova Scotia.

»TOOLS AND TECHNIQUES

Shooting from the hip with a small-format 35mm camera and black-and-white film, Frank used an innovative shallow depth of field technique to capture a slice of life. Designed to create the illusion of actually being inside the picture frame and involved with the subjects, his way of shooting mimics the way we choose focus points with the human eye.

BOOK

The Americans

Central Park, New York, from the 'Untitled Series'.

→ EVE ARNOLD

(1913—)

A MAGNUM ORIGINAL, EVE ARNOLD'S SOMETIMES SUBTLE, OFTEN CHALLENGING, ALWAYS BEAUTIFUL, PICTURES HAVE HELPED TO SHAPE PHOTOJOURNALISM AND DEFINE THE MODERN WORLD

Born in Philadelphia, Pennsylvania, of immigrant Russian parents, Eve Arnold's first photographs were taken on a $40 Rolleicord while working at a photo-finishing plant in New York in 1946.

Largely self-taught, Arnold's submission of reportage-style images taken on the streets of Harlem, to the editor of *Picture Post* in Britain, launched her name. In 1951, she became the first woman to join Magnum, becoming a full member in 1955.

Arnold's photographic subjects have been numerous and diverse, exposing the subtle complexities and contradictions of the human condition in a uniquely empathic way. She has photographed political dissidents in a Russian mental institution; American mothers giving birth; Malcolm X and the Black Muslim Movement in the 1960s, and the People's Republic of China after the Americans resumed diplomatic relations in 1979. She was one of the first photographers allowed into Tibet after the Dalai Lama left.

But it is perhaps for her portraiture of celebrities—most famously, Marilyn Monroe—for which Arnold will be enduringly recognized. Arnold's photographs of Monroe are revealing and sympathetic, and they have a luminous quality that is unforgettable.

Among the many prizes and accolades that Arnold has been awarded for her work, perhaps the most prestigious are being elected a fellow of the Royal Photographic Society in 1995, and 'Master Photographer'— the world's most prestigious photographic honor—awarded by New York's International Center of Photography. In 2003, she was awarded an OBE by the British Government.

»TOOLS AND TECHNIQUES

Early on, Arnold's camera of choice was the Rolleiflex, but, unable to source a Leica in America, she switched to a 35mm Nikon. She has always travelled light to remain a discreet and respectful observer.

A washroom in Chicago Airport, Marilyn Monroe waits for a plane to Champaign, Illinois, where she was to attend the centenary celebrations of the town of Bement. 1955.

BOOKS

In China
Marilyn Monroe: An Appreciation
In Retrospect
Magna Brava: Magnum's Women Photographers

→ **DON MCCULLIN**

(1935—)

AN ACTIVE PARTICIPANT IN THE WORLD'S FIRST MEDIA-FRIENDLY CONFLICT, THE VIETNAM WAR, DON MCCULLIN'S WORK WAS INSTRUMENTAL IN CHANGING PUBLIC OPINION

With unbridled access to the front line, Don McCullin was able to share the real-life horror of American soldiers in the Vietnam War. Unlike previous conflicts where access to action was restricted and newspapers were forbidden to reproduce any negative propaganda, Vietnam was different. With a passion for showing the realities of war and the emotional effects on the participants, McCullin left nothing to the imagination. Stuck in the center of the action rather than shooting the aftermath, McCullin's camera stripped away all notions about the glory of war and helped to force a sea change in public opinion, calling for an end to the conflict. Shot in a gritty reportage style to give his images maximum graphic impact when reproduced in the press, McCullin's work

has become an icon of the era. At the end of his war photography career, the stress and repeated exposure took its toll on the photographer, who withdrew from active service on the front line.

➤➤TOOLS AND TECHNIQUES

Shot with a basic 35mm Nikkor camera kit and, by today standards, grainy fast film, the style of McCullin's images match the horror of his subject matter. Designed in the dominant high-contrast style of the day, these images were the perfect addition to the emerging graphic style of the *Sunday Times* and *Observer* magazine supplements in the UK. With a hard-hitting attitude, both titles questioned authority and were the vehicle for a new breed of journalism.

BOOK

The Destruction Game

American Marine throwing hand grenade, Tet Offensive, Hue, Vietman, 1968.

→ JOSEF KOUDELKA

(1938—)

ARMED WITH THE MOST GRACEFUL EYE OF HIS GENERATION, JOSEF KOUDELKA'S WORK MIXES DOCUMENTARY OBSERVATION WITH A STRONG SENSE OF DESIGN

One of the most remarkable stories to emerge from the cold war, Czech Koudelka was 'discovered' by a Magnum photographer, who observed him climbing fearlessly onto Russian tanks in Prague while still shooting. Koudelka was finally smuggled out to the West, where he produced several thousands of rolls of unprocessed film depicting life in Soviet occupied Czechoslovakia. Once enrolled into the Magnum photo agency, Koudelka began to document many subjects close to his heart, such as the European gypsy, and pilgrims. Like Sebastião Salgado, Koudelka's best work shows an innate flair for design, which doesn't dominate or detract from the strong messages in his photographs. Printed with a gritty and contrasty style, Koudelka's work falls within the black-and-white tradition, but offers an extra dimension. A skilful observation of light and shadow, shape and contour, is always present in his best work and shows how the very best photographers can juggle all these factors in a single image.

>>TOOLS AND TECHNIQUES
Living proof that equipment is secondary to observational skills, Koudelka's early work was shot using the kind of low-grade equipment and materials common to a country behind the Iron Curtain. In recent years, Koudelka has experimented with a panoramic camera to great success, shooting a wide range of different subjects, such as the dissolution of the Soviet Union, and the natural landscape of South Wales.

BOOK
Exiles

Ireland, 1970.

→ TONY RAY-JONES

(1941—1972)

A SHORT-LIVED CAREER THAT FORGED THE WAY FOR MANY PHOTOGRAPHERS, TONY RAY-JONES IS BEST REMEMBERED FOR HIS UNIQUE OBSERVATIONAL SKILLS

Combining the new-found skills of his American contemporaries in the late 1960s, British-born Tony Ray-Jones developed his own approach and subject matter. Studying under editorial designer Alexei Brodovich, Ray-Jones went on to shoot some memorable images of English life before class and social division was a fashionable subject. Digging into the complex rituals of life in England offered Ray-Jones rich pickings. Nuns bathing at the seaside, holiday camps, morris dancers, and petty officialdom at open air fêtes were all captured and shown for what they were. With a keen eye for the unexpected, Ray-Jones' best-remembered image captures a deck-chaired couple dining at the open-air Glyndebourne opera. Oblivious to the background of cows,

the scene is frozen in a surreal moment. Ray-Jones' terrain of everyday life among the English is often cited as a formative inspiration by Martin Parr (see page 173).

»TOOLS AND TECHNIQUES

The 35mm camera was used very much in the Cartier-Bresson tradition. With such a keen eye for capturing a surreal moment in the frame, timing the shutter release is everything. With composition spoiled by delaying a fraction of a second, the best photographers, like Ray-Jones, developed an instinctive understanding of when to press the release.

Picnicking at Glyndebourne, Sussex, England, 1967.

→ LEE FRIEDLANDER

(1934—)

THE ORIGINAL AMERICAN STREET PHOTOGRAPHER, FRIEDLANDER APPROACHES PHOTOGRAPHY LIKE AN EAGLE-EYED BEACHCOMBER

Life on the street is an inspiring subject for many photographers, excited by the constantly shifting relationships of signs, symbols, and traffic. Lee Friedlander captured and documented this emerging cultural landscape in the 1960s and 1970s, creating a body of work that tried to make order out of visual chaos. Faced with the complexities of too much information to cram into the frame, many of Friedlander's best photographs show off his virtuoso skills in composition and observation. With a keen eye for detail and fleeting moments, Friedlander's camera went with him at all times. Many of his images display a unique form of visual humor, where the seemingly unconnected and unrelated are miraculously brought together within his viewfinder. In a later body of work entitled *Letters from the People*, Friedlander developed a clever approach to shooting grafitti, carefully cropping and arranging words, numbers, and letters in to a new and sophisticated composition. Observing beauty in the vernacular places Friedlander firmly within the tradition established by Walker Evans.

»TOOLS AND TECHNIQUES

A modest and entirely portable 35mm camera kit formed the basis for most of Friedlander's historic work, enabling him to dart about the streets unnoticed. Quick to spring into action and seize the moment, the 35mm camera also provides a strong rectangular frame within which to arrange the subject.

New York, 1974 (Courtesy of Fraenkel Gallery, San Fransisco).

BOOK

Letters from the People

→ JOEL MEYEROWITZ

(1938—)

BIG, BOLD COLOR STATEMENTS ARE THE HALLMARK OF THIS AMERICAN LANDSCAPE PHOTOGRAPHER

Working in the tradition of the American landscape photographers such as Ansel Adams, Meyerowitz is drawn to capturing the dramatic American terrain, but in color. Along with contemporary Harry Callaghan, Meyerowitz is one of the first photographers to successfully explore the medium, and to capture and document the spectacular intensity of natural color. Working in a deliberate and carefully composed manner, Meyerowitz uses the more cumbersome large-format camera to create gigantic enlargements where each and every detail is perfectly rendered in pin-sharp focus. Drawn to spectacular weather events and transitory lighting conditions, his work captures the latent forces of the land. Using the natural world and the emergence of the city as his favorite subject matter, his services are now highly sought-after for commercial assignments.

»TOOLS AND TECHNIQUS

Meyerowitz champions the use of large-format view cameras on location, loaded with color negative film. Without the ability to control contrast in the darkroom, only color balance, color landscape photographers frequently resort to using type L film, normally designed for exposure under tungsten lighting. With the ability to work at long exposure times without reciprocity failure, type L film enables photographers like Meyerowitz to maintain vivid color.

From the exhibition 'After September 11th: Images from Ground Zero'.

WEBSITE
You can follow the recent work of this master of color landscape at his own website on www.joelmeyerowitz.com

http://

→ JOEL-PETER WITKIN

(1939—)

COMBINING THE LURE OF SENSUOUS PRINTING WITH SHOCKING SUBJECT MATTER, WITKIN'S IMAGES PROVOKE A WIDE RANGE OF RESPONSES

For many photography enthusiasts, the work of Joel-Peter Witkin becomes even more shocking when they realize that all is real. Haunted and driven by memories of a campaign in Vietnam, and an obsession with Victorian medical photography, Witkin's work collects and arranges the physically malformed into elaborate tableaux. Working with the full consent of willing participants, except when using body parts sourced from unnamed hospital incinerators, Witkin's work is both shocking and compulsive viewing. Attracting attention just like the latter day circus freak show, his images reveal the grotesque in aesthetically arranged scenarios. Without sentiment for his subjects, Witkin unleashes the full power of his creative intentions to make highly charged, unforgettable, stunning images.

›› TOOLS AND TECHNIQUES

Joel-Peter Witkin shoots his work in a traditional photographic studio, but the real sign of his craft doesn't appear until the darkroom phase. Film originals are scratched and scored to produce a distressed look and seductive print effects are created by using wet tissue paper between the enlarger and the printing paper. A Witkin print is as hand-rendered as a drawing or an artist's etching and offers the full range of variation in tone and mark-making.

The Fool. (Photograph courtesy of the artist and Ricco/Maresca Gallery, New York).

WEBSITE
See the inspiration for Witkin's work at the website of the Burns Archive of Medical Photography, a curious mixture of the side-show and the historical.

www.burnsarchive.com

http://

→ STEVE MCCURRY

(1950—)

ROAMING THE WORLD FOR THE 'UNEXPECTED, THE MOMENT OF SERENDIPITY', MCCURRY'S IMAGES ARE BEAUTIFUL SNAPSHOTS OF HUMANITY REVEALED

Born in Philadelphia in 1950, McCurry studied film at university and dreamt of becoming a documentary film-maker. But, after graduating cum laude, he became a newspaper photographer. In 1978, he went to India to freelance as a photojournalist.

His career was launched when, disguised as a native, and with rolls of film sewn into his clothes, he crossed the Pakistan border into rebel-controlled Afghanistan just before the Russian invasion. The resulting images were among the first to show the conflict, and were published worldwide. His coverage won the Robert Capa Gold Medal for Best Photographic Reporting from Abroad.

He is the recipient of numerous awards, including, in 1984, Magazine Photographer of the Year and four first prizes in the World Press Photo Contest. He has twice won the Olivier Rebbot Memorial Award.

McCurry has covered many areas of conflict, including the Iran-Iraq war, Beirut, Cambodia, the Philippines, the Gulf War, the former Yugoslavia, and Afghanistan. Recently, he has also covered Angkor Wat, Yemen, Kashmir, India's fiftieth anniversary of its independence, Burma, Sri Lanka, and most poignantly, the 9/11 tragedy in New York. Whatever the subject, McCurry's unswerving focus is the human consequence.

"I try to convey what it is like to be a person caught in a broader landscape, that I guess you'll call the human condition."

»TOOLS AND TECHNIQUES

For McCurry, taking risks is an essential technique for getting his historic pictures. The morning following the 9/11 tragedy in New York, McCurry and his assistant were able to break through the cordoned area under cover of darkness, crawling along and cutting through a cyclone fence. Spending as much time evading pursuers as taking pictures, McCurry was persistently forced back, and would retreat for a moment and then double back immediately. By staying, he was able to translate into film what he, and New York, was feeling: intense horror and loss.

Red boy, Bombay, 1996.

BOOKS

Books on McCurry's inspiring work include *Monsoon*, *Portraits*, and *Sanctuary: The Temples of Angkor Wat*

→ SEBASTIÃO SALGADO

(1944—)

NOW REGARDED AS THE WORLD'S FINEST DOCUMENTARY
PHOTOGRAPHER, SALGADO'S WORK COMBINES THE GRACE OF
CARTIER-BRESSON WITH A BURNING POLITICAL INTENTION

Trained initially in economics, Sebastião Salgado came to photography as a late starter, but has been a major player ever since. Based in Europe but drawing from his Brazilian cultural heritage, Salgado's work is intended to draw attention to complex social issues such as workers' rights, poverty, and the destructive effects of economic policy on the developing world. Salgado's most famous series, shot in the Serra Pelada gold mine in Brazil, depicts an horrific abuse of human rights on such a vast scale not seen since the construction of the great pyramids of Egypt. Thousands of people are shown clambering out of a giant quarry on primitive ladders, forced to carry sacks of mud which may contain strands of gold. Unlike most photographers who shoot to earn a living, Salgado uses his photography to raise funds as well as awareness for charitable organizations and disadvantaged groups.

››TOOLS AND TECHNIQUES

Shooting in the traditional mode using black-and-white film and a standard 35mm camera kit, Salgado's technique is portable and unobtrusive. Famed for using Leica camera systems for their superior quality lens optics, Salgado's images can be enlarged to a grand scale without losing impact or sharpness. With careful attention placed on the tonal balance of the final print, bleaches are applied by brush to reduce intense shadows.

From the 'Serra Palada Gold Mine, Brazil' series.

BOOK

Salgado's images are immortalized in many books including *Workers* and *In our Time*.

→ CINDY SHERMAN

(1954—)

USING HERSELF AS THE CENTRAL CHARACTER IN A SERIES
OF ELABORATE SELF-PORTRAITS, CINDY SHERMAN'S WORK
IS ENTIRELY INVENTED RATHER THAN OBSERVED

With her now famous series of 'Untitled Film Stills', Cindy Sherman shot into the fine art world in the early 1980s. One of a new breed of artists who used the medium of photography to express their ideas and concepts instead of using paint and canvas, Sherman's Film Stills work depicted familiar scenes from 1950s' 'B' movies. Without re-enacting scenarios or duplicating film sets verbatim, Sherman's photographs provoked an almost subconscious recollection of scenes from nameless films. With exact attention placed on the minute details of costume, make-up, and set-design, the photographic images are designed to look film-like and transitory, but are, in fact, highly constructed and posed. Sherman's more recent work involves the use of masks and surgical prosthetics, developing a curious mixture of black humor and the sinister. Compared to traditional photographers, Sherman's work is entirely fabricated rather than found on the street, and belongs to a group of postmodern artists using photography with a completely different set of values. Unconcerned with the craft of darkroom technique and printmaking, conceptual photographers are instead driven by an intellectual motive.

»TOOLS AND TECHNIQUES
Unlike many documentary photographers who become attached to their own methods and ways of shooting, Sherman's tools and techniques are secondary to the conceptual development of the image. Staged in a photographic studio, Sherman's work is produced in large-scale print format for exhibition in public and private galleries in the USA and Europe.

From the 'Untitled Film Stills' series.

→ **MARTIN PARR**

(1952—)

SEEN AS THE FATHER FIGURE TO A WHOLE GENERATION OF COLOR PHOTOGRAPHERS, PARR'S PHOTOGRAPHS COMBINE SOCIAL OBSERVATION WITH A KEEN EYE FOR HUMOR

Shooting his own documentary projects in the UK since the mid-1970s, Martin Parr's work has now become much sought after by magazines and advertising agencies. Now a member of the prestigious Magnum photo agency, Parr continues to shoot his own brand of cynical documentary but now on a world stage. His favorite subjects are social classes and world tourism and his photographs are typified by his strong opinions. For a long time color photography was seen as the preserve of the amateur snapshot photographer, but Parr has developed its brash colors and limited range into a celebration of the kitsch. Parr has self-published many books of his own work including *The Last Resort*, *Signs of the Times* and *Bored Couples*, where unsuspecting subjects are shown in all their glory. Criticism of Parr's work centres on the way he reinforces stereotypes through his work, such as the uneducated working class and the grim reality of life in the north of England.

»TOOLS AND TECHNIQUES

Parr uses a medium-format rangefinder camera like the Plaubel Makina to gain pin-sharp results from 6x7 negatives. Shooting with color negative film stock and a large, portable flashgun, subject colors are enhanced and made more vivid with use of fill-flash.

New Brighton Beach from *The Last Resort*.

→ ENCYCLOPEDIA

A

≫AGITATION

Agitation is a necessary part of film and paper processing and works by moving new chemistry in and around sensitive material. All films processed in a developing tank are based on set developing times and rates of agitation. When films are not agitated, the result will be uneven processing and underdevelopment.

≫AMBIENT LIGHT

A continuous light source that, unlike electronic flash, is not transitory, ambient light is measured by a traditional in-camera or hand-held light meter. Ambient light forms the basis of all timed exposures but can be of variable color temperature.

≫ALIASING

In digital photography, CCD sensors create square-shaped pixels. Unfortunately, square blocks can't describe curved shapes very well and when viewed close-up look jaggy. Aliasing is most noticeable in low-resolution images but less so in higher-resolution images due to the increase in pixel numbers. To counteract this, camera manufacturers place an anti-aliasing filter between the lens and image sensor to reduce the visible effects. A by-product of this is a slight reduction in contrast.

≫APERTURE

The aperture is a variable opening inside a camera lens that lets light pass onto film or in a digital camera, the CCD sensor. Aperture settings are arranged in an internationally recognized scale measured in f-numbers. These f-numbers are typically arranged as follows: f/2.8, f/4, f/5.6, f/8, f/11, f/16, and f/22. Aperture values are primarily designed to moderate the varying intensity of light to enable successful exposures. Wider

apertures such as f/2.8 let in the maximum amount of light compared to narrow apertures such as f/22, which let in the least amount of light. Aperture values can also influence depth of field.

≫APERTURE PRIORITY MODE

This is the most popular autoexposure option found in SLRs and better compact cameras. Aperture priority works when the photographer defines the aperture value and the camera sets the right shutter speed to make a correct exposure. Aperture priority is useful when you want to create a particular depth of field effect.

≫APS FORMAT

The Advanced Photo System format is designed to give a choice of three different print shapes on the same roll of film. APS film can only be used in APS compact cameras, which are easily identified by the triangular logo. Unlike 35mm film, APS film is loaded and rewound automatically, via a special loading compartment and once processed, film is stored in the cassette for safekeeping. Designed primarily for amateur and family use, APS prints cannot be enlarged like 35mm film without a noticeable reduction in image quality.

≫AUTO EXPOSURE

Found on most compact and SLR cameras, the autoexposure mode is a convenient tool if you don't want to keep manually controlling exposure. With this type of setting, the camera automatically sets both shutter speed and aperture value, so precise control over depth of field and movement cannot be guaranteed.

≫AUTOFLASH

Most digital and film compact cameras have an autoflash function which fires when light levels are too low for a normal exposure. A disadvantage of autoflash is the loss of control over its intensity and direction, resulting in snapshot-type photos. Much better results are produced using manual flash modes or an external hammerhead flashgun.

≫AUTOFOCUS

Autofocus cameras take the human error out of focusing a lens. With this system, most compact cameras lock focus on the object in the centre of your frame, which can cause a problem if your composition is off-centre. Better SLRs have multi-zone autofocus systems which can respond to more creative framing. Autofocus work best when locked onto an area with sufficient contrast.

≫ARTIFACTS

Artifacts are unfortunate by-products of digital image-processing which degrade image quality. Once artifacts are present in an image, they become even more noticeable if further manipulation is carried out. There are many different types of artifact caused by circumstances like over-compression, high ISO speed and drastic color adjustments. This example shows the effects of an over-compressed JPEG file.

B

≫BIT DEPTH

Sometimes called color depth, bit depth describes the size of color palette used to create a digital image. 8-bit, 16-bit, and 24-bit, are common palette sizes, creating 256, several thousand, and 16.7 million colors respectively.

BITMAP IMAGE

A bitmap is a common term for a pixel-based image. Also called a raster image, this describes a grid of pixels arranged in a checkerboard-like arrangement.

≫BACKLIGHTING

If your subject is arranged against a background of intense light, such as a portrait in front of a window, autoexposure will record this as a image. Use fill-flash to lighten up the sitter in the foreground or use a reflector to reduce the difference in contrast.

≫BARREL DISTORTION

Found most frequently when using wide-angle lenses, barrel distortion causes parallel lines to converge at the edges of the film frame. Top-quality lenses suffer less from barrel distortion, and worst offenders are low-grade zoom lenses used at their wide-angle setting.

≫BLOWER BRUSH

A useful tool for removing dust and hair off lenses and negatives, the blower brush is used instead of physically touching delicate surfaces which could easily be damaged. Dust on both enlarger and camera lenses lowers the quality of the final image and must be removed regularly to ensure best results. On no account should a lens be rubbed with any household cleaning cloth as this will result in the removal of the lens coatings.

>>BLURRING

Blurred images are frequently caused by camera shake caused by slight body movement during exposure. Coupled with a slow shutter speed, this will cause your lens to shake during exposure. The problem is more noticeable in low-light situations, but this can be solved using a tripod. Always use at least 1/125s and 1/250s with long telephoto lenses.

>>BURNING IN

A technique used in the darkroom for adding extra exposure to a section of a photographic print. Burning in commonly occurs through a small hole cut into a larger piece of card, designed to protect the print from darkening.

>>BURST RATE

In digital camera technology, the term burst rate indicates the speed at which a camera can save and store image data, then get ready to capture the next shot. Better cameras with onboard memory chips can shoot at a fast rate.

>>BRACKETING

Used by professional photographers, bracketing is an insurance against uncertain exposure conditions. Instead of gambling on one single frame, several identical versions of the image are taken, each with a different exposure variation. After processing, the best frame for printing or reproduction can be selected. This example shows five variations on one subject.

>>BULB SETTING

Despite the term, the Bulb setting has nothing to do with flash photography. Marked as a 'B' on your shutter speed scale, it keeps the shutter open for as long as your finger keeps the shutter release pressed down. Bulb is used at night-time to make moving car headlights record as luminous stripes.

C

≫C41
A universal process used for developing color negative and chromogenic film. The C41 process is the same worldwide and offers the convenience of identical processing times for all film types regardless of their ISO speed.

≫CARD READER
A card reader is a small device used to transfer digital card data to a computer. After removing the card from the camera, it is inserted into a card reader which is permanently connected to a computer. This kind of device is essential if camera upload software is incompatible with an older computer, or when faster data transfer is desired from a camera which has a slower serial port connector. Dual-format card readers accept both SmartMedia and CompactFlash cards. The Lexar Jumpshot cable shown below is a fast USB card reader.

≫CCD
CCD stands for Charge Coupled Device and is the light-sensitive sensor used in place of film in a digital camera. A CCD is like a honeycomb of tiny individual cells, with each one creating an individual pixel. CCD sensors are sold with different recording capabilities described in megapixels, or million pixels, such as a 3.34M camera.

≫CD-R
Compact Disk Recordable is the most cost-effective kind of storage media used in digital photography. Despite the low cost, you need to have a CD writer to write data to CDR disks, but they can all be played back in a standard CD-ROM drive.

≫CHROMOGENIC FILM
A special monochrome film based on the same emulsion used in color negative film. Very fine grain and not prone to excessive density through overexposure, films such as Ilford XP2 are good multipurpose materials. Unlike other monochrome films, chromogenic films can be developed in C41 chemistry, found in any shopping mall photo processors. Enlargements from 35mm chromogenic film can be made larger than normal films of a similar speed.

≫CLIP TEST
When it's not possible to reshoot, many photographers shoot a trial roll of film at the beginning to use as a clip test. After the shoot, the first few frames of the trial roll are processed under normal conditions to test if the exposure is accurate or not. If the clip test is under or over, the remaining batch of film can be push or pull processed for perfect results.

≫CMYK IMAGE MODE
Cyan, Magenta, Yellow, and Black (described as K to avoid confusion with Blue) is an image mode used to prepare digital

photographs for commercial lithographic printing. All magazines and books are printed with CMYK inks, which have a smaller gamut than the RGB image mode.

>>CMYK INKS
CMYK inks are the standard colors used in inkjet printers for mixing realistic photographic colors. Better inkjets have three additional colors: light magenta, cyan, and black for reproducing better skin tone.

>>COLOR CASTS
Color casts are unexpected tints that appear on your photographs. Casts are generally caused by shooting under an artificial light source such as domestic lightbulbs or fluorescent tubes without flash. With daylight-balanced film, this will result in orange and green casts respectively. For professional use, special color-correcting filters can be used over the camera lens to counteract this problem. Digital cameras have an in-built automatic filtering system called the White Balance function.

>>COLOR NEGATIVE FILM
The most popular form of photographic film used for wedding, portrait, press, and sports photography. Designed for use when a print outcome is required, the film is cheap to process and enlarge. Color negative has a wider exposure latitude compared to transparency material and is much more forgiving. In medium-format, color negative is available in two variants: daylight, sometimes called type S, and tungsten, sometimes called type L.

>>COLOR SPACE
In digital photography, different image modes such as RGB, CMYK, and LAB are designed with different color characteristics called color space. Like different palettes, a color space is defined with unique characteristics and limitations. LAB is the largest color space, with RGB next, followed by the much smaller CMYK space. When converting images from a larger space to a smaller space, loss of original color can occur.

>>COLOR TEMPERATURE
An exact measurement of light color, expressed in the Kelvin (k) scale. Measured by a hand-held color temperature meter during color-critical assignments, both daylight and artificial light can be corrected using filters.

>>COLOR TRANSPARENCY FILM
Once the professionals' favorite, but now being largely superseded by digital and color negative, transparency is the hardest sensitive material to use. With little more than a half-stop margin of error, transparency is designed to be used in a reprographic workflow, where no enlargement or prints are required. Used by magazine and advertising photographers, transparencies are developed in the universal E6 process by professional laboratories in a tightly controlled environment.

>>COMPRESSION
Crunching digital data into smaller files is called compression. Without physically reducing the pixel dimensions of an image, compression routines devise compromise color recipes for a larger group of pixels, rather than individual ones. JPEG is a commonly used compression routine.

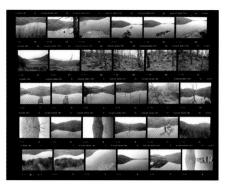

≫CONTACT PRINT

Sometimes referred to as a proof sheet, the contact print is a positive same-size print made from color or black and white negatives. The contact sheet is made so you can decide which negatives are worth printing up. Using a modern digital mini-lab, a smaller kind of reference sheet called an index print offers the same service, albeit at a reduced size.

≫CROPPING

Images can be recomposed after shooting by a process called cropping. Used to create visually stronger images, cropping can occur during enlarging or mounting. Digital photographers can use a simple crop tool to remove unwanted pixels.

D

≫DENSITOMETER

There are two types of densitometer used in professional processing labs: the reflective and the transmissive. The transmissive densitometer is used to measure the effectiveness of the developing stage in film processing. The reflective densitometer is used to test development of print materials. Both tests allow a lab manager to adjust processing times, chemical replenishment, or processing temperature to ensure consistent results.

≫DEPTH OF FIELD

The zone of sharpness set between the nearest and furthest parts of a scene. You control DOF by two factors: your position to the subject and the aperture value selected on your lens. Higher f-numbers, such as f/22, create a greater depth of field than lower numbers, such as f/2.8.

≫DEVELOPMENT

Exposure of photographic materials creates a hidden and latent image which needs to be amplified by a process called development. Within the light-sensitive emulsion, tiny, silver crystals are enlarged by the developer until they become visible. Development is the first and most critical stage of converting a latent image.

≫DIGITAL ZOOM
Used in digital compact cameras for pulling a distant subject closer, digital zoom is not to be confused with proper telephoto functions. It works by enlarging a small patch of pixels by interpolation to make detail look bigger than it really was. Results from a digital zoom setting will show a loss of sharpness.

≫DODGING
Also called holding back, dodging is a darkroom term for limiting exposure in small areas of a darkroom print. Used when areas of an original negative are thin and don't hold enough detail to make a straight print, dodging is often carried out on the facial areas of location portraits.

≫DOUBLE DARK SLIDE
Used for holding sheet film ready for exposing in a view camera, the double dark slide must be loaded and decanted in total darkness. Designed with color coded sides so you can remember which sheet has already been exposed, the double dark slide must be kept free from dust.

≫DX CODING
Most modern 35mm cameras use an automatic film-speed detection function called DX coding. Fitted with tiny electrical sensors inside the film cassette chamber the process works by reading the checkerboard pattern printed on the outer 35mm cartridge. While designed to prevent exposure errors caused by setting the wrong film speed, many cameras are not able to override DX coded speed in order to uprate film speed. In these circumstances new checkerboard strips can be bought and stuck on the cassette to fool the camera.

≫DYNAMIC RANGE
The dynamic range is a measurement of the brightness range in both photographic materials and digital sensing devices. The higher the number, the greater the range of captured tone from white to black.

E

≫E6
The standard processing sequence for color transparency films. Like C41, the E6 process is universal and can accommodate films of all speeds and formats in a single run. Uneconomic to try at home, and difficult to maintain constant quality, the E6 service is best bought as a professional lab service.

≫EMULSION
The layer of photographic film which contains the light-sensitive chemicals. Emulsion is a mixture of inert gelatin and silver halides, mixed together to form an even coating which is permeable during processing but stable when dry.

≫EXPOSURE
Exposure is the amount of light that falls onto a digital sensor or light sensitive material. In both photographic printing and shooting, exposure is controlled by a combination of time and aperture setting. The term is also used to describe a single frame or shot taken.

»EXPOSURE COMPENSATION DIAL

Used to set smaller third-of-a-stop variations in exposure, the exposure compensation dial offers a precise way of controlling demanding subjects. Sometimes referred to as the EV or +/- function, it offers smaller incremental change compared to exposure adjustments offered by the shutter speed and aperture scales, especially on mechanical cameras.

F

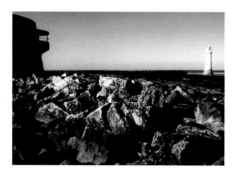

»FAST FILM

Film such as ISO 800 is designed to permit shooting in a low-light situation or freezing fast-moving subjects. High-speed film is manufactured with a light-sensitive emulsion which needs much less light compared to standard ISO 100 film materials.

»FAST LENSES

Prime camera lenses designed with wider maximum apertures, such as f/1.8 or f/2.8 are known as fast lenses. Compared to mini-zoom lenses, which are frequently sold with a maximum aperture like f/4, fast lenses allow you to shoot in low-light conditions, use faster shutter speeds and, most importantly, present a much brighter viewfinder image to aid accurate focusing.

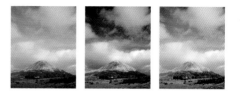

»FILTERS

Glass, plastic, or gelatin filters can be attached to a camera lens for adding a creative effect to your photograph. For color critical assignments, color correction filters can be used to match lighting color temperature with film stock. Filters work by absorbing or transmitting different wavelengths of light, thereby allowing some colors to pass through to the film while some are prevented.

»FILTER FACTORS

All creative and corrective filters work by changing the composition of both artificial light and natural daylight. To compensate for the absorbtion of certain wavelengths, additional light is needed to ensure a correct exposure. All filters are supplied with corresponding filter factors which indicate how much extra exposure is required. Filter factors of 2, 4, or 8 mean an extra 1, 2, or 3 stops of extra light.

»FILM RECORDER

A high quality digital output device which is designed to produce films from digital files. Fitted with a tiny internal laser, digital data is beamed directly onto film to produce film negatives. High-resolution digital files can also be output to large-format transparencies using this device.

≫FILM RETRIEVER

A clever device used to extract the film leader from 35mm film without needing a light-tight loading room. Once extracted three or four inches, the leader can be trimmed and pre-loaded onto a developing spiral to make for easier loading.

≫FIX

Fixing is the last chemical stage of film and paper development and provides two important functions: rendering the material insensitive to light and washing away any unprocessed emulsion. Before light sensitive film is fixed, unexposed and underdeveloped emulsion is still present and gives film a characteristic 'milky' appearance. After fixing, film is cleared and assumes a transparent state. The chemical residues of fix must be removed by thorough washing or staining will occur in forthcoming months.

≫FLARE

When shooting into direct light such as the sun, lens flare will occur. Flare looks like a series of translucent discs overlapping on your image, or a drastic white burst of light. Caused by excessive light entering a lens which is not protected by a lens shade or hood, flare is impossible to remove. All lenses have a specially designed shade which is shaped to prevent flare from occurring. Cheap rubber or universal lens hoods will never afford proper protection against flare.

≫FLASH

Electronic flash is calibrated to produce light of a consistent and neutral color. Flash is created when an electrical current passes through a tiny, gas-filled tube which produces a rapid burst of light. Unlike continuous light, the light quality from a flash can't be seen before the moment of exposure.

≫FLASHMETER

A hand-held device for measuring the intensity of flash light falling on a subject. Camera meters are not equipped to measure flash and this must be undertaken with a separate meter. Flash meters can be operated in two principle ways: corded and non-corded. With the corded method, the meter is connected to the flash unit with a sync cable which is then test fired by the meter operator. In the non-corded method, no sync cable is required and the flash unit is fired by an extra pair of hands while the meter is held in place. Flash meters express an aperture reading only because the duration of the flash burst itself defines the time element of the exposure, which is unaffected by any change in shutter speed.

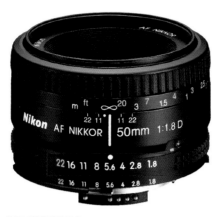

>>F-NUMBERS

Aperture values are described in f-numbers, such as f/2.8 and f/16. Smaller f-numbers let more light onto your film or digital sensor, and, with bigger numbers, less light.

>>FOGGING

Fogging occurs in both film and paper materials when they are inadvertently exposed to light. Low-light fogging can occur if a darkroom or processing tank is not sufficiently light-tight, producing a severe dark patch on your film, making it impossible to print properly. Fogging can also occur if you accidentally open the camera back before rewinding your film or by leaving your film cannister on a sunny windowsill.

G

>>GAMUT

Gamut is a description of the range of a color palette used for the creation, display, or output of a digital image. Unexpected print outs often occur after CMYK mode images are prepared on RGB monitors and are said to be out of gamut.

>>GIF

The Graphics Interchange Format is a universal image format designed for monitor and network use only. Not suitable for saving photographic images due to the 256-color, 8-bit palette, GIFs are best used for saving solid color graphics with a tiny file size.

>>GRAIN

Grain is the gritty texture visible in enlargements made from fast film negatives. A by-product of extended development, especially when film is push-processed, grain can gradually reduce sharpness. Although modern film emulsions are designed to offer maximum speed with minimum grain, older style monochrome film is still very much in demand. The emulsion used in Kodak Tri-X Pan offers a distinctive grain, favored nowadays for its retro style.

>>GRAYSCALE

In digital imaging, the Grayscale mode is used to create and save black-and-white images. In a standard 8-bit Grayscale there are 256 steps from black to white, just enough to prevent banding to the human eye.

▶▶GUIDE NUMBER

The strength of a flash unit is described by its guide number. The bigger the guide number, the more powerful light output it can produce and the further it will reach. Shooting photographs using a large aperture value, such as f/2.8, will increase the reach of flash compared to shooting with a narrow aperture such as f/16.

H

▶▶HALFTONE

A halftone image is constructed from a series of fine dots to simulate the continuous tone and color found in a photographic image. Halftones are used in publishing and are based around the four process colors: Cyan, Magenta, Yellow, and Black.

▶▶HIGH AND LOW KEY

Two terms commonly used to describe different lighting styles. High-key lighting is bright, sharp, and brings out every detail in a subject and is commonly used by portrait photographers for shooting front covers. Low-key lighting is dimmer and more suggestive than descriptive and is used to create more atmospheric photographs.

▶▶HIGH RESOLUTION

High-resolution images are generally captured with many millions of pixels and are used to make high-quality print outs. Many pixels make a better job of recording fine detail compared to fewer. High-resolution images can demand lots of storage space and need a computer with a fast processor to cope.

▶▶HOT SHOE

This is a universal socket for attaching an external flashgun to better compact and SLR cameras. Tiny electrical contacts ensure that the flashgun communicates with the camera to synchronize during exposure.

▶▶HOT SPOT

Hot spots are unplanned patches of flash light that appear in your images. When shooting against a shiny or reflective surface such as glass, windows, or spectacles, light bounces straight back onto the film and will cause drastic problems. Avoid these errors by shooting at an angle or bouncing flash off a ceiling.

I

»INKJET PRINTER

A versatile output device used in digital imaging which works by spraying fine droplets of ink onto media. Inkjets can print onto a wide range of media such as paper, card, vinyl, plastic, and canvas, and are used for point of sale displays and advertising hoardings as well as desktop printing.

»INTERPOLATION

All digital images can be enlarged by introducing new pixels to the bitmap grid. Called interpolation, images that have gone through this process never have the same sharp qualities or color accuracy of original non-interpolated images.

»ISO SPEED

Both film and digital camera sensors can be graded by their sensitivity to light. The ISO value of a film or sensor describes its ability to work under low or bright light conditions. ISO 50 and 100 is the slower end of the scale and describes materials only suitable for use in the brightest light situations. ISO 200 and 400 are general purpose films able to work in changeable environments, but ISO 800, 1600, and above are for shooting in lowest light conditions. Just like aperture and shutter speed scales, the doubling or halving of an ISO value halves and doubles the amount of light needed to make a successful exposure.

J

»JPEG

JPEG is an acronym for Joint Photographic Experts Group and is a universal file format used for compressing photographic images. Most digital cameras save images as JPEG files to make more efficient use of limited capacity memory cards. The JPEG format is known as a lossy compression method as image quality deteriorates after re-saving.

L

»LANDSCAPE FORMAT

Shooting while holding your camera in a horizontal position will create landscape-format photographs. Like the shape of a TV screen, landscape-format images are best suited for recording groups of people. The landscape shape is a much more suitable format for images destined for web-page use as they fit within the shape of a computer monitor.

»LIGHT METER

Most 35mm cameras are fitted with a built-in light meter which is used to gauge the brightness range of the scene due to be photographed. The light meter reacts to light levels by sending instructions to the camera to set the right aperture and shutter speed combination under an autoexposure function or provides a guide for the photographer to base a manual exposure setting on. Most important to remember is that light meters can't sense individual colors, only brightness.

M

≫MACRO
Macro is a term used to describe close-up photography. The lens itself determines how close you can focus and not all cameras are fitted with macro lenses as standard. Many mid-range zoom lenses offer an additional macro function, but much better results are gained by using specially designed macro lenses. When close focusing, effective depth of field shrinks to a matter of centimetres even when using narrow apertures like f/22.

≫MEGAPIXEL
The term megapixel is used as a measurement of the maximum bitmap size a digital camera can create. A bitmap image measuring 1800x1200 pixels contains 2.1 million pixels (1800x1200=2.1 million), the maximum capture size of a 2.1 Megapixel camera. The higher the megapixel number, the bigger and better quality print out you can make.

≫MIRROR LOCK-UP
A useful function on heavier medium-format cameras used to lock the viewing mirror in the 'up' position before an exposure is made. On very long exposures, heavy mirrors can cause minute vibrations, which in turn can create a slight loss of image sharpness.

≫MODELING LIGHT
Found on a studio flash unit, the modeling light is a separate tungsten light source designed to give a preview of the likely quality produced by the flash bulb. The intensity of the modelling light has no bearing on the flash meter exposure reading.

≫MOTORIZED FILM ADVANCE
On modern SLRs, motorized film advance automatically winds the film into position for the next shot after each exposure is taken. Older, mechanical 35mm SLRs and most mechanical medium-format systems use a film advance lever to do the same task. Motorized film advance and rewind can drain batter power quickly, especially in colder weather conditions.

≫MOTOR WIND
A motor wind or high-speed film advance allows you to shoot a sequence of frames in quick succession. Professional SLRs usually have a built-in motor wind which offers the chance to shoot in excess of three frames per second. Good for use in sports or action photography.

≫MULTIGRADE FILTERS
These are used in conjunction with variable contrast (VC) photographic paper to determine paper contrast. Filter packs are made to fit under the lens or within a special filter draw inside the enlarger head and are graded 0-5. At the zero end of the range, a low-contrast print effect is created. At the opposite end of the scale, grade five will make a high-contrast print. Normal contrast is achieved by using a grade two filter, or no filter at all.

N

≫NEGATIVE FILM

All brands of photographic film which end with the word -color are color negative materials. Agfacolor, Fujicolor, and Kodacolor are all negative films and are developed in the standard C41 process. Color negatives are designed with an integral orange dye to assist with later color printing.

≫NEWTON'S RINGS

When film is sandwiched between any glass or polyester surfaces, strange ring-like shapes appear called Newton's Rings. This causes a problem in both glass enlarger carriers and scanner film holders as the mysterious shapes transfer to the print and scan. Newton's Rings can be minimized by cleaning glass beforehand with an antistatic cloth.

≫NOISE

Similar to grain in conventional photographic film, digital noise occurs when shooting in low-light conditions or when a CCD sensor is used at a high ISO setting. When too little light falls onto a digital sensor, strange colored pixels are made in error. Most often bright red or green, these randomly arranged pixels are called noise and are found in darker and shadow areas of your photographs. Noise can be reduced in most image-editing packages by using a filter designed to merge them with surrounding pixels, making them less noticeable.

O

≫OPENING UP

Opening up is a traditional photographic term which describes the act setting a wider lens aperture thereby opening the lens to allow more light to pass through to your film. Opening up is the opposite of stopping down.

≫OVEREXPOSURE

This occurs when too much light is passed onto your light-sensitive material or digital sensor due to a miscalculated exposure. When using negative films, overexposure causes dark and dense negatives, but with transparencies and digital images, it creates pale results with washed out colors.

P

≫PANTONE COLOR

The Pantone color library is an internationally established system for describing color with pin-number-like codes. Used in the lithographic printing industry for mixing color by the weights of ink, pantone color printing is used to mimic chemical tone effects in photographic prints.

≫PARALLAX

Parallax error occurs in cameras fitted with an optical viewfinder set close to one side or above the lens. When used to close focus, what you see through the viewfinder will be different to the image captured by the lens. Twin lens cameras commonly suffer from parallax error.

≫POLAROID BACK

Most good medium-format and all large-format camera systems can accept a specially designed film holder for using Polaroid proofing film. For medium-format cameras, film is supplied in a pod or pack, but for large-format cameras Polaroid film is supplied in individual sheets. All Polaroid backs need their rollers regularly cleaned to avoid expensive misfeeds.

≫PICTROGRAPHIC PRINTER

A modern color printing system designed by Fuji offering photographic quality prints from digital files. Pictro printers need only water to process special chemical impregnated paper. Compared to conventional minilabs using RA4 chemicals, Pictro printers are environmentally friendly and do not discharge spent chemicals into the drains.

≫PIXEL

Derived from the words PICture ELement, a pixel is the building block of a digital image like a single tile in a mosaic. Pixels are generally square in shape and are arranged in a grid-like matrix called a bitmap.

≫POLAROID PROOFING FILM

Peel apart Polaroid film is used by photographers to check their lighting before committing to film. Known as proofing material, the Polaroid offers an instant way of checking that everything is working properly. Polaroid produces a very different kind of image compared to color transparency, so cannot really be used to gauge exposure or color balance.

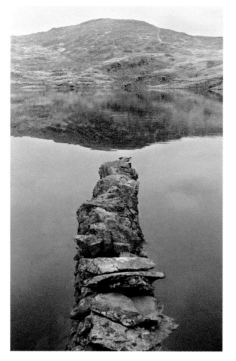

▶▶PORTRAIT FORMAT
By holding a 35mm camera upright, portrait format images are produced. Many magazine pages depend on portrait format images for eye-catching layouts. Most printed books and periodicals are designed in this shape.

▶▶PROCESS CONTROL STRIP
These are pre-exposed strips of film or paper that are designed to test the effectiveness of a processing sequence. In carefully managed processing labs, control strips are put through at regular intervals in order to judge the effectiveness of the process.

▶▶PUSH PROCESSING
Most mid-speed and all high-speed films can have their ISO values increased to enable shooting in low light. Called uprating, the apparent reduction in exposure is counteracted by a corresponding increase in development time called push processing. Slightly underexposed film can also be pushed to increase the brightness of transparencies or density of negative material. An increase in image contrast is usually a by-product of this process.

▶▶PULLING
In film processing, the normal development stage can be reduced in time in order to correct overexposed film. Many photographers deliberately over expose and underdevelop to reduce harsh subject contrast or to minimize contrast gain when copying artwork for reproduction.

R

▶▶RA4
The latest standard processing cycle for developing color prints, RA4 is designed to allow rapid development and a quick washing cycle. Most minilabs use RA4 chemicals to process color prints quickly. Only RA4 compatible color paper can be used within this process.

>>RAM

Random Access Memory is the computer component that holds image data during work in progress. Computers with little RAM will process images slowly as data is written to the slower hard drive. Extra RAM is easy to install, and can dramatically improve the performance of your PC.

>>RED EYE

Red eye is a familiar error caused when on-camera flash is used to photograph people at close range. Especially when combined with low ambient light conditions, red eye occurs when flash bounces back off the retina and onto the film. Most cameras have a red-eye reduction mode which works by firing a tiny pre-flash in order to close down your subject's irises. Red eye never occurs when flash is bounced or used off-camera.

>>RESOLUTION

The term resolution is used to describe several overlapping concepts in digital imaging. In general, high-resolution images are destined for print out and have millions of pixels made from a palette of millions of colors. Lower-resolution images have fewer pixels and are only suitable for computer monitor display. Low-resolution images make poor-quality print outs.

S

>>SAFELIGHTING

In a black-and-white darkroom, a low-level red or orange light can be used while printing. Modern monochrome printing papers are designed to be insensitive to this end of spectrum, but only for a short time. Unexposed paper left under constant red safe lighting will eventually fog.

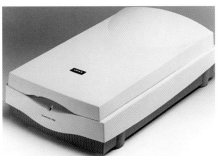

>>SCANNER

A scanner is a tool for converting photographic film and prints into digital files which can then be used on a computer. Flatbed scanners are shaped like small photocopiers and are used for capturing flat artwork by reflective light. Film scanners are much smaller devices and are designed to capture information by transmitting light through both negative and transparency films onto a receiving sensor.

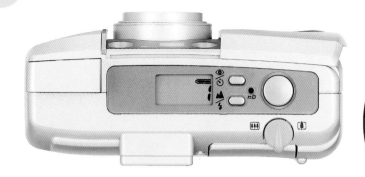

≫SHUTTER

All cameras are fitted with a shutter, either a thin curtain or series of blades which open and close to let light onto your film or digital sensor. Fast shutter speeds are used to capture fast-moving sports or action subjects, where as slower shutter speeds are used to create deliberate blur or during very low light levels with a tripod.

≫SHUTTER RELEASE

This button is the one you click to make an exposure. On small- and medium-format cameras, the shutter release is situated to the top of the camera body, but on large-format cameras is actually found in the lens housing. Most good autofocus cameras allow you to pre-focus on subjects outside the centre of the frame by keeping the shutter release button held halfway down.

≫SLAVE UNIT

Attached or integrated into a studio flash unit, the slave cell works by triggering a second flash head after sending a burst of flash light from another flash unit. Slave cells can be used instead of sync leads to connect different flash units together, especially useful when shooting a large interior with many spaced-out flash positions.

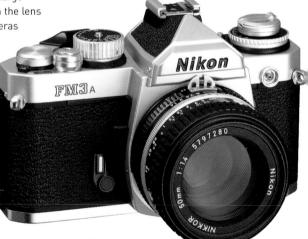

≫SLR

The single lens reflex camera is designed to let the photographer compose directly through the lens. This occurs due to a clever series of mirrors called a pentaprism which presents a corrected scene to your viewfinder. The pentaprism gives a more accurate tool for precise composing compared to rangefinder viewers.

>>STOP

A common term use to describe a single shift of exposure along the aperture or shutter speed scale. When an exposure of f/8 at 1/60th of a second is changed to f/5.6 at 1/60th of a second, the result is an increase by one stop. Smaller units of exposure such as half or third of a stop can be set by using the exposure compensation dial.

>>STOP BATH

Used in both film and paper processing, the stop bath is the second stage of development and works by neutralizing the developing agent. Although running water will wash off developer fast enough, proper acid stop will halt the harmful effects of the agent within a few seconds and is a much better option. Most brands are designed to be reused and have a built-in dye indicator, so you can tell when it has gone beyond its effectiveness.

>>STOPPING DOWN

The opposite of opening up, stopping down refers to the process of setting a smaller aperture to prevent excessive light from passing onto your light-sensitive media. It is based on the use of traditional lenses where aperture scales were presented as click stops on the lens barrel.

>>SYNC LEAD

An electrical connector used to join an electronic flash unit to a camera's PC socket. Sync leads are easily damaged and it pays to carry a spare one when out on location. Sync leads are also needed when taking light readings with a hand-held flashmeter.

T

>>TIFF

Tagged Image File format is the most common cross-platform image format. The much less compatible compressed TIFF variation can be used for reducing file size without sacrificing image quality. Compressed TIFFs use a lossless routine compared to the destructive lossy JPEGs.

>>TTL METERING

Simple cameras use a basic kind of light metering mounted on the outside of the camera body. Modern cameras use a more sophisticated TTL or through-the-lens metering for precise results. By reading the actual light that passes through the lens, more accurate results are achieved.

U

>>UNDEREXPOSURE

When not enough light reaches photographic film or a digital sensor, underexposure occurs. In extreme low-light conditions or most often by human error, underexposure causes negatives to look thin and lacking in detail and transparencies and digital images to appear dark with muddy colors.

>>USB

Universal Serial Bus is a recent type of computer peripheral connector which offers high speed date transmission. USB is cross-platform and also known as 'hot-swappable' as it can be plugged in and unplugged without crashing your computer. Many different USB devices can be connected together using a kind of junction box called a USB hub.

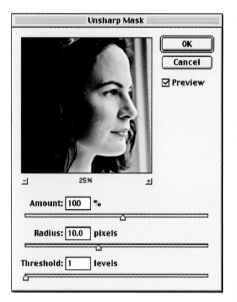

V

››VARIABLE CONTRAST PAPER

In the black-and-white darkroom, five different grades of photographic paper are used to compensate for negative contrast. Variable contrast paper is designed to offer the full range of grades from low- to high-contrast within the same box. Manufactured with a sensitivity to yellow and magenta light, contrast is assigned by the enlarger with the use of swing under filters or a color head. Ilford Multigrade is a popular variable contrast paper brand.

››UNSHARP MASK (USM)

The USM filter is a software tool for sharpening slightly soft digital images. Found as a standard tool in most image-editing applications, the USM filter works by increasing the contrast of pixels existing at the edges of shapes within an image.

››UPRATING FILM

Photographic film is designed to work at a fixed ISO speed, but faster speed films can have their speed increased to compensate for low-light levels. ISO films can easily be uprated to ISO 800 without much loss of quality but the film must be developed by push processing to compensate.

››UV FILTER

Natural light is a complex mixture of visible wavelengths and invisible such as ultra violet and infra-red. When using color photographic films, excessive UV light can cause hazy and less saturated results. To counteract this effect without causing any visible discoloration, a UV filter can be placed over the lens.

››VIGNETTING

If the corners of your images are dark, this is caused by vignetting. Most commonly created by using a non-standard lens shade or by using too many filters at once, vignetting can only be removed by cropping the image down to a smaller size. Wide angle lenses and wide-angle zooms are most prone to vignetting as their extreme angle of view can sometimes include the edge of a filter or lens hood in the picture.

W

≫WAIST-LEVEL VIEWER

Used in medium-format camera systems, the waist-level viewer is a primitive device for previewing your subject through the camera lens. Unlike the pentaprism found in an SLR camera, this kind of viewer offers a laterally reversed preview on a ground-glass screen. Waist-level viewers are also difficult if not impossible to use when the camera is held in an upright format.

≫WETTING AGENT

A weak solution of detergent designed especially for film processing, wetting agent works by reducing the surface tension of water. This helps water to slip off film easier when drying, and prevents destructive drying marks from spoiling your film. Over-concentrated wetting agent, or film which has suffered an over-extended period standing in wetting agent, will end up with permanent bubble marks.

≫WHITE BALANCE

Digital cameras are fitted with a device for measuring the color temperature of light. The white balance control is used to prevent unwanted color casts when shooting under artificial light or natural cloud cover. Unlike photographic color film which needs filtering when exposed under fluorescent and domestic lights, digital cameras can self-correct color casts.

≫WHITE OUT

Overexposure in a digital image causes a total loss of image detail called white out. Unlike traditional negative film, where overexposed details can be brought out with careful printing, pure white pixels can't be adjusted to reveal hidden or lurking details.

→ APPENDIX

→ INDEX

D

E

→ PICTURE CREDITS & WEBSITES

Picture credits

Andrew Sole	**97**
Anthony Croydon	**162–173**
Apple Computers	**27**
Canon	**10, 13, 26, 31**
Corbis	**98, 99, 100, 101,112, 140, 141, 142, 143, 144, 148, 149, 150,155**
Epson	**78, 79**
Fuji	**20, 21**
Hasselblad	**18, 24**
Kodak	**17, 34, 35**
Leica	**15**
Mamiya	**16, 17, 20, 30**
Monique Kavanagh	**162–173**
Nina Esmund	**36, 38, 39, 43, 44, 46, 47, 48, 49, 50, 51, 52, 53, 54, 55, 57, 59, 60, 61, 62, 63, 64, 65, 68, 69, 72, 73, 74, 75, 76, 77, 78, 79, 82,83, 84,85, 86,87,88, 90,91, 92, 93, 94, 97, 103, 104, 105,106, 108, 109, 110, 111, 115, 117, 118, 119, 120, 121**
Magnum Photos	**56, 89, 115, 120, 147, 153, 161, 162–173**
Metro Pictures	**160**
Nikon	**10, 11, 12, 27, 28, 29, 31, 32, 42, 56**
NB Pictures	**152, 159**
Neil McElheron	**162–173**
Paul Tucker	**45, 47, 57, 58, 60, 61, 66, 67, 80, 84, 91, 95, 102, 107, 113**
Phillip Andrews	**109**
Sekonic	**70, 71**
Science and Society Picture Library	**124, 125, 126, 127, 128, 129, 130, 131, 132, 133, 135, 154**
Sinar	**22, 23**
Tom Need	**40, 48, 49, 53, 66, 107, 116**
US Library of Congress	**134, 137, 146**

Websites

Further information on products and equipment featured in this book can be found at the following websites:

Apple computers: www.apple.com
Canon: www.canon.com
Epson: www.epson.com
Fuji: www.fujifilm.com
Leica: www.leica.de
Hasselblad: www.hasselblad.com
Ilford: www.ilford.com
Kodak: www.kodak.com
Mamiya: www.mamiya.com
Nikon: www.nikon.com
Sekonic: www.sekonic.com
Sinar: www.sinar.com

Further advice and information can be found at the author's own website at
www.photocollege.co.uk

→ ACKNOWLEDGMENTS

The author would like to thank the following for their help with this book:

Kylie Johnston, photography editor at Rotovision, Nigel Atherton, editor of *What Digital Camera* magazine, Nick Merritt, editor of *Digital Camera* magazine, Chris Dickie, editor of *AG* magazine.

Nina Esmund, Paul Tucker, Phillip Andrews, and Tom Need for their generous photographic contributions.

Anthony Croydon, Monique Kavanagh, and Neil McElheron from the department of photography at East Surrey College, Redhill, Surrey, UK.